# Canon®
# PowerShot®
# Digital Field Guide

Michael Guncheon

BICENTENNIAL
1807
WILEY
2007
BICENTENNIAL

Wiley Publishing, Inc.

**Canon® PowerShot® Digital Field Guide**

Published by
**Wiley Publishing, Inc.**
10475 Crosspoint Boulevard
Indianapolis, IN 46256
www.wiley.com

WILEY

# About the Author

**Michael Guncheon** is a contributing editor for *PCPhoto* magazine. His "HelpLine" column is one of the oldest and most popular columns in the magazine. He has also written for *Outdoor Photographer* and *DigitalPhotoPro* and has authored several popular books on digital cameras. Michael is the technical editor for *HDVideoPro* and also writes the magazine's "VideoAssist" column. His photography has appeared in magazines and calendars. In addition, he is a partner in HDMG, a high definition video company, and a member of the Society of Motion Picture and Television Engineers.

# Credits

**Senior Acquisitions Editor**
Kimberly Spilker

**Senior Project Editor**
Cricket Krengel

**Technical Editor**
Marianne Wallace

**Copy Editor**
Lauren Kennedy

**Editorial Manager**
Robyn B. Siesky

**Vice President & Group Executive Publisher**
Richard Swadley

**Vice President & Publisher**
Barry Pruett

**Business Manager**
Amy Knies

**Senior Marketing Manager**
Sandy Smith

**Project Coordinator**
Erin Smith

**Graphics and Production Specialists**
Stacie Brooks
Carrie A. Cesavice
Brooke Graczyk
Jennifer Mayberry

**Quality Control Technician**
Cynthia Fields

**Proofreading**
Broccoli Information Management

**Indexing**
Sherry Massey

**Wiley Bicentennial Logo**
Richard Pacifico

*This book is dedicated to Carol.*
*Without her, both this book and my*
*life would be just blank pages.*

# Acknowledgments

Thanks to Kimberly Spilker for the phone call that one day, and to her trust in my work; to Cricket Krengel for mentioning my name to Kimberly and whose knack for keeping this "engine" running would put a locomotive engineer to shame; and to my technical editor Marianne Wallace, an outstanding photographer in her own right.

You can't write a book about cameras without help from manufacturers and the folks at Canon are always selfless in giving their time and knowledge. Thanks to Rudy Winston, Chuck Westfall, and Geoff Coalter. Mike Wong and the gang at Sandisk have been a great help with explaining memory card care and feeding. My appreciation also to Kriss Brunngraber at Bogen for his support in more ways than one. Thanks also to Jason Ledder and Kyle Kappmeier at R & J Public Relations for putting me in touch with some fantastic resources.

Thanks to my family, spread out throughout the country — Kay, Andrea, Paul, and Mark. And to my family close by — who have the misfortune of having to put up with all the picture taking — Kelly, Holly, Rowen, Vienne, and Kari.

Lastly, I would like to thank my first editor, Rob Sheppard. Rob called me ten years ago, when the term digital photography was new, and told me that he thought I would be a great fit for writing about it. We both knew that the technology would take off, and Rob has made it a fun ride! His dedication to the image and making photography accessible is an inspiration.

# Contents at a Glance

# Contents

## Chapter 2: Navigating Your PowerShot Camera   59

## Chapter 3: Getting the Most Out of Your PowerShot Camera 83

# Part II: Creating Great Images with Your Canon PowerShot 107

## Chapter 4: The Fundamentals of Photography 109

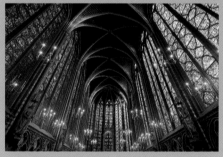

**Chapter 5: Accessories 125**

**Chapter 6: Capturing
Great Images 137**

**Chapter 7: Downloading, Editing, and Outputting**    **215**

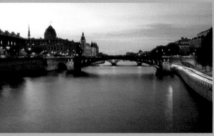

# Introduction

I first started taking pictures using an old film camera when I was a child. Luckily we had access to a darkroom and didn't have to wait for the pictures to come back. But still, the picture-taking process was half mystery, half imagination — we just never knew what we would get.

When I first got my hands on a digital camera, the resolution wasn't much. The camera could only take eight images before you *had* to hook it up to a computer and download the files from the camera's built-in memory. The whole process was clunky but it was still amazing because just seconds after you took a picture, you could see what you photographed.

The PowerShot was introduced by Canon in 1996. Although primitive by today's standards, it was the start of a long line of digital cameras that has increasingly pushed the capabilities of digital imaging technology. The PowerShot isn't just a snapshot camera; it is a sophisticated digital imaging device. Images captured by PowerShots have appeared in magazines and newspapers, dorm rooms and photo albums.

## Who is this Book for?

This book is written for those PowerShot owners who are new to photography and those who are transitioning from shooting film. If you are a long-time PowerShot owner and want to improve your picture-taking techniques, there are chapters for you, as well. And if staring at camera menus causes you to become blurry-eyed, these pages will help.

Although this book covers many specific PowerShot models, if you have an older model or if a newer PowerShot makes its debut, this field guide can still help you. Although Canon continues to improve their cameras' performance, the basic operations are consistent and the fundamental photographic principles of lens, image sensor, and image processing still apply.

## Making this Book Work for You

This book is laid out to give you a lot of options. You're anxious to start using your PowerShot, so jump to the Quick Tour at the front of the book. It will give you the basics so you can begin capturing digital images and get a feel for the camera.

Once you have done some experimenting, you can start reading Chapter 1, where you learn about some of the technologies built into your camera. Given this guide covers the entire PowerShot line, Chapter 1 also examines the specific models in the line. Chapter 2 goes into great detail about camera menus, giving you practical suggestions for menu settings.

Setting up your camera by using menus is one thing, but once you get out and start photographing, all the shooting adjustments, such as exposure and focus, come into play. Chapter 3 details how to make your way through all of the adjustments.

Part II of this book begins the exploration of creating great images. The chapters start with some fundamentals of photography and proceed to explore accessories to improve your photography skills.

Chapter 6 gives you real-world tips for many photographic shooting environments. You can easily read this huge chapter in chunks and it is a good reference out in the field.

Each topic is broken down into:

✦ Discussions about the subject matter

✦ Example images

✦ Thoughts to inspire

✦ A practice image detailing camera settings, lighting, and accessories used

✦ Instructions for capturing a similar image

✦ Specific shooting tips for each subject

Next, Chapter 7 provides an overview of downloading, editing, and printing your images. Lastly, Chapter 8 explores the video recording option on your PowerShot.

This is a field guide. Take it with you. Mark it up. Don't leave it home until you really know your PowerShot. Even then it can be a great go-to book when you get in an unfamiliar situation or want to try something new.

Each PowerShot owner can take something different from this text. Some of you just want a better understanding of how to operate your camera; others of you may want to take your photography from snapshots to photographs. Whatever your motivation, I believe first and foremost that photography should be enjoyable. Before, photography was half mystery and half imagination. Taking pictures with a PowerShot should be a little bit magic and a whole lot of fun.

Now, move on to the Quick Tour and start taking pictures!

# Quick Tour

I t is exciting to unpack a new camera, fire it up, and see what it can do. And, a little patience in the beginning can provide a good foundation for capturing great photographs in the future.

This Quick Tour helps get you going by providing brief explanations of some of the controls and settings you need to use as you take your first photographs (and assumes you have read your camera manual). By the end of the Quick Tour you should be taking pictures with your PowerShot. Then, you can move into the later chapters where you find more detailed explanations of camera controls, rules for basic photo composition, and guides on how to capture different types of scenes.

## Getting Your Camera Ready

Because this field guide covers a wide range of PowerShot models, it is important to point out some controls and indicators that are common throughout the series. On some models a given function is controlled by a single button while on other models several functions are grouped onto one control.

- ✦ **Power button.** The power button is located on the top of most models. If it is near the shutter release button, it is slightly recessed so you don't accidentally turn off the camera instead of taking the picture.

- ✦ **Shutter release button.** On some models the shutter release button is surrounded by the zoom control.

- ✦ **Indicators.** If your camera has a viewfinder, you may find two LEDs located by the viewfinder. If your camera doesn't have a viewfinder, then you should see a single indicator near the LCD. The indicator lamps let you know when the camera is ready to take a picture and when it is writing to the memory card.

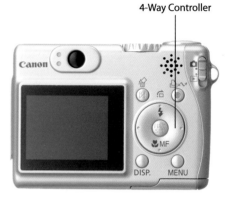

4-Way Controller

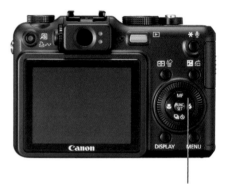

4-Way Controller

✦ **Zoom control.** You can identify the zoom control by the tree icons— one side has one tree and the other has three trees. On some models this is a lever. On other models, the zoom control is integrated into the 4-Way Controller on the back of the camera.

✦ **Mode dial.** You may find this control on the back of your camera or on the top of it. To save room on some models, the dial has been changed to a sliding switch.

✦ **4-Way Controller.** The 4-Way Controller is typically a circular control with different functions assigned to the top, bottom, left, and right sections of the circle.

✦ **Menu button.** This button accesses the on-screen menus that appear on the LCD.

✦ **Func./Set button.** This control may be centered in the middle of the 4-Way Controller. Any time the LCD displays "SET," it refers to this button.

Several other buttons on the back of the camera are explained in Part I of this field guide, but knowing the previously listed controls will allow you to quickly start using the PowerShot.

Before you go any further, make sure that your battery is charged, installed correctly, and that your memory card is also inserted.

**Caution**  *The memory card can only be installed one way. If you have to force it, you are not inserting it correctly.*

QT.1 Two examples of the different styles of 4-Way Controllers—yours may look different even from these, but the functionality is largely the same.

## Setting the time and date

When you power up the camera the first time, you are asked to set the date, time, and, in some models, the time zone.

**Note**  *If the camera has been powered up previously for a checkout, the display might not ask you to set the time and date. In that case, press the Menu button and use the left and right portion of the 4-Way Controller to highlight the Setup menu (the yellow-orange tab with the wrench and hammer). Use the 4-Way Controller to navigate to Date/Time and press the Func./Set button.*

The camera displays the date with the month highlighted. Use the up and down controls on the 4-Way Controller to select the current month. Use the right control to advance to the date. Continue using the up and down and right portions to set the date and year. The time is set using 24-hour notation. The seconds are reset to zero when you press the Func./Set button.

> **Tip** *To figure out 24-hour time quickly, add 12 to the current hour when the time is past noon. For example, 4:00pm is 12:00+4:00, so it is 16:00.*

After you set the date and time, you should set the order of the month, day, and year. You can use the typical U.S. setting of month/day/year (mm/dd/yy), the European setting of day/month/year, or a computer-centric setting of year/month/day.

If your camera supports daylight saving time, a sun icon appears to the right of the date setting. Use the up and down controls on the 4-Way Controller to choose between daylight saving time and standard time. Once you have set the date and time, date format, and daylight saving time mode, press the Func./Set button to accept.

Next, if your PowerShot model supports it, you should set the time zone. PowerShot cameras can track two time zones: one for home and one for travel. If your camera uses time zones, for now just set the home time zone to your local time zone. To do this, follow these steps:

1. **Press the Menu button.** The menu appears on the LCD.

2. **Use the 4-Way Controller to select the Setup menu.** The Setup menu is indicated by the yellow and orange tool icon.

3. **Use the down portion of the 4-Way Controller to select the Time Zone setting.** If you don't see this option in your menu, your PowerShot does not support time zones.

4. **Press the Func./Set button.** The display shows two time zones.

5. **Use the 4-Way Controller to scroll down to the time zone indicated by a house icon.** This is your local time.

6. **Press the Func./Set button to display a world map.** The map has a city indicated by a cross and the geographical time zone is high-lighted in yellow.

7. **Use the left and right portions of the 4-Way Controller to select your time zone.**

8. **Press the Func./Set button to accept or the Menu button to cancel.**

> **Tip** *Check to make sure that the correct hour appears when you have finished setting the time zone. You may need to reset the time. If the time you set initially was not correct, then the time zone you set will also display the incorrect time.*

## Formatting the memory card

PowerShots use solid-state memory cards called Secure Digital (or SD) cards. Before you use a memory card in a PowerShot, it must be formatted in the camera. To format the memory card:

1. **Press the Menu button.** The menu is displayed on the LCD.

2. **Use the 4-Way Controller to select the Setup menu.** The Setup menu is indicated by the yellow and orange tool icon tab.

3. **Use the down portion of the 4-Way Controller to select Format... setting.** This selection might be below the bottom of the screen if the Setup menu has a long list of settings. Continue to press the down portion of the 4-Way Controller until you get to the Format... setting.

4. **Press the Func./Set button.** The display asks you if you want to format the card. It also displays the size of the card.

5. **Use the 4-Way Controller to select OK and press the Func./Set button.** A busy message appears and the card is formatted.

 *Formatting erases any data on the memory card, including any images that have been protected.*

In Auto mode, the camera takes over most of the controls, so you can simply frame your shot and press the Shutter release button. The camera adjusts all the other settings. The

QT.2 The Auto mode icon

PowerShot cameras do a remarkable job at estimating the proper camera settings when photographing a variety of subjects. When you first start using your camera, keep it on Auto for a while so you can get used to the camera's other basic operations. However, even though the camera is in Auto mode, you still have some control. You can tell the camera whether you want to use flash or use a red-eye reduction flash. You can engage the Self-Timer, turn on Macro for close focusing, and change the light sensitivity of the camera.

 *Using the flash, self-timer, red-eye reduction, and adjusting light sensitivity with ISO, are all covered in Chapter 3.*

# Selecting a Shooting Mode

The Shooting modes vary by PowerShot model. Most versions of the PowerShot include Auto, Manual, a variety of Special Scene modes, and Movie modes. The more advanced cameras include Aperture and Shutter priority modes, in addition to the others.

*Cross-Reference* *Detailed explanations of all of the Shooting modes can be found in Chapter 3.*

# Selecting a Scene Mode

In addition to Auto, the camera's Scene modes can help you photograph certain types of subjects. Each scene optimizes various camera settings according to typical situations to help capture better images.

Throughout the wide range of PowerShot models, different Scene modes are accessed by using different controls. Some cameras have Scene mode icons on the

Mode dial while on others they are accessed by pressing the Func./Set button. Depending on your model, you can choose from these Scene modes:

 **Note** *Not all PowerShot cameras have all of the following Scene modes.*

✦ **Portrait**

✦ **Kids & Pets**

✦ **Sports**

✦ **Indoor**

✦ **Foliage**

✦ **Snow**

✦ **Fireworks**

✦ **Beach**

✦ **Night Scene**

✦ **Night Snapshot**

✦ **Landscape**

✦ **Aquarium**

✦ **Underwater**

✦ **Color Accent**

✦ **Color Swap**

 **Cross-Reference** *Refer to Chapter 3 for an explanation of individual Scene modes.*

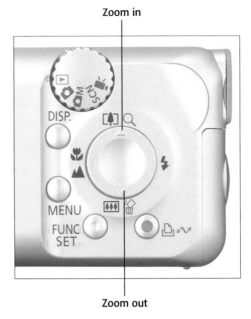

Zoom in

Zoom out

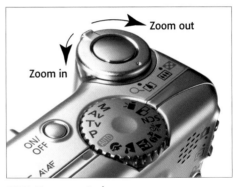

Zoom out

Zoom in

QT.3 Zoom control

# Taking the Picture

Once you have selected your Shooting mode or Scene mode, taking the picture is pretty straightforward. You can use either the viewfinder (if your model has one) or the LCD to frame your scene. Use the Zoom control to bring the scene closer to you.

Once you adjust your zoom, press the Shutter release button halfway to allow the camera to set focus. When focus is achieved, the camera beeps and one or more green rectangular outlines appear on the LCD. These boxes indicate the objects in your scene on which the camera has locked focus.

**Cross-Reference** *If you are taking pictures in a location where the camera beep may be distracting, you can mute the camera. Refer to Chapter 2.*

Once the camera has focused and is ready to take the picture, finish pressing the Shutter release button. A clicking sound or beep lets you know that the shutter has been engaged. The LCD blanks out momentarily as the data is captured and written to the memory card.

# Reviewing Images

After the image has been written to the memory card, the captured image is displayed on the LCD for a few seconds.

**Cross-Reference** *In Chapter 2, you learn how to change the standard image review time.*

**Tip** *If you want to display the image longer while still in Shooting mode, press the Disp. button right after the image is presented on the LCD. This causes the image to stay on the LCD until you press the Shutter release button halfway.*

To review all the pictures on your memory card, it is necessary to put your camera into Playback mode. Depending on your PowerShot model, you do this by rotating the Mode dial (or moving the switch) to the Playback icon (shown in figure QT-4) or by pressing a separate Record/Play button to engage playback.

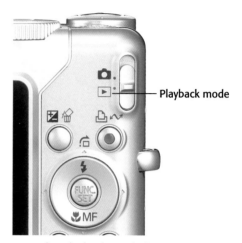

Playback mode

**QT.4** The Playback mode icon

When you enter Playback mode, the first image displayed is the most recent one you captured. You can scroll through your images by using the 4-Way Controller. You can also use the camera's zoom control to magnify the picture so you can look at details. On some models, if you zoom all the way out, you can look at a grid of several images and quickly scroll through groups of images by using the 4-Way Controller.

# Deleting Images

During image playback, you have the opportunity to delete those shots you don't like. Look for the blue trashcan icon that represents the Delete button. Although it varies by PowerShot model, on many cameras, it is the down portion of the 4-Way Controller. Other models have a separate Delete button, and still others use a different control, such as the Exposure button.

When you press the Delete button while reviewing images on the LCD, a dialog box appears asking if you want to erase the current image. If you want to, make sure ERASE is highlighted, and then press the Func./Set button and the image is removed from the card.

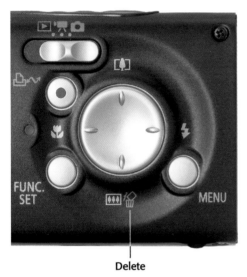

Delete

**QT.5** The Delete image icon

 **Caution** *There is no undo for deleting images!*

If your camera has a separate Playback mode button, you can return to shooting just by lightly pressing the Shutter release button. Otherwise, you need to turn the Mode dial back to one of the Shooting modes to resume taking pictures.

# Output

When you are ready to transfer your images from your camera, you have several options. You can:

✦ Connect your camera directly to your computer

✦ Use a card reader

✦ Print directly from your camera

## From camera to computer

You can connect your camera directly to your computer by using the USB cable that comes with your camera. Although this method might be good for a few transfers, I do not recommend it for regular use.

**Cross-Reference** *Chapter 7 covers the pitfalls of downloading via a USB connection.*

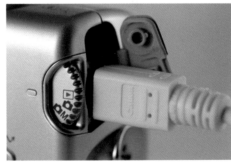

**QT.6** A USB cable connected to a PowerShot, ready for downloading

# Using a card reader

You can attach a card reader to your computer and output your photos. When you need to transfer files, simply remove the memory card from your camera and insert it into the reader. When you have finished downloading the images, eject the card and leave the reader connected to your computer for your next downloading session.

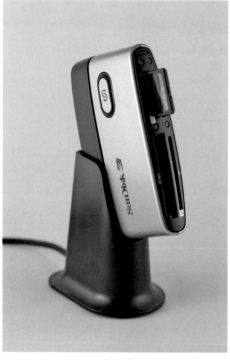

QT.7 A memory card reader

**Caution** *Make sure to properly eject the memory card. If using Windows, right click on the memory card in My Computer and choose Eject. If you use a Mac, go to your Desktop and drag the memory card icon to the Trash. For more information on memory cards, see Chapter 7.*

Whether you use a card reader or connect your camera directly to your computer, Canon has provided software to help you download and organize your images. The CD that comes with your camera contains applications that work on both Macintosh and Windows. The Macintosh application is called ImageBrowser and the Windows application is called ZoomBrowser EX.

**Cross-Reference** *Chapter 7 shows you how to use ImageBrowser and ZoomBrowser EX.*

# Directly from the camera

You can also connect your camera directly to a Canon printer or many other brands of printers, and print your photos directly from the camera.

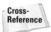

**Cross-Reference** *Printing in general, including printing from the camera, is covered in much more detail in Chapter 7.*

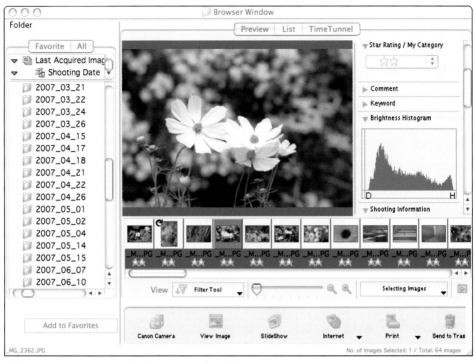

**QT.8** ImageBrowser application on Macintosh

**QT.9** ZoomBrowser EX application on Windows.

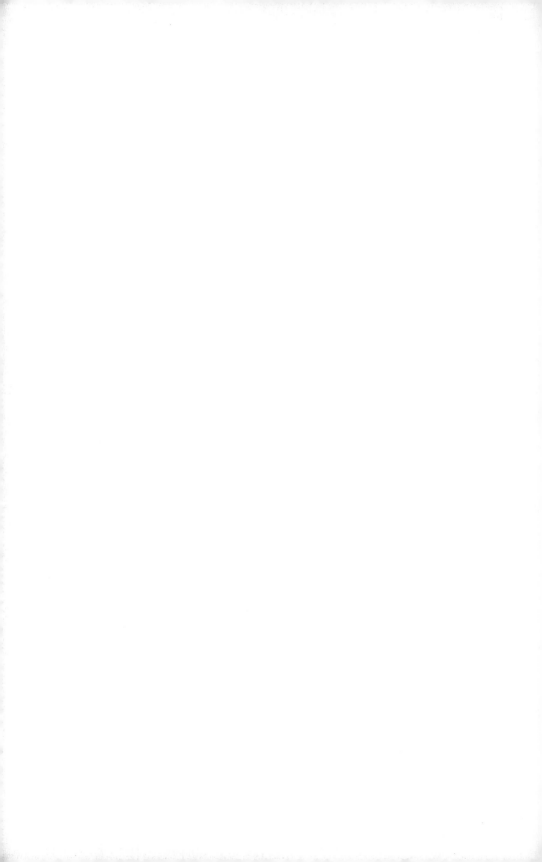

# Using Your Canon PowerShot Camera

# Exploring the PowerShot Cameras

**Y**ou've probably had some fun going out and taking some snapshots, but now you're ready to start on the road to great pictures with your PowerShot. The Quick Tour was just that—quick—something to give you a taste of how to work the camera. Now it is time for a more in-depth look and to begin exploring the features of your camera.

One path to learning might be to jump right in and start going through menus and settings, but I find it useful to step back first and look at the camera from a bit of a distance. That is what this chapter is all about. There is plenty of time to delve into menus when you get to Chapter 2.

Better knowledge of the various PowerShot technologies helps transform you from someone who simply presses the shutter to a photographer who captures great images. First this chapter briefly explains many of the technologies spread across the PowerShot line. Then I take a look at the various models and point out a few of the features that set each apart from the others.

## About the Technology

Some of the technology mentioned here may not be included in your model of PowerShot, but being aware of the technology that makes your camera's functions work is useful for building a base for good photography. For example, your camera might not have optical image stabilization, but learning about it might help you to think about how you can improve your picture taking by keeping the camera stable yourself.

✦ **DIGIC.** Canon calls their image processors DIGIC, which stands for Digital Integrated Circuit. The current PowerShot cameras contain either the DIGIC II or DIGIC III processor. Any digital camera works on a simple concept: Light enters through the lens and is captured by an image sensor. The image sensor takes the energy of the light and converts it into a voltage. It then amplifies the voltage, turns it into a digital signal, and sends it to a computer processor. The DIGIC processor processes the digital data, turning it into a color image, and then writes it to a memory card.

Note
*The Canon PowerShot has had a long history in the digital camera market. Fortunately Canon has been fairly consistent in the design of their cameras, so if you have an older camera, this field guide will still work for you.*

✦ **AiAF.** This funny looking acronym stands for Artificial Intelligence Auto Focus. When the camera tries to set focus for your scene, it intelligently looks at objects in the frame and determines which ones to lock onto, evaluating them by position and movement. There are two types of autofocus, depending on your camera model.

  • **Multiple point AiAF.** This is the default setting.

  • **FlexiZone AF/AE.** This option allows you to move a rectangular box around the LCD in order to explicitly tell the camera where you want the focus and exposure measurements to occur.

✦ **iSAPS.** This stands for Intelligent Scene Analysis based on Photographic Space and is an entirely original scene-recognition technology developed by Canon for digital cameras. Using an internal database of thousands of different photos, iSAPS works with the fast DIGIC III Image Processor to improve focus speed and accuracy, as well as exposure and white balance.

✦ **Optical zoom.** The optical zoom refers to the capability of changing the focal length or optical power of the lens. Simply put, a zoom lens helps make things look closer. Lenses are often specified by their zoom power, such as a 3X zoom.

✦ **Focal length.** Focal length is a measure of the optical center of a lens to the image sensor (when the lens is focused on infinity). Wide angle lenses have short focal lengths and telephoto lenses have long focal lengths. For a zoom lens the focal length is given as a range, such as 35-140mm or 28-105mm. The first number is the lens at its widest-angle (shortest) setting. The second number is the lens measured at its longest, or telephoto, setting. While two lenses might be called 3X zooms, they might not give you the same results. A lens that starts at 28mm gives you a wider angle and gets more people in a group shot than a lens that starts at 35mm.

✦ **Digital zoom.** This type of zoom is not achieved by changing the length of the lens; it is accomplished by cropping and magnifying the image that is captured by the image sensor. Because the digital zoom is actually just cropping your image the same way you can crop in an image editing program, I cannot recommend relying on it to get closer to your subject.

 *Canon offers a feature on some PowerShots called Safety Zoom. I describe this feature in Chapter 2.*

✦ **Optical image stabilization.** On some PowerShot models, Canon has added optical image stabilization technology to reduce image blur caused by camera movement. The system works by using tiny motion sensors inside the camera to measure camera movement. From this measurement, a correction signal is derived and sent to a special lens element that shifts the focus of the light, minimizing blur. This is especially helpful when taking photos when there is not much light or if you don't have a very steady hand.

**Note** *This stabilization cannot correct blur caused by moving objects in the scene.*

✦ **ISO.** ISO comes from the film world of photography and represents the International Organization for Standardization. It is a way of specifying the sensitivity of film to light. PowerShot cameras have ISO settings. The higher the ISO number, the less light you need when you take a picture, but the more *noise* (a grainy appearance in your photo) the image has. Some PowerShots have improved noise reduction techniques, so those models have larger ISO ranges.

✦ **Red-Eye Reduction.** PowerShots use a bright LED on the front of the camera to help reduce *red-eye*, which is when light reflects off of the retina at the back of the eye, causing a red reflection. The LED turns on just before the picture is taken. This light also helps to illuminate a dark scene, which helps with focus.

✦ **Red-Eye Correction.** If your camera uses the DIGIC III image processor chip, then it might also have Red-Eye Correction technology, which isolates eyes in the scene and replaces any red eyes with darker ones.

# 4-Way Controller

Before getting into more of the specifics, I want to explain the 4-Way Controller—it is normally referred to by one or more of its parts. Aside from the Shutter release button, you use this control more than any other. It is used to move up, down, left, and right between selections on the LCD much like the arrow keys on a computer keyboard. Those same up, down, left, and right areas may also give you quick access to a core group of functions. Depending on your PowerShot model, those functions may even change based on your Shooting Mode. Your camera may include one or several of the following functions:

✦ **ISO speed setting.** This adjusts the camera's apparent light sensitivity.

✦ **Jump mode.** Jump mode can be used only in Playback mode. Rather than cycling one by one through a memory card full of images trying to get to the one you are looking for, you can jump by groups of ten or a hundred images. Depending on camera support, you can also jump by category, shooting date, and folder.

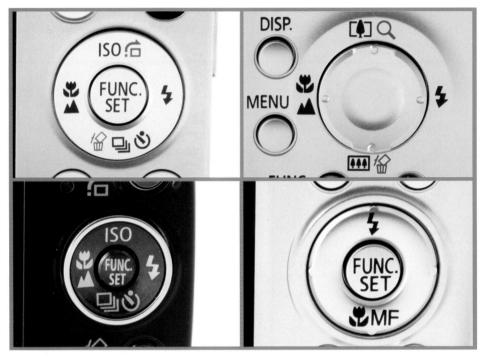

**1.1** The layout and options on 4-Way Controller. The 4-Way Controller varies among PowerShot models.

✦ **Drive mode.** You can select whether to take a single picture with each shutter press, or capture a series of images by holding down the shutter button.

✦ **Self-Timer.** Allows you to be in the picture.

✦ **Erase.** When you play back or review images (just after the picture is taken), if you press the trashcan icon, the LCD displays a query about whether you want to erase the image — permanently — from the memory card.

✦ **Macro/Infinity.** This controls how the lens focuses on images. When the function is not set, objects close to the camera are out of focus. Setting your PowerShot to

Macro allows the camera to focus on extremely close objects — so close, in fact, that you need to be careful not to hit the objects with the front of the lens, possibly damaging your camera. When you use the Macro setting, do not zoom in with the lens; if you do, you will lose the close-up focus. Set your PowerShot to Infinity if you want to concentrate on objects farther away.

✦ **Manual focus.** A few PowerShots let you manually focus the camera. When you press this icon, it displays a magnified area of the scene. Use the Left/Right portions of the 4-Way Controller to adjust focus. A readout at the top of the LCD shows the focus distance.

✦ **Zoom.** On some PowerShots, you access the Zoom control from the 4-Way Controller. Look for the tree icons: One tree is telephoto; several trees is wide.

✦ **Magnify.** Most PowerShots use the Zoom control to magnify the image during playback. When the Zoom is part of the 4-Way Controller, so is the magnify feature. Look for the magnifying glass icon.

✦ **Flash.** Depending on the model and Shooting mode, you can set the flash to always fire, never fire, fire only if needed, or even use Red-Eye Reduction. Some PowerShot models can also engage a Slow Synchro mode.

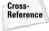 *Slow Synchro is explained in Chapter 2.*

**Cross-Reference** *Some PowerShot models include a hidden feature set (Auto Exposure Lock, Flash Exposure Lock, and Auto Focus Lock) that you can also access through the 4-Way Controller. In these cases, when you face difficult shooting situations, you can call upon these hidden features to bring your shooting skills up to the next level. These features are explained in Chapter 3.*

# Standard Features

There are many differences among PowerShot cameras even within the same series. However, there are also many features that are nearly standard across all cameras in the PowerShot line. The features, buttons, and functions covered in this section are standard. In sections of specific camera coverage, you can find these items shown in the figures, but they are not listed

or covered a second time unless the functionality differs from what is covered here.

✦ **AF-assist/Red-Eye Reduction/Self-Timer lamp.** This light has three functions. As the Auto-focus assist lamp, it provides additional illumination when the camera attempts focus in dark situations. If flash and Red-Eye reduction are turned on, the lamp illuminates just before the picture is taken to reduce the red-eye effect. When using the Self-Timer it provides a visual countdown.

✦ **Print/Share button.** This button lights up when the camera is properly connected to a printer or computer. Press it to begin printing your images.

✦ **Upper indicator light.** The upper indicator next to the viewfinder helps let you know when the camera is ready to take a picture.

  • **Green.** The camera is ready.

  • **Green blinking.** The camera is accessing the memory card. When this light is blinking you should never power off the camera or open the battery/memory card compartment.

  • **Orange.** The camera is ready with flash charged.

  • **Orange blinking.** The camera is ready, but either the flash is not yet charged or, if the flash isn't turned on, the scene is too dark and you may end up with a blurry image due to camera shake.

✦ **Lower indicator light.** The lower indicator is used to indicate focus issues. Both the upper and lower indicators can be seen even if you use the optical viewfinder.

- **Yellow.** A solid light indicates that the camera is either in Macro or Infinity focus mode.

  - **Yellow blinking.** If the camera can't achieve proper focus this light blinks.

✦ **Microphone.** Used to record sound.

✦ **Speaker.** Emits the beeps heard when accessing menus and taking the picture.

✦ **Shutter release button.** Pressing the Shutter release button halfway prepares the camera for taking the picture. It is also useful for quickly exiting any menu.

✦ **Menu button.** This button allows access to all the camera menus.

✦ **Func./Set button.** Use this button to accept menu choices and to bring up the Function menu when in a Shooting mode.

✦ **Display button.** Use the Display button to turn off the text information on the LCD, or even to turn off the LCD itself. One of the Display modes includes a special exposure graph called a histogram to help you evaluate your exposure settings.

Cross-Reference *Learn more about the Function menu in Chapter 3. You can also find more information on understanding the Histogram in Chapter 3.*

Tip *If you want to mute the camera sounds, hold the Display button down when turning on the camera.*

✦ **Zoom control.** This control operates differently depending on if you are in Shooting mode or Playback mode.

  - **In Shooting mode.** Push the lever in one way to zoom in (telephoto) and the other way to zoom out (wide angle). Which direction controls which zoom varies by model.

  - **In Playback mode.** Push the lever one direction to magnify the playback image and the other to display a grid of nine images (index).

# A Series

The PowerShot A series offers an extremely wide range of models. It starts with cameras well-suited to the beginning photographer and ranges all the way up to fully manual models that many professional photographers keep with their gear. For ease of explanation, cameras with similar features are grouped together in the following sections.

Cameras in the A series are: A430, A460, A530, A540, A550, A560, A570 IS, A630, A640, A700, and A710 IS.

## A430 and A460

The A430 and A460 are very similar, both with a 4X optical zoom lens, the same available Shooting modes, a DIGIC II processing chip, and nearly identical camera controls. Both offer AiAF to help you focus quickly on objects in your frame. There is also an auto-focus assist lamp that emits light in dark situations to help the AiAF to do its job.

The A430 is a 4.0 megapixel camera whereas the A460 is a 5.0 megapixel camera. The A460 also offers more autofocus points and the ability to shoot at a much slower shutter speed. The maximum ISO setting is 400.

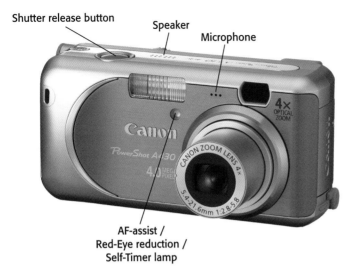

Shutter release button   Speaker   Microphone

AF-assist /
Red-Eye reduction /
Self-Timer lamp

Indicator lights   Display button   Mode dial   4-Way Controller

Func. / Set button
Menu button   Print / Share button

*Images courtesy of Canon.*
1.2 The front and back of the A430

Not shown are the A/V connector, which is located under a cap on the left side of the camera, and the USB and power connectors, which are located on the right side of the camera. The battery and memory card compartments are also located on the right side of the camera.

✦ **Flash.** The flash has a range of just under 10 feet when shooting at a wide angle.

✦ **Mode dial.** This switches between playback of images and various Shooting modes.

  • **Play.** Initiate playback of your recorded images and movies.

● **Auto.** The camera takes control of most camera settings.

● **M.** Manual mode gives you control over camera settings.

● **Special Scene modes.** Brings up a selection of modes for specific shooting situations.

● **Movie.** Puts the camera into video recording mode.

✦ **4-Way Controller.** The 4-Way Controller has many functions, depending on the mode the camera is in.

● **In Shooting mode.** Use the up (zoom in) and down (zoom out) portions to control the zoom (unlike other PowerShot models, these two cameras do not have a separate Zoom control). The left portion switches among Macro focusing, Infinity focusing, or normal focusing. The right portion cycles through Flash modes: Auto, Auto w/Red-Eye reduction, On w/Red-Eye reduction, On, Off, and Slow Synchro. Some Shooting modes, such as Auto, limit the number of flash modes.

**Tip** *Use Macro to shoot objects that are from 2 to 18 inches away from the camera. Use Infinity for objects that are 10 feet or more away. There is a Super Macro mode accessed in the manual Shooting mode that decreases the shooting range to 0.3 to 2 inches on the A460 and 0.39 to 2 inches on the A430.*

● **In Playback mode.** When you are in Playback mode, pressing up magnifies your image on the LCD screen. Pressing down erases the image, so use this

function with caution. Use left and right to browse through your images.

## A530 and A540

The A530 (5.0 megapixels) and A540 (6.0 megapixels) models are the first ones in the A series that have a more traditional camera shape and design. Each has a DIGIC II processing chip and a 4X optical zoom lens as well as nine auto-focus points. The low-light performance is enhanced, allowing for an ISO setting of 800.

The A540 has a few more manual control options than the A530. With the A540, you can control exposure by manually setting aperture and shutter speed, which allows you to explicitly set both the shutter speed and the aperture.

**Note** *Do not confuse the less-complex Manual camera setting with the ability to control exposure. The Manual camera setting allows you to control the ISO and other camera settings not related to exposure, but it does not let you set the shutter speed or the aperture.*

**Cross-Reference** *For more detailed explanations on controlling shutter speed and aperture, see Chapter 3.*

There is also an Aperture-Preferred exposure mode (Av) that allows you to set the aperture you want, forcing the camera to adjust shutter speed to achieve a proper exposure. The reverse is also possible with a Shutter-Preferred exposure mode (Tv) that allows you to set the shutter speed you prefer while the camera sets the correct aperture.

**Note** *Av stands for Aperture value and Tv stands for Time value.*

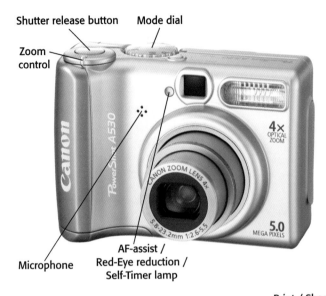

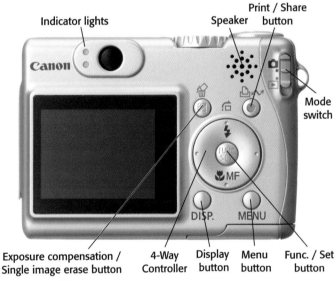

*Images courtesy of Canon.*

1.3 The front and back of the A530

Not shown are the A/V, USB, and power connectors, which are located under a cover on the left side of the camera, and the battery and memory card compartments, which are located on the bottom of the camera.

✦ **Flash.** The flash has a range of 11 feet when shooting at a wide angle.

✦ **Mode dial.** The Mode dial switches between various shooting modes.

• **Auto.** The camera takes control of most camera settings.

• **M.** Manual mode gives you control over camera settings.

• **Portrait.** Use this mode to take photographs of people.

• **Landscape.** Use when taking pictures of wide vistas with objects far away.

• **Night scene.** Combines flash and a slow shutter speed to capture images of people against a night background.

• **Special Scene modes.** Brings up a menu selection of modes for specific shooting situations.

 *Check out Chapter 3 for more information on Special Scene modes.*

• **Stitch Assist.** Use this mode to shoot panoramic images.

• **P.** Program mode is an Auto Exposure mode where the camera sets the exposure, but you have control of other (non-exposure) camera settings.

• **Movie.** Puts the camera into video recording mode.

✦ **Ring.** On the A540 only. Located to the bottom right of the lens, this is removed to attach accessory lenses

✦ **Ring release button.** On the A540 only. Press this button, which is located below and to the right of the lens, to allow removal of the ring.

✦ **Exposure compensation/Single image erase button.** In Shooting mode use this button to adjust exposure. During review or in Playback mode use this control to delete the current image.

 *Chapter 3 explains how to use the Exposure compensation button.*

✦ **Mode switch.** Use this control to change between Shooting and Playback modes.

✦ **4-Way Controller.** The 4-Way Controller has many functions, depending on the mode the camera is in.

• **In Shooting mode.** Use the top portion to cycle through flash modes: Auto, On, and Off. When the *camera* is in Auto mode the flash mode cannot be adjusted. When Red-Eye reduction is turned on the options are Auto w/Red-Eye reduction, On w/Red-Eye reduction, and Off. Use the lower portion to set focus for close-up photography (Macro), or use it to focus the camera manually.

• **In Playback mode.** When you are in Playback mode, pressing up displays a jump control on the LCD allowing you to jump through images 10 at a time, 100 at a time, by date, by folder, or jump to a movie. Use left and right to browse through your images.

## A550

The A550 features 7.1 megapixels, a DIGIC II processing chip, and a 4X optical zoom lens. It is very similar to the A530 in that it also offers nine auto-focus points and an ISO setting of 800. The 4-Way Controller layout of the A550 is the most common layout on the PowerShot models. The playback function moves off the Mode dial and on to a dedicated button.

 **Caution** *PowerShot model numbers do not necessarily reflect the number of features available. For example, though you might assume the A550 has all of the A540's features and then some, in fact there are more Shooting modes in the A540 than in the A550.*

Not shown are the A/V, USB, and power connectors, which are located under a cover on the left side of the camera. The battery and memory card compartments are located on the bottom of the camera.

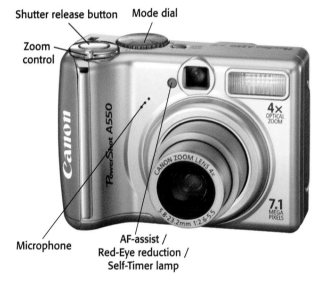

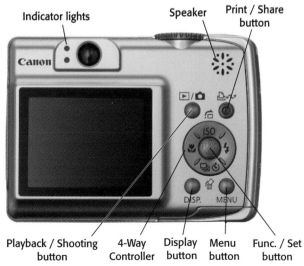

*Images courtesy of Canon.*

**1.4** The front and back of the A550

✦ **Flash.** The flash has a range of just under 10 feet when shooting at a wide angle.

✦ **Mode dial.** The Mode dial switches between various Shooting modes.

　• **M.** Manual mode gives you control over camera settings.

　• **Auto.** Allows for camera to take control of most camera settings.

　• **Portrait.** Use this mode to take photographs of people.

　• **Landscape.** Use when taking pictures of wide vistas with objects far away.

　• **Night Snapshot.** Combines flash and a slow shutter speed to capture images of people against a night background.

　• **Kids & Pets.** Use to photograph fast moving objects.

　• **Indoor.** Use to avoid blur caused by camera shake indoors.

　• **Special Scene modes.** This brings up a selection of modes for specific shooting situations.

**Cross-Reference** *Check out chapter 3 for more information on special scene modes.*

　• **Movie.** Puts the camera into video recording mode.

✦ **Playback/Shooting button.** Use this control to flip between Shooting and Playback modes.

✦ **4-Way Controller.** The 4-Way Controller has many functions, depending on the mode the camera is in.

• **In Shooting mode.** Use the up portion to adjust the sensitivity of the camera (ISO). The down portion accesses the Self-Timer and the Continuous shooting (drive) mode. The left portion switches the camera in and out of close-up (Macro) focusing. Use the right portion to cycle through flash modes: Auto, On, and Off. When the *camera* is in Auto mode the flash mode cannot be adjusted.

• **In Playback mode.** When you are in Playback mode, pressing up displays a jump control on the LCD, allowing you to jump through images 10 at a time, 100 at a time, by date, by folder, or jump to a movie. Pressing down erases the image, so use this feature with caution. Use left and right to browse through your images.

## A560

The A560 takes the outward design of the A550, increases the LCD to 2.5 inches, and replaces the DIGIC II processing chip with the DIGIC III. The new chip adds Face Detection to the feature set. It features a 7.1 megapixel sensor, a 4X optical zoom, and a top ISO of 1600.

Not shown are the A/V, USB, and power connectors, which are located under a cover on the left side of the camera. The battery and memory card compartments are located on the bottom of the camera.

✦ **Flash.** The flash has a range of 11 feet when shooting at a wide angle.

✦ **Mode dial.** The Mode dial switches between various Shooting modes.

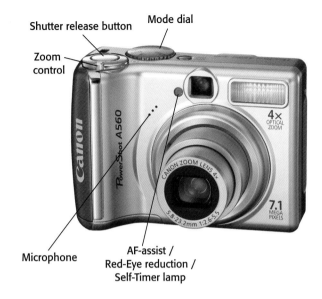

Shutter release button    Mode dial

Zoom control

Canon

PowerShot A560

4×
OPTICAL
ZOOM

CANON ZOOM LENS 4×

7.1
MEGA
PIXELS

S 5.8-23.2mm 1:2.6-5.5

Microphone

AF-assist / Red-Eye reduction / Self-Timer lamp

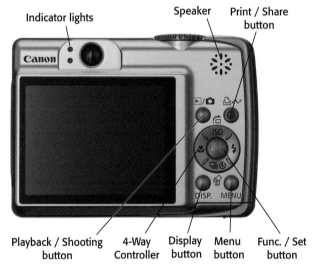

Indicator lights          Speaker    Print / Share button

Canon

Playback / Shooting button    4-Way Controller    Display button    Menu button    Func. / Set button

*Images courtesy of Canon.*

1.5 The front and back of the A560

- **M.** Manual mode gives you control over camera settings.

- **Auto.** Allows the camera to take control of most camera settings.

- **Portrait.** Use this mode to take photographs of people.

- **Landscape.** Use when taking pictures of wide vistas with objects far away.

- **Night Snapshot.** Combines flash and a slow shutter speed to capture images of people against a night background.

## How does Face Detection Work?

Without Face Detection, if a person stands next to a bright object with a lot of detail, the camera focuses on and sets exposure for the bright object, not the person's face. If you have ever taken a picture where someone is out of focus or where their image is too dark, it was probably because the camera wasn't paying attention to their face. DIGIC III's Face Detection AF/AE (autofocus/auto exposure) helps solve this problem. And when you use flash, the Face Detection FE (flash exposure) adjusts the flash's light level and the camera's exposure setting in order to minimize the common problem of the overexposed face against a dark background.

- **Kids & Pets.** Use to photo-graph fast moving objects.

- **Indoor.** Use this mode to avoid blur caused by camera shake indoors.

- **Special Scene modes.** This brings up a selection of modes for specific shooting situations like fireworks, beaches, and snow scenes.

 Check out Chapter 3 for more information on Special Scene modes.

- **Movie.** Puts the camera into video recording mode.

✦ **Playback/Shooting button.** Use this control to flip between Shooting and Playback modes.

✦ **Speaker.** The speaker emits the beeps heard when accessing menus and taking the picture.

✦ **4-Way Controller.** The 4-Way Controller has many functions, depending on the mode the camera is in.

  - **In Shooting mode.** Use the up portion to adjust the sensitivity of the camera (ISO). The down portion gives access to the Self-Timer and the Continuous

shooting (drive) mode. The left portion switches the camera in and out of close-up (macro) focusing. Use the right portion to cycle through flash modes: Auto, On, and Off. When the *camera* is in Auto mode the flash mode cannot be adjusted.

**Cross-Reference** *Learn more about Drive mode in Chapter 3.*

- **In Playback mode.** When you are in Playback mode, pressing up displays a jump control on the LCD allowing you to jump through images 10 at a time, 100 at a time, by date, by folder, or jump to a movie. Pressing down erases the image, so use this feature with caution. Use left and right to browse through your images.

## A570 IS

The A570 IS offers 7.1 megapixels, a DIGIC III image processing chip, and a 4X optical zoom. It also has optical image stabilization (IS) and full manual control. *Image stabilization* automatically detects and corrects camera shake. You can also attach accessory lenses to this camera to increase the telephoto range and to enhance wide-angle

shots. A close-up adaptor is available for macro shots that exceed the built-in macro capabilities.

Not shown are the A/V, USB, and power connectors, which are located under a cover on the left side of the camera. The battery and memory card compartments are located on the bottom of the camera.

✦ **Flash.** The flash has a range of 11 feet when shooting at a wide angle.

✦ **Ring.** This is removed to attach accessory lenses

 **Cross-Reference** See Chapter 5 for more information on PowerShot accessories.

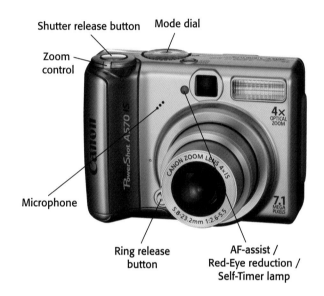

Shutter release button   Mode dial
Zoom control
Microphone
Ring release button   AF-assist / Red-Eye reduction / Self-Timer lamp

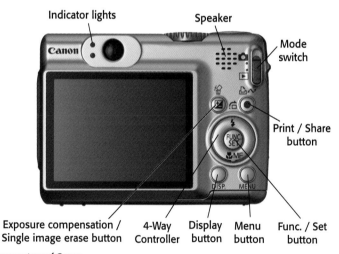

Indicator lights   Speaker   Mode switch
Print / Share button
Exposure compensation / Single image erase button   4-Way Controller   Display button   Menu button   Func. / Set button

*Images courtesy of Canon.*

**1.6** The front and back of the A570 IS

✦ **Ring release button.** Press this button to remove the ring.

✦ **Mode dial.** Switches among various Shooting modes.

- **Auto.** Allows the camera to take control of most camera settings.

- **M.** Manual mode gives you control over camera settings.

- **Portrait.** Use for taking photographs of people.

- **Landscape.** Use when taking pictures of wide vistas with objects far away.

- **Night Snapshot.** Combines flash and a slow shutter speed to capture images of people against a night background.

- **Kids & Pets.** Use to photograph fast moving objects.

- **Indoor.** Use to avoid blur caused by camera shake indoors.

- **Special Scene modes.** This brings up a selection of modes for specific shooting situations.

Cross-Reference

*Check out chapter 3 for more information on Special Scene modes.*

- **Underwater.** Use when shooting using an underwater housing.

- **Stitch Assist.** Use to shoot panoramic images.

- **P.** Program mode is an Auto Exposure mode where the camera sets the exposure but you have control of other camera settings.

- **Av.** (Aperture-priority) An exposure mode that allow you to set the aperture of the lens and the camera chooses the proper shutter speed.

- **Tv.** (Shutter-priority) An exposure mode that allow you to set the shutter speed and the camera chooses the proper aperture of the lens.

- **Movie.** Puts the camera into video recording mode.

✦ **Mode switch.** Use this control to flip between Shooting and Playback modes.

✦ **Exposure compensation/Single image erase button.** In Shooting mode use this button to adjust exposure. During review or Playback mode use this control to delete the current image.

Cross-Reference

*Chapter 3 explains how to use the Exposure compensation button.*

✦ **4-Way Controller.** The 4-Way Controller has many functions, depending on the mode the camera is in.

- **In Shooting mode.** Use the up portion to cycle through flash modes: Auto, On, and Off. When the *camera* is in Auto mode the flash mode cannot be adjusted. Use the down portion to set focus for close-up photography (Macro), or use it to focus the camera manually.

- **In Playback mode.** When you are in Playback mode, pressing up displays a jump control on the LCD allowing you to jump through images 10 at a time, 100 at a time, by date, by folder, or jump to a movie. Use left and right to browse through your images.

# A630 and A640

The A630 and A640 both feature a 4X optical zoom lens, full manual control, and a custom setting that enables you to save your favorite setup and recall it at a later time. Both use the DIGIC III image processing chip.

> **Note**
> *A minor difference between the two camera models is the continuous shooting speed, which is slightly slower on the A640 than the A630. This can be attributed to the A640's larger sensor size. It just takes a little longer to process and write larger amounts of data.*

These A series models add a swivel LCD to the mix. This 2.5 inch display flips out from the back of the camera and can swivel upward so that you can shoot close to the ground without getting a face full of dirt. Or it can swivel downward so that you can hold the camera up in the air to shoot over a crowd. It can even flip to the front of the camera so that you can do a quick self-portrait.

Not shown are the A/V, USB, and power connectors, which are located under a cover on the right side of the camera. The battery and memory card compartments are located on the bottom of the camera.

✦ **Flash.** The flash has a range of 11 feet when shooting at a wide angle.

✦ **Ring.** This is removed to attach accessory lenses

✦ **Ring release button.** Press this button to allow removal of the ring.

✦ **Mode dial.** Switches among various Shooting modes.

• **Auto.** Allows the camera to take control of most camera settings.

• **Portrait.** Use to take photographs of people.

• **Landscape.** Use when taking pictures of wide vistas with objects far away.

• **Night scene.** Combines flash and a slow shutter speed to capture images of people against a night background.

• **Special Scene modes.** Brings up a selection of modes for specific shooting situations.

>  **Cross-Reference**
> *Check out Chapter 3 for more information on Special Scene modes.*

• **Stitch Assist.** Use this mode to shoot panoramic images.

• **P.** Program mode is an Auto Exposure mode where the camera sets the exposure but you have control of other camera settings.

• **Av.** (Aperture-priority) An exposure mode that allows you to set the aperture of the lens and the camera chooses the proper shutter speed.

• **Tv.** (Shutter-priority) An exposure mode that allows you to set the shutter speed and the camera chooses the proper aperture of the lens.

• **M.** Manual mode allows you to manually set the shutter speed and aperture.

• **Movie.** Puts the camera into video recording mode.

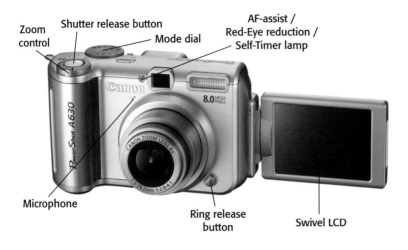

Zoom control

Shutter release button

Mode dial

AF-assist / Red-Eye reduction / Self-Timer lamp

Microphone

Ring release button

Swivel LCD

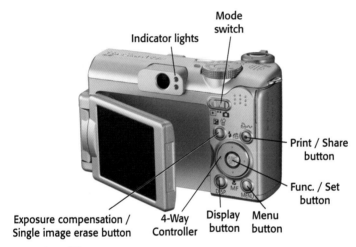

Mode switch

Indicator lights

Print / Share button

Func. / Set button

Exposure compensation / Single image erase button

4-Way Controller

Display button

Menu button

*Images courtesy of Canon.*

**1.7** The front and back of the A630

✦ **Mode switch.** Use this control to flip between Shooting and Playback modes.

✦ **Exposure compensation/Single image erase button.** In Shooting mode, use this button to adjust exposure. During review or Playback mode, use this control to delete the current image.

**Cross-Reference** *Chapter 3 explains how to use the Exposure compensation button.*

✦ **4-Way Controller.** The 4-Way Controller has many functions, depending on the mode the camera is in.

- **In Shooting mode.** Use the up portion to cycle through Flash modes: Auto, On, and Off. When Red-Eye reduction is turned on the options are Auto w/Red-Eye reduction, On w/Red-Eye reduction, and Off. Use the down portion to set focus for close-up photography (Macro), or use it to focus the camera manually.

- **In Playback mode.** When you are in Playback mode, pressing up displays a jump control on the LCD allowing you to jump through images 10 at a time, 100 at a time, by date, by folder, or jump to a movie. Use left and right to browse through your images.

## A700 and A710 IS

Both the A700 and A710 IS feature a 6X optical zoom lens and full manual control. You can use a tele-converter add-on lens with these models, increasing the optical zoom to 15X.

The A700 has a 6.0 megapixel sensor whereas the A710 IS has a 7.1 megapixel sensor. Both use the DIGIC III image processing chip. The major difference in these two cameras is that the A710 IS has image stabilization, which automatically detects and corrects camera shake.

Not shown are the A/V, USB, and power connectors, which are located under a cover on the left side of the camera. The battery and memory card compartments are located on the bottom of the camera.

✦ **Flash.** The flash has a range of 12 feet when shooting at a wide angle.

✦ **Ring.** This is removed to attach accessory lenses

✦ **Ring release button.** Press this button to remove the ring.

✦ **Mode dial.** Switches among various Shooting modes.

- **Auto.** This Shooting mode allows the camera to take control of most camera settings.

- **Portrait.** Use this mode to take photographs of people.

- **Landscape.** This is a great mode to use when taking pictures of wide vistas with objects far away.

- **Night scene.** Combines flash and a slow shutter speed to capture images of people against a night background.

- **Special Scene modes.** This brings up a selection of modes for specific shooting situations like fireworks, beaches, and aquariums.

- **Stitch Assist.** Use this mode to shoot panoramic images.

 Cross-Reference *Refer to chapter 6 for tips on how to shoot panoramas.*

- **P.** Program mode is an Auto Exposure mode where the camera sets the exposure but you have control of other camera settings.

- **Av.** (Aperture-priority) An exposure mode that allows you to set the aperture of the lens and the camera chooses the proper shutter speed.

- **Tv.** (Shutter-priority) An exposure mode that allows you to set the shutter speed and the camera chooses the proper aperture of the lens.

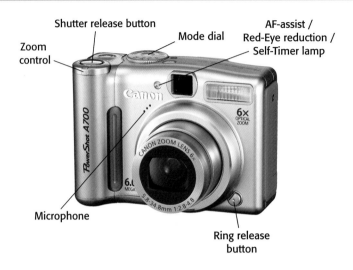

Shutter release button

Mode dial

AF-assist /
Red-Eye reduction /
Self-Timer lamp

Zoom
control

Microphone

Ring release
button

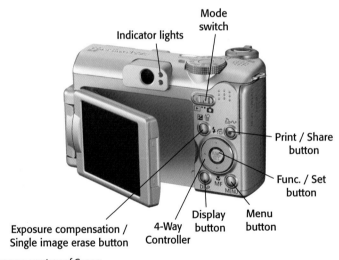

Mode
switch

Indicator lights

Print / Share
button

Func. / Set
button

Exposure compensation /
Single image erase button

4-Way
Controller

Display
button

Menu
button

*Images courtesy of Canon.*
1.8 The front and back of the A700

• **M.** Manual mode allows you to manually set the shutter speed and aperture.

• **Movie.** Puts the camera into video recording mode.

✦ **Mode switch.** Use this control to flip between Shooting and Playback modes.

✦ **Exposure compensation/Single image erase button.** In Shooting mode use this button to adjust exposure. During review or in Playback mode, use this control to delete the current image.

*Chapter 3 explains how to use the Exposure compensation button.*

✦ **4-Way Controller.** The 4-Way Controller has many functions, depending on the mode the camera is in.

- **In Shooting mode.** Use the up portion to cycle through Flash modes: Auto, On, and Off. When Red-Eye reduction is turned on the options are Auto w/Red-Eye reduction, On w/Red-Eye reduction, and Off. Use the down portion to set focus for close-up photography (Macro) or use it to focus the camera manually.

- **In Playback mode.** When you are in Playback mode, pressing up displays a jump control on the LCD allowing you to jump through images 10 at a time, 100 at a time, by date, by folder, or jump to a movie. Use left and right to browse through your images.

# SD Series

When Canon brought out the ELPH film camera in 1996, it was a highly successful product introduction. Not only was it the tiniest zoom camera with autofocus, but its exterior design was remarkable, making it *the* choice for a portable point-and-shoot film camera. In 2000 Canon introduced the Digital ELPH — otherwise known as the PowerShot S100 — and once again the sleek styling and portability made it a hit among photographers looking for a shirt-pocket digital camera.

 **Note** *ELPH comes from the merging of the words **elf** (symbolizing something small, but with a touch of fantasy) and **ph**otography.*

A common feature of the Digital ELPH series is the proprietary battery. This rechargeable lithium power cell offers the convenience of not having to purchase new batteries every time the low battery indicator is displayed. A similar type of camera running on high-performance AA batteries might produce more shots before its batteries are drained, but the fact that you can recharge your lithium battery is hard to beat.

**Note** *Just because these cameras are covered in numerical order doesn't mean the highest numbered camera is the top of the line.*

Cameras in the SD series are SD40, SD430, SD500, SD530, SD700 IS, SD750, SD800 IS, SD850 IS, SD900, and SD1000.

## SD40

The PowerShot SD40 is a 7.1 megapixel camera with a 2.4X optical zoom. It is the only camera in the series that uses a docking station. When you place the SD40 in its station, you can recharge the battery, download images to your computer, send images to your printer to be printed, and view your images on a TV. It even comes with a wireless remote control so you can sit back and browse through your images.

The SD40 also has a shooting feature not found on any other PowerShot. Given this camera doesn't have an optical viewfinder, when you take a vertically-oriented shot, the Shutter release button ends up in an inconvenient spot. In situations like this, the SD40's Vertical Shutter mode activates the Print/Share button as a second shutter release.

| Note | *This second Shutter release button does not have the half-way mode of the normal Shutter release button. When you press the Print/Share button, the camera focuses, meters, and immediately takes the shot.* |
|---|---|

The SD40 also features the DIGIC III processor. It is the smallest PowerShot to date.

Not shown is the Camera Station connector, which is located on the bottom of the camera. The battery and memory card compartments are located on the right side of the camera.

✦ **Flash.** The flash has a range of 6.5 feet when shooting at a wide angle.

✦ **Mode switch.** Use this control to flip between Playback, Movie, and Shooting modes.

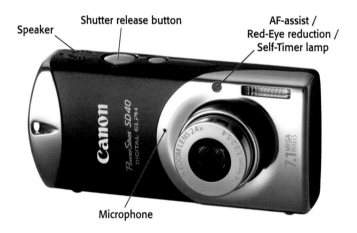

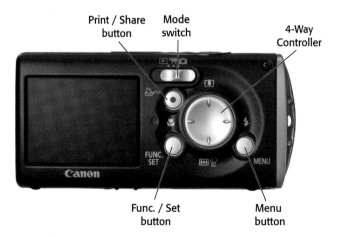

*Images courtesy of Canon.*
1.9 The front and back of the SD40

✦ **Print/Share button.** On the SD40, this button also acts as a Shutter release button when holding the camera vertically.

Cross-Reference *Chapter 2 explains how to turn the vertical shutter release function on.*

✦ **4-Way Controller.** The 4-Way Controller has many functions, depending on the mode the camera is in.

• **In Shooting mode.** Use the up (zoom in) and down (zoom out) portions to control the zoom. Use the left portion to switch between Macro or normal focusing. Use the right portion to cycle through Flash modes: Auto, On, Off. Flash cannot be adjusted when the camera is in Auto mode.

• **In Playback mode.** When you are in Playback mode, pressing up magnifies your image on the LCD screen. Pressing down erases the image, so use this feature with caution. Use left and right to browse through your images.

✦ **Indicator light.** The SD40 has only one indicator light, located to the right of the LCD. It functions as the top indicator light does, to let you know when the camera is ready to take a picture.

• **Green.** The camera is ready.

• **Green blinking.** The camera is accessing the memory card. When this light is blinking you should never power off the camera or open the battery/memory card compartment.

• **Orange.** The camera is ready with flash charged.

• **Orange blinking.** The camera is ready, but either the flash is not yet charged, or, if the flash isn't turned on, the scene is too dark and you may end up with a blurry image due to camera shake.

# SD430

While the SD430 couples a 3X optical zoom with a 5.0 megapixel sensor, this camera is known more for its connectivity than its shooting features. In fact, outside of North America this camera is known not as the SD430 but the IXUS WIRELESS. This is the first PowerShot to have wireless capability. When you plug a wireless print adaptor (supplied with the camera) into a Canon PictBridge-enabled printer, you can print images via a Wi-Fi connection.

Cross-Reference *Learn more about printing and PictBridge in Chapter 7.*

If your computer has a wireless connection, you can download your images to your PC without having to connect the USB cable to your camera. You can even use the computer to take the picture. This remote capture function can be a useful way to photograph wildlife.

 Caution *A firmware upgrade is necessary on older SD430 models in order to communicate wirelessly with Mac OS X computers. See Appendix A for more information on firmware updates.*

Not shown are the A/V and USB terminals, which are located under a cover on the right side of the camera. The battery and memory card compartments are located on the bottom of the camera.

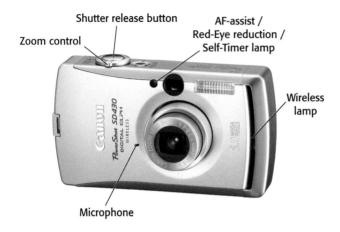

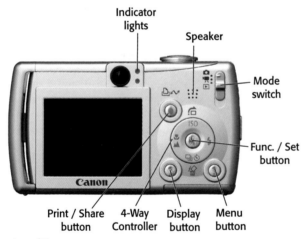

*Images courtesy of Canon.*
1.10 The front and back of the SD430

✦ **Flash.** The flash has a range of 12 feet when shooting at a wide angle.

✦ **Wireless lamp.** This light indicates the status of the wireless connection.

  • **Blue.** Wireless connection has been made.

  • **Blue slow blinking.** Connection in standby mode.

  • **Blue fast blinking.** Data is being transferred.

  • **Blue and Orange blinking.** Acquiring connection.

  • **Orange.** Connection failed.

  • **Orange blinking.** Connection error with wireless print adaptor.

✦ **Mode switch.** Use this control to flip between Shooting, Movie, and Playback modes.

✦ **4-Way Controller.** The 4-Way Controller has many functions, depending on the mode the camera is in.

• **In Shooting mode.** Use the up portion to adjust the sensitivity of the camera (ISO). The down portion gives access to the Self-Timer and the Continuous shooting (drive) mode. Use the left portion to switch among Macro, Infinity, or normal focusing. Use the right portion to cycle through Flash modes: Auto, Auto w/Red-Eye reduction, On w/Red-Eye reduction, On, Off, and Slow Synchro. When the *camera* is in Auto mode the Flash mode cannot be adjusted.

**Cross-Reference** *Learn more about Drive mode in chapter 3. Learn more about Red-Eye and Slow Synchro in Chapter 2.*

• **In Playback mode.** When you are in Playback mode, pressing up displays a jump control on the LCD, allowing you to jump through images 10 at a time, 100 at a time, by date, by folder, or jump to a movie. Pressing down erases the image, so use this feature with caution. Use left and right to browse through your images.

## SD600 and SD630

Starting with the SD600 and up, the cameras in the PowerShot SD series begin to look more like the original film ELPH. Both the SD600 and SD630 have 6.0 megapixels and a 3X optical zoom lens. They use a sophisticated technology to improve picture taking, called iSAPS (Intelligent Scene Analysis based on Photographic Space). Essentially, what iSAPS does for you is evaluate the scene against the myriad photographic data it stores so the camera can more readily adjust its settings to capture and process a better image.

The only difference between the SD630 and SD600 is the size of the LCD and the viewfinder. The LCD is huge, coming in at 3 inches, measured diagonally. Because of the size of the display, there is no room for an optical viewfinder.

## Photographic Space?

If you are wondering what "Photographic Space" is, you are not alone. So, briefly, here is an explanation.

Canon has built a comprehensive database of photographic data that contains information on how people take pictures. By examining parameters, Canon engineers arrived at statistical relationships among focal length, focus distance, scene brightness, and other factors. From this knowledge they developed iSAPS technology to automatically balance the relationship between these elements for a higher quality picture.

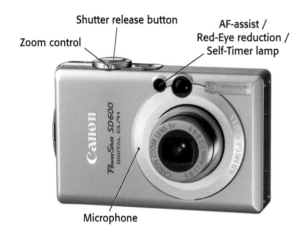

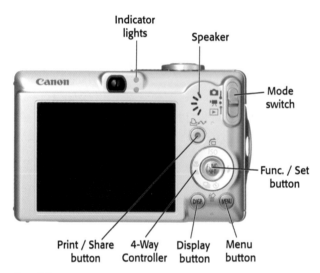

*Images courtesy of Canon.*

1.11 The front and back of the SD600

Not shown are the A/V and USB connectors, which are located under a cover on the left side of the camera. The battery and memory card compartments are located on the bottom of the camera.

✦ **Flash.** The flash has a range of 11 feet (SD630) or 12 feet (SD600) when shooting at a wide angle.

✦ **Mode switch.** Use this control to switch among Shooting, Movie, and Playback modes.

✦ **Touch Control dial (SD630).** Use this ring that surrounds the 4-Way Controller to easily browse through your images in Playback mode.

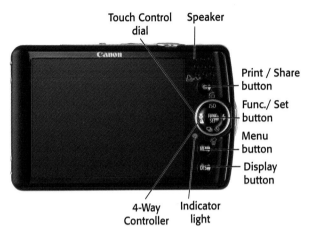

Touch Control | Speaker
dial

Print / Share button

Func./ Set button

Menu button

Display button

4-Way Controller | Indicator light

*Image courtesy of Canon.*

1.12 The back of the SD630

✦ **4-Way Controller.** The 4-Way Controller has many functions, depending on the mode the camera is in.

• **In Shooting mode.** Use the up portion to adjust the sensitivity of the camera (ISO). The down portion gives access to the Self-Timer and the Continuous shooting (drive) mode. The left portion switches between close-up (macro) focusing, infinity, and normal focus. Use the right portion to cycle through Flash modes: Auto, Auto w/Red-Eye reduction, On w/Red-Eye reduction, On, and Off. The SD600 also has a Slow Synchro option. When the *camera* is in Auto mode the Flash mode cannot be adjusted.

Cross-Reference *Learn more about Red-Eye and Slow Synchro in Chapter 2. Learn more about Drive mode in Chapter 3.*

• **In Playback mode.** When you are in Playback mode, pressing up displays a jump control on the LCD, allowing you to jump through images 10 at a time, 100 at a time, by date, by folder, or jump to a movie. Pressing down erases the image, so use this feature with caution. Use left and right to browse through your images.

✦ **Indicator light (SD630).** The SD630 has only one indicator light. It functions as the top indicator light does, to let you know when the camera is ready to take a picture.

• **Green.** The camera is ready. On the SD630 it also indicates when the camera is connected to a computer.

• **Green blinking.** The camera is accessing the memory card. When this light is blinking you should never power off the camera or open the battery/memory card compartment.

- **Orange.** The camera is ready with flash charged.

- **Orange blinking.** The camera is ready, but either the flash is not yet charged, or, if the flash isn't turned on, the scene is too dark and you may end up with a blurry image due to camera shake.

# SD700 IS

The SD700 IS is a 6.0 megapixel camera with a 4X optical zoom. It features image stabilization (the IS in its model number), which allows it to minimize blur caused by camera movement. By using image stabilization, you can take handheld shots with a much slower shutter speed than on a camera without image stabilization. It uses the DIGIC II processor and has a maximum ISO of 800.

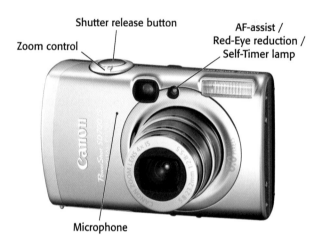

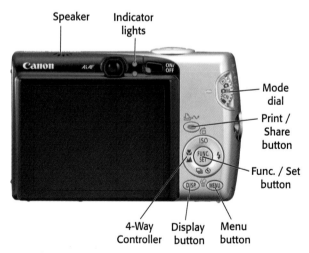

*Images courtesy of Canon.*

**1.13** The front and back of the SD700 IS

Not shown are the A/V and USB connectors, which are located under a cover on the left side of the camera. The battery and memory card compartments are located on the bottom of the camera.

✦ **Flash.** The flash has a range of 11.5 feet when shooting at a wide angle.

✦ **Mode dial.** Switches among playback of images and various Shooting modes.

  • **Play.** Use to initiate playback of your recorded images and movies.

  • **Auto.** Allows the camera to take control of most camera settings.

  • **M.** Manual mode gives you control over camera settings.

  • **Special Scene mode.** This brings up a selection of modes for specific shooting situations.

  • **Movie.** Puts the camera into video recording mode.

✦ **4-Way Controller.** The 4-Way Controller has many functions, depending on the mode the camera is in.

  • **In Shooting mode.** Use the up portion to adjust the sensitivity of the camera (ISO). The down portion gives access to the Self-Timer and the Continuous shooting (drive) mode. The left portion switches between close-up (macro) focus, Infinity focus, and normal focus. Use the right portion to cycle through Flash modes: Auto, Auto w/Red-Eye reduction, On w/Red-Eye reduction, On, Off, and Slow Synchro. When the *camera* is in Auto mode the

Flash mode can be adjusted but only to the Auto settings— Auto, Auto with Red-Eye reduction, or Off.

 **Cross-Reference** *Learn more about Drive mode in Chapter 3. Learn more about Red-Eye and Slow Synchro in Chapter 2.*

  • **In Playback mode.** Pressing up displays a jump control on the LCD, allowing you to jump through images 10 at a time, 100 at a time, by date, by folder, or jump to a movie. Pressing down erases the image, so use this setting with caution. Use left and right to browse through your images.

# SD750 and SD1000

The SD750 and SD1000 both come in at 7.1 megapixels with a 3X optical zoom. The SD750 has a large 3-inch (diagonal) LCD, so it doesn't have an optical viewfinder. The SD1000 has a 2.5-inch LCD and an optical viewfinder. Both cameras feature Canon's DIGIC III processing chip with Face Detection.

Coupled with the new noise reduction technology built into the DIGIC III, both these SD series models offer a top ISO of 1600, allowing you to capture images in more dimly lit places than ever before.

Not shown are the A/V and USB connectors, which are located under a cover on the left side of the camera. The power connector, battery, and memory card compartments are located on the bottom of the camera. The speaker is located on the right side of the SD750.

✦ **Flash.** The flash has a range of 11 feet when shooting at a wide angle.

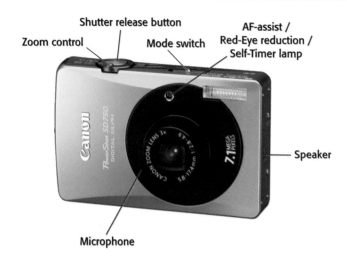

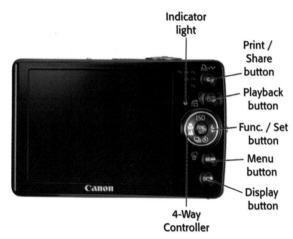

*Images courtesy of Canon.*

1.14 The front and back of the SD750

✦ **Mode switch.** Use this control to flip between Movie, Special Scene, and Auto modes.

✦ **Playback button (SD750).** Toggles between Playback and Shooting modes and power Off. You can also assign other functions to this button.

Cross-Reference \ *Chapter 2 explains how to re-assign the button.*

✦ **Touch Control dial (SD750).** Use this ring that surrounds the 4-Way Controller to easily browse through your images in Playback mode.

✦ **4-Way Controller.** The 4-Way Controller has many functions, depending on the mode the camera is in.

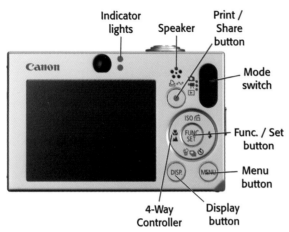

Indicator lights    Speaker    Print / Share button

Canon

Mode switch

Func. / Set button

Menu button

4-Way Controller    Display button

*Image courtesy of Canon.*
1.15 The back of the SD1000

● **In Shooting mode.** Use the up portion to adjust the sensitivity of the camera (ISO). The down portion gives access to the Self-Timer and the Continuous shooting (drive) mode. The left portion switches between close-up (Macro) focus, Infinity focus, and normal focus. Use the right portion to cycle through Flash modes: Auto, On, and Off. When the *camera* is in Auto mode the Flash mode cannot be adjusted.

 **Cross-Reference** *Learn more about Drive mode in Chapter 3.*

● **In Playback mode.** When you are in Playback mode, pressing up displays a jump control on the LCD, allowing you to jump through images 10 at a time, 100 at a time, by date, by category, by folder, or jump to a movie. Pressing down erases the image, so use this feature with caution. Use left and right to browse through your images.

✦ **Indicator light.** The SD750 has only one indicator light, located to the right of the LCD. It functions as the top indicator light does, to let you know when the camera is ready to take a picture.

● **Green.** The camera is ready.

● **Green blinking.** The camera is accessing the memory card. When this light is blinking you should never power off the camera or open the battery/memory card compartment. This may also indicate that the camera is in Time Lapse movie mode.

**Cross-Reference** *See Chapter 8 to learn more about Time Lapse recording.*

● **Orange.** The camera is ready with flash charged.

● **Orange blinking.** The camera is ready, but either the flash is not yet charged, or, if the flash isn't turned on, the scene is too dark and you may end up with a blurry image due to camera shake.

image stabilization (IS),
:e camera blur in photos
ɔr other camera move-
ment. It is a 7.1 megapixel camera with a
3.7X optical zoom lens. This model offers the
widest angle zoom lens in any of the
PowerShots—not just the SD series. Because
the SD800 IS uses the DIGIC III processor,

it also features Face Detection, higher ISO
shooting capabilities (1600), and noise
reduction capabilites.

Not shown are the A/V and USB connectors,
which are located under a cover on the left
side of the camera. The power connector,
battery and memory card compartments are
located on the bottom of the camera.

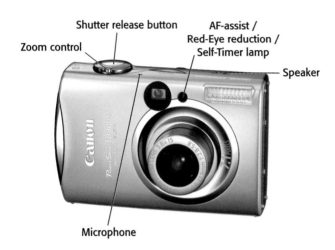

Zoom control
Shutter release button
AF-assist /
Red-Eye reduction /
Self-Timer lamp
Speaker
Microphone

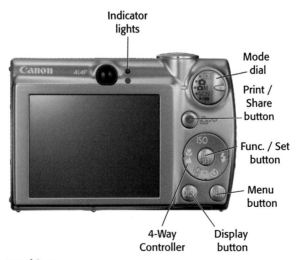

Indicator
lights
Mode
dial
Print /
Share
button
Func. / Set
button
Menu
button
4-Way
Controller
Display
button

*Images courtesy of Canon.*

**1.16** The front and back of the SD800 IS

✦ **Flash.** The flash has a range of 13 feet when shooting at a wide angle.

✦ **Mode dial.** Switches between playback of images and various Shooting modes.

  • **Play.** Use to initiate playback of your recorded images and movies.

  • **Auto.** Allows the camera to take control of most camera settings.

  • **M.** Manual mode gives you control over camera settings.

  • **Special Scene mode.** This brings up a selection of modes for specific shooting situations.

  • **Movie.** Puts the camera into video recording mode.

✦ **4-Way Controller.** The 4-Way Controller has many functions, depending on the mode the camera is in.

  • **In Shooting mode.** Use the up portion to adjust the sensitivity of the camera (ISO). The down portion gives access to the Self-Timer and the Continuous shooting (drive) mode. The left portion switches between close-up (Macro) focus, Infinity focus, and normal focus. Use the right portion to cycle through Flash modes: Auto, On, and Off. When the *camera* is in Auto mode the Flash mode cannot be adjusted.

**Cross-Reference** *Learn more about Drive mode in Chapter 3.*

  • **In Playback mode.** When you are in Playback mode, pressing up displays a jump control on the LCD, allowing you to jump through images 10 at a time, 100 at a time, by date, by category, by folder, or jump to a movie. Pressing down erases the image, so use this feature with caution. Use left and right to browse through your images.

## SD850 IS

The SD850 IS is an 8.0 megapixel camera with image stabilization (IS), which compensates for blur in photos caused by camera movement during shooting. While the DIGIC III chip adds Face Detection, the SD850 IS takes it one step further. Face Detection technology is also used during playback to remove red-eye after the shot and in-camera.

This camera also has a new Shooting mode, called Creative Light Effect. When you shoot night scenes, this special effect adds shapes to lights. Using the IS technology, a controlled image blur is created during a long exposure. While the foreground is sharp due to the flash, the little pinpoints of lights in the background appear as stars or flowers or other user-selectable shapes.

Not shown are the A/V and USB connectors, which are located under a cover on the left side of the camera. The power connector, battery and memory card compartments are located on the bottom of the camera.

✦ **Flash.** The flash has a range of 11 feet when shooting at a wide angle.

✦ **Mode dial.** Switches between playback of images and various Shooting modes.

  • **Play.** Use to initiate playback of your recorded images and movies.

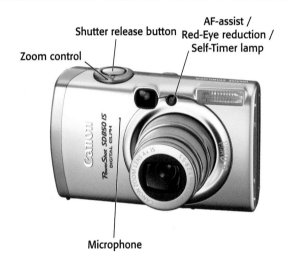

Zoom control

Shutter release button

AF-assist /
Red-Eye reduction /
Self-Timer lamp

Microphone

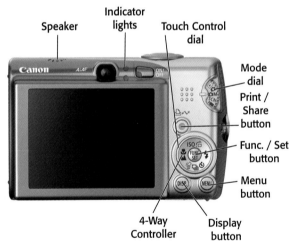

Speaker

Indicator
lights

Touch Control
dial

Mode
dial

Print /
Share
button

Func. / Set
button

Menu
button

4-Way
Controller

Display
button

*Images courtesy of Canon.*

**1.17** The front and back of the SD850 IS

- **Auto.** Allows the camera to take control of most camera settings.

- **M.** Manual mode gives you control over camera settings.

- **Special Scene mode.** This brings up a selection of modes for specific shooting situations.

**Cross-Reference** *Check out Chapter 3 for more information on Special Scene modes.*

- **Movie.** Puts the camera into video recording mode.

✦ **Touch Control dial.** Use this ring that surrounds the 4-Way

Controller to easily browse through your images in Playback mode. You can also use it to access Shooting modes when the camera is in Manual mode.

✦ **4-Way Controller.** The 4-Way Controller has many functions, depending on the mode the camera is in.

• **In Shooting mode.** Use the up portion to adjust the sensitivity of the camera (ISO). The down portion gives access to the Self-Timer and the Continuous shooting (drive) mode. The left portion switches between close-up (Macro) focus, Infinity focus, and normal focus. Use the right portion to cycle through Flash modes: Auto, On, and Off. When the *camera* is in Auto mode the flash mode cannot be adjusted.

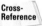 **Cross-Reference** *Learn more about Drive mode in Chapter 3.*

• **In Playback mode.** When you are in Playback mode, pressing up displays a jump control on the LCD, allowing you to jump through images 10 at a time, 100 at a time, by date, by category, by folder, or jump to a movie. Pressing down erases the image, so use this feature with caution. Use left and right to browse through your images.

## SD900

In terms of resolution, the SD900 tops out the SD series with 10.0 megapixels. The lens is a 3X optical zoom. The camera features the DIGIC III processor with Face Detection.

Not shown are the A/V and USB connectors, which are located under a cover on the left side of the camera. The power connector, battery, and memory card compartments are located on the bottom of the camera.

✦ **Flash.** The flash has a range of 17 feet when shooting at a wide angle.

✦ **Indicator lights.** The indicator lights on the SD900 are placed horizontally. Their functionality is the same as the top (left) and bottom (right) lights on other PowerShots.

✦ **Mode dial.** Switches among Playback of images and various Shooting modes.

• **Play.** Use to initiate playback of your recorded images and movies.

• **Auto.** Allows the camera to take control of most camera settings.

• **M.** Manual mode gives you control over camera settings.

• **Special Scene mode.** This brings up a selection of modes for specific shooting situations.

**Cross-Reference** *Check out Chapter 3 for more information on Special Scene modes.*

• **Movie.** Puts the camera into video recording mode.

✦ **Touch Control dial.** Use this ring that surrounds the 4-way controller to easily browse through your images in Playback mode.

✦ **4-Way Controller.** The 4-Way Controller has many functions, depending on the mode the camera is in.

Zoom control

Shutter release button

AF-assist /
Red-Eye reduction /
Self-Timer lamp

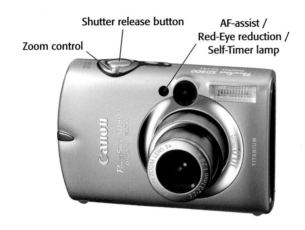

Speaker

Indicator
lights

Mode
dial

Print /
Share
button

Display
button

Func. / Set
button

Menu
button

Touch Control
dial

4-Way
Controller

*Images courtesy of Canon.*
**1.18** Front and back of the SD900

• **In Shooting mode.** Use the up portion to adjust the sensitivity of the camera (ISO). The down portion gives access to the Self-Timer and the Continuous shooting (drive) mode. The left portion switches the camera between close-up (Macro) focusing, Infinity focusing, and normal focusing. Use the right portion to cycle through Flash modes: Auto, On, and Off. When the *camera* is in Auto mode the flash mode cannot be adjusted.

**Cross-
Reference** *Learn more about Drive mode in Chapter 3.*

- **In Playback mode.** When you are in Playback mode, pressing up displays a jump control on the LCD, allowing you to jump through images 10 at a time, 100 at a time, by date, by category, by folder, or jump to a movie. Pressing down erases the image, so use this feature with caution. Use left and right to browse through your images.

# G7

The G series has had a long history with Canon. Beginning with the G1 introduced in 2000, the Gs are aimed at the prosumer photographer who wants a high-performance digital camera without taking the next step into digital SLRs.

> **Note** *SLR stands for Single Lens Reflex. It refers to using a moveable mirror that first sends light from the lens to the viewfinder and then flips up, allowing that light to hit the image sensor. Most people these days equate an SLR to a camera that has interchangeable lenses.*

From Day One, the G cameras have had most of the features found in a digital SLR, including full manual adjustments and a *hot shoe*, which is where you can attach an external flash. The G7 takes the G series to 10.0 megapixels with a 6X optical zoom lens and a DIGIC III processor chip. The maximum ISO is 1600. It offers advanced Shooting modes, including Exposure Bracketing and Focus Bracketing.

> **Cross-Reference** *Chapter 3 details exposure and focus bracketing.*

Two custom settings allow you to store preferred camera settings. So if you like a particular camera setup you can program it into a custom memory so that you don't have to wade through a series of menus. There is also a feature that allows you to program a frequently-used function to a button on the back of the camera.

The functions that can be programmed include Resolution, Compression, White Balance, My Colors, Light Metering, ND Filter, Digital Teleconverter, IS Mode, AF Lock, Create Folder, and Display Off.

Your G7 also has a neutral-density filter. A neutral density filter is kind of like sunglasses for your camera. When activated, it cuts down the amount of light that reaches the image sensor. This allows you to use a slower shutter speed in bright light.

Not shown are the A/V, USB, and power connectors, which are located under a cover on the right side of the camera. The battery and memory card compartments are located on the bottom of the camera. The speaker is located on the left side of the camera.

✦ **Flash** The flash has a range of 13 feet when shooting at a wide angle.

✦ **Ring.** This is removed to attach accessory lenses

>  **Cross-Reference** *See Chapter 5 for more information on PowerShot accessories.*

✦ **Ring release button.** Press this button to remove the ring.

✦ **Hot Shoe connector.** This connection is used for mounting an external flash unit.

✦ **ISO Speed dial.** Rotate this dial to change the light sensitivity of the camera.

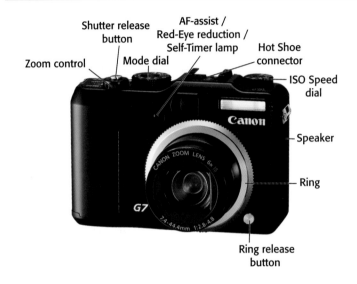

Zoom control

Shutter release
button

Mode dial

AF-assist /
Red-Eye reduction /
Self-Timer lamp

Hot Shoe
connector

ISO Speed
dial

Speaker

Ring

G7

Ring release
button

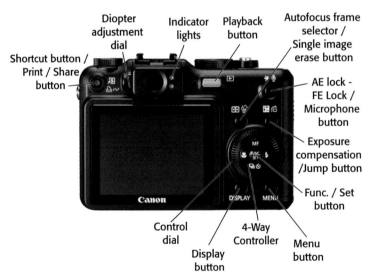

Shortcut button /
Print / Share
button

Diopter
adjustment
dial

Indicator
lights

Playback
button

Autofocus frame
selector /
Single image
erase button

AE lock -
FE Lock /
Microphone
button

Exposure
compensation
/Jump button

Func. / Set
button

Control
dial

4-Way
Controller

Display
button

Menu
button

*Images courtesy of Canon.*
**1.19** The front and back of the G7

✦ **Mode dial.** The mode dial
switches between various Shooting
modes.

  • **Auto.** Allows the camera to
  take control of most camera
  settings.

• **Special Scene modes.** This
brings up a selection of modes
for specific shooting situations.

 *Check out Chapter 3 for more
information on Special Scene
modes.*

- **Stitch Assist.** Use this mode to shoot panoramic images.

- **Movie.** Puts the camera into video recording mode.

- **P.** Program mode is an auto exposure mode where the camera sets the exposure but you have control of other camera settings.

- **Av.** (Aperture-priority) An exposure mode that allows you to set the aperture of the lens and the camera chooses the proper shutter speed.

- **Tv.** (Shutter-priority) An exposure mode that allows you to set the shutter speed and the camera chooses the proper aperture of the lens.

- **M.** Manual mode allows you to manually set the shutter speed and aperture.

- **Custom settings.** If you like the camera set up a specific way, such as a particular resolution, metering mode, and white balance, you can program it into either of two custom settings memories.

✦ **Shortcut button / Print/Share button.** In addition to indicating when the camera is correctly connected to a printer, on the G7, when not connected to a printer, this button can be programmed for commonly used functions.

✦ **Diopter adjustment dial.** Adjusts the optical viewfinder focus. For some with glasses that have minor corrections, you can adjust the diopter so that you can take pictures without wearing your glasses.

✦ **Exposure compensation/Jump button.** In Shooting mode use this button to adjust exposure. During review or in Playback mode, use this control to display a jump menu on the LCD allowing you to jump through images 10 at a time, 100 at a time, by date, by folder, or jump to a movie.

*Chapter 3 explains how to use the Exposure Compensation button in more detail.*

✦ **Auto-focus frame selector/Single image erase button.** In Shooting mode press to choose from AiAF, FlexiZone, and Face Detect Focus modes. During review or in Playback mode, use this control to delete the current image.

*Chapter 2 explains more about focus modes and FlexiZone and Face Detect in particular.*

✦ **AE Lock/FE Lock button.** Auto-exposure lock and Flash-exposure lock can be activated by pressing this button.

*Chapter 3 explains why you might want to use AE Lock and FE Lock.*

✦ **Mode switch.** Use this control to flip between Shooting and Playback modes.

✦ **4-Way Controller.** The 4-Way Controller has many functions, depending on the mode the camera is in.

- **In Shooting mode.** Use the top portion of the control to turn on manual focus. Use the right portion to cycle through flash modes: Auto, On, and Off. When the *camera* is in Auto

mode the flash mode cannot be adjusted. Use the left portion to set focus for close-up photography (Macro). The down portion gives access to the Self-Timer and the Continuous shooting (Drive) mode.

- **In Playback mode.** Use the left and right areas to browse through your images. When the image is magnified, use all of the areas to move around the displayed image.

✦ **Control dial.** This control surrounds the 4-Way Controller and is the rotary equivalent of the 4-Way Controller. Rotate the dial to the right (clockwise) and it is the same as pressing the right area of the 4-Way Controller. It is most useful for picking the auto focus frame and adjusting manual focus.

# S5 IS

The S line of Canon cameras focuses on having high-performance zoom lenses. The S5 IS is an 8.0 megapixel camera with a 12X optical zoom image-stabilized lens. The S5 IS has a 2.5-inch flip-out LCD and a *hot shoe*, which is where you can add an external flash unit. The built-in flash pops up when needed. A DIGIC III processor helps with noise reduction and offers Face Detection. The maximum ISO is 1600.

The S5 IS provides a full complement of Shooting modes, including Shutter Priority, Aperture Priority, Full Manual, and a user-programmable mode. While many PowerShots show you a histogram of the captured image, the S5 IS provides a live histogram. You can see your exposure

before you take the picture. Together with Auto Exposure Bracketing, it gives you great control over image capture.

There is a custom setting that allows you to store preferred camera settings. So if you like a particular camera setup you can program it into a custom memory so that you don't have to wade through a series of menus. There is also a feature that allows you to program a frequently-used function to a "shortcut" button on the back of the camera. The functions that can be programmed include Light Metering, Compression, White Balance, Custom White Balance, Digital Teleconverter, AE Lock, AF Lock, and Display Off.

Not shown are the A/V, USB, and power connectors, which are located under a cover on the right side of the camera. The battery and memory card compartment are located on the bottom of the camera. The speaker is located on the left side of the camera.

✦ **Self-Timer/Red-Eye reduction/Tally lamp.** On the S5 IS, if flash and Red-Eye reduction are turned on, the lamp illuminates just before the picture is taken to reduce the red-eye effect. When using the Self-Timer it provides a visual countdown. During movie recording the lamp acts as a Tally lamp, similar to a video camera, indicating that the camera is recording.

✦ **AF-assist lamp.** The Auto-focus assist lamp provides additional illumination when the camera is trying to focus in dark situations.

✦ **Flash.** The flash pops up when needed. By moving the flash farther away from the center axis of the lens, red-eye is minimized. The flash has a range of 17 feet when shooting at a wide angle.

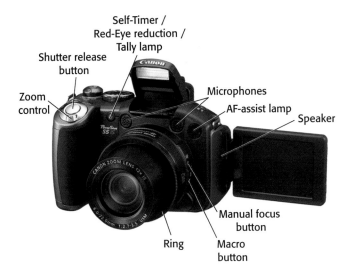

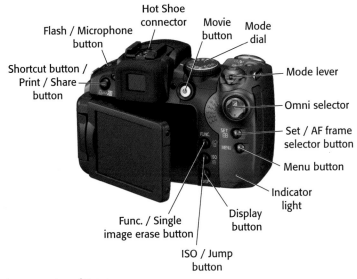

*Images courtesy of Canon.*

**1.20** The front and back of the S5 IS

 **Note** *The S5 IS has two microphones in order to record stereo.*

 **Cross-Reference** *See Chapter 5 for more information on PowerShot accessories.*

✦ **Ring.** This is removed to attach accessory lenses.

✦ **Ring release button.** Press this button to allow removal of the ring.

✦ **Manual Focus button.** Turns off automatic focus and allows you to manually focus using the up/down areas of the Omni Selector.

✦ **Macro button.** Use for close up focus. Press once to turn on Macro focus. Press and hold for a second to turn on Super Macro, which is an extremely close Focus mode.

Caution  *When shooting macro, watch what is happening at the front of the camera. It is easy to get objects so close to the camera that they damage the front of the lens.*

✦ **Indicator lamp.** This lamp tells you what mode the camera is in.

• **Orange.** The camera is in Shooting mode.

• **Green.** Playback mode is selected or the camera is attached to a printer.

• **Yellow.** The camera is connected to a computer.

• **Blinking Red.** The camera is accessing memory card. When this light is blinking you should never power off the camera or open the battery/memory card compartment.

✦ **Hot Shoe connector.** This connection is used for mounting an external flash unit.

✦ **Flash/Microphone button.** Press this button to raise the flash. During review or in Playback mode, press this button to record an audio memo that is related to the image. You can record up to a minute's worth of audio.

✦ **Mode lever.** The lever switches between shooting and playback. If

you switch from shooting to playback the lens will not retract. If you switch to playback again the lens will retract. The quickest way to get back to Shooting mode is to press the Shutter release button halfway.

✦ **Mode dial.** The mode dial switches between various Shooting modes.

• **Auto.** Allows for the camera to take control of most camera settings.

• **Portrait.** Use this mode to take photographs of people.

• **Landscape mode.** This is a great mode to use when taking pictures of wide vistas with objects far away.

• **Night Snapshot.** Combines flash and a slow shutter speed to capture images of people against a night background.

• **Sports.** Use to photograph fast moving objects.

• **Special Scene modes.** This mode brings up a selection of specific scene modes for specific shooting situations like snow scenes.

Cross-Reference  *Check out Chapter 3 for more information on Special Scene modes.*

• **Stitch Assist.** Use this mode to shoot panoramic images.

• **Movie.** Puts the camera into video recording mode.

• **P.** Program mode is an auto exposure mode where the camera sets the exposure, but you have control of other camera settings.

- **Av.** (Aperture-priority) An expo-sure mode that allows you to set the aperture of the lens and the camera chooses the proper shutter speed.

- **Tv.** (Shutter-priority) An expo-sure mode that allows you to set the shutter speed and the camera chooses the proper aperture of the lens.

- **M.** Manual mode allows you to manually set the shutter speed and aperture.

- **Custom settings.** If you like the camera set up a specific way, such as a particular resolu-tion, metering mode, and white balance, you can program it into a custom setting memory.

✦ **Shortcut button / Print/Share button.** In addition to indicating when the camera is correctly con-nected to a printer, on the S5 IS, when not connected to a printer, this button can be programmed for commonly used functions.

✦ **Diopter adjustment dial.** This dial adjusts the optical viewfinder focus. For some with glasses that have minor corrections, you can adjust the diopter so that you can take pictures without wearing your glasses.

✦ **Movie button.** Use this button to quickly go into movie mode and start recording without having to change the Mode dial. To stop recording press this button again.

✦ **ISO/Jump button.** In Shooting mode use this button to bring up a selection of ISO speeds to set the sensitivity of the camera. During review or in Playback mode, use this control to display a jump

menu on the LCD allowing you to jump through images 10 at a time, 100 at a time, by date, by folder, or jump to a movie.

 *Consult Chapter 3 to learn more about ISO speed.*

✦ **Set/AF frame selector.** While in menus, use the control to accept settings. In Shooting mode press to choose from AiAF, FlexiZone, and Face Detect focus modes.

 *Chapter 2 explains more about focus modes and FlexiZone and Face Detect in particular.*

✦ **AE Lock/FE Lock.** Use the Auto-exposure lock or Flash-exposure lock button to lock your exposure or your flash power.

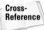 *Chapter 3 explains why you might want to use AE Lock and FE Lock.*

✦ **Func./Single image erase but-ton.** Use this button to bring up the function menu when in Shooting mode. During review or in Playback mode use this control to delete the current image.

✦ **Omni Selector.** In Shooting mode use this button to adjust exposure. In Playback mode use the left and right areas to browse through your images. If the image is magnified use all four areas to move around your image. Otherwise, use this con-trol for moving around in menus.

# TX1

The TX1 is the stranger among the PowerShot cameras. It looks more like a tiny camcorder than a digital still camera. That's

because it was designed with high-definition video in mind. This hybrid video and still camera is operated in a vertical orientation. It offers a 7.1 megapixel sensor with a 10X image-stabilized optical zoom lens, but it is optimized to capture high-definition video.

It features the DIGIC III processor, which adds Face Detection to video recording so focus is adjusted as objects in the scene move. Because the video recording is done in high-definition, the TX1 has a special MovieSnap mode that allows you to capture still images while recording a movie.

Not shown are the A/V, USB, and component video connections, which are located under a cover on the right side of the camera. The battery is located on the bottom of the camera. The memory card compartment is on the back of the camera.

✦ **Flash** The flash has a range of a little over 6 feet when shooting at a wide angle.

 **Note**   *The TX1 has two microphones in order to record stereo.*

✦ **Mode dial.** Switches among playback of images and various Shooting modes.

- **Play.** Use to initiate playback of your recorded images and movies.

- **Auto.** This Shooting mode allows the camera to take control of most camera settings.

- **M.** Manual mode gives you control over camera settings.

- **Special Scene modes.** This mode brings up a selection of specific scene modes like portrait or night snapshots or beach scenes for specific shooting situations.

**Cross-Reference**   *Refer to Chapter 3 for an explanation of Special Scene modes.*

**Cross-Reference**   *The component video connection is used to playback images and videos in high definition. Refer to Chapter 8 to learn more.*

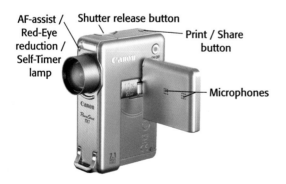

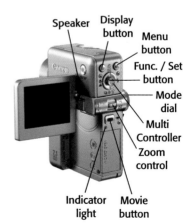

*Images courtesy of Canon.*

1.21 The front and back of the TX1

✦ **Multi Controller.** Called the Multi Controller in the TX1 manual, this control functions the same as the 4-Way Controller. It has many functions, depending on the mode the camera is in.

    • **In Shooting mode.** Use the up portion to adjust the sensitivity of the camera (ISO). The down portion gives access to the Self-Timer and the Continuous shooting (drive) mode. The left portion switches between close-up (Macro) focus, Infinity focus, and normal focus. Use the right portion to cycle through Flash modes: Auto, On, and Off. When the *camera* is in Auto mode the flash mode cannot be adjusted.

**Cross-Reference** *Learn more about Drive mode in Chapter 3.*

    • **In Playback mode.** When you are in Playback mode, pressing up displays a jump control on the LCD, allowing you to jump through images 10 at a time, 100 at a time, by date, by folder, or jump to a movie. Pressing down erases the image, so use this feature with caution. Use left and right to browse through your images.

✦ **Movie button.** Use this button to quickly go into Movie mode and start recording without having to change the Mode dial. To stop recording press this button again.

✦ **Indicator light.** When the camera is recording, reading, erasing, or transferring images this lamp blinks red.

# Navigating Your PowerShot Camera

CHAPTER 2

✦   ✦   ✦   ✦

**In This Chapter**

Main menu categories

Record menu

Setup menu

Play menu

Print menu

My Camera menu

✦   ✦   ✦   ✦

Y ou've explored your PowerShot model and learned a bit about the technology behind it. Now it's time to set up your camera. The PowerShot menus control a lot of the features you looked at in Chapter 1 but they also control much more. At first they can seem a bit overwhelming, but if you concentrate on a few important settings for your model, your PowerShot's controls can be less intimidating.

Although this chapter covers all of the menu options for the PowerShot line, it isn't a replacement for your manual. This is a field guide — something you can take with you. It offers suggestions on how to shoot in different situations, but also provides a good reference for setting up your camera and quickly finding the menu you need.

## Main Menu Categories

When you press the Menu button on your camera, the main menu categories appear on your LCD screen as tabs. While the category tabs and menu that appear depend on the mode the camera is in, the icons for the categories are the same. The four main categories are:

✦   **Play.** This is represented by a right-pointing triangle. You only see this Menu tab if the camera is in Playback mode when the menus are accessed.

✦ **Print.** This is symbolized by an icon that looks like a page being printed. This Menu tab is only visible when the menus are accessed while the camera is in Playback mode.

✦ **Set Up.** This is represented by tools—a hammer and wrench. This Menu tab is available from either Playback mode or Record mode.

✦ **Record.** This is symbolized by a camera icon on the Menu tab. It is available while in Shooting mode.

✦ **My Camera.** Not all PowerShot cameras have this mode. If your model does, it is represented on the Menu tab by a person and a camera.

✦ **Wireless.** This Menu tab is only available on the PowerShot SD430, which supports a wireless connection.

Because not all menus are available at all times, if you can't find the Menu tab you are looking for, try putting your camera into a different mode by using the Mode dial or switch.

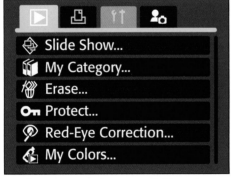

**2.1** Some menu tabs are available only when the camera is in a specific mode. In this figure, for example, this SD700 IS is in Playback mode.

You can access all of the main Menu tabs by pressing the Menu button, then using the 4-Way Controller to move across the Menu tabs and up and down through Menu options.

When you are in Shooting mode you can access additional functions in a Function menu by using the Func./Set button. However, because the functions accessed by the Func./Set button are used primarily to make adjustments while shooting, they are covered in depth in Chapter 3.

**Note** *Your PowerShot model's menu items may be in a different order than those listed in this chapter. Canon is pretty consistent in how it names menu items, so although the order may be different, the function will be the same.*

Be sure to read this chapter with your camera in hand so you can step through the menus to see which ones are available on your PowerShot. Keep in mind that just as menus are only available in certain modes, some menu settings are only available in specific shooting modes. For example, if you have the camera in full automatic mode, you won't be able to adjust the flash manually if that is a feature on your camera.

**Tip** *When going through this chapter with your camera, put a check mark next to each menu item that is available on your camera.*

# Record Menu

The Record menu is where you set up some of your camera's basic shooting parameters. Generally you make adjustments to this menu when you move into a new shooting environment, such as moving indoors after shooting in bright sunlight.

## AiAF

Chapter 1 introduced Artificial Intelligence Auto Focus (AiAF) as a feature that uses multiple AF frames to help you get a quick focus – the menu allows you to turn it On or Off. Some models also offer a Face Detect option that instructs the camera to automatically locate and focus on a face.

Generally AiAF should be set to On or Face Detect. Occasionally, however, you may want to turn it off if you have problems achieving proper focus. There are several situations where you may have difficulty:

✦ **Low contrast scenes.** AiAF keys in on sharp details in a scene. If there is little contrast, details can be hard to detect.

✦ **Moving objects.** By the time an object has been evaluated by the camera for focus, it has already moved to a different location, requiring a different focus setting.

✦ **Bright objects.** Brightly-lit objects near the center of the composition and even reflections can be magnets for AiAF detection.

✦ **Busy scenes.** Sometimes there are just too many potential subjects at different distances for the camera to focus on.

If you turn off AiAF, the camera uses the center Auto Focus point to achieve focus.

Rather than turning off the AiAF setting, you can achieve similar results by using your camera's AF lock (pressing the Shutter release button halfway). And you don't have to wade through menus! AF lock can help you get through most focus difficulties.

 *Learn about using AF lock in Chapter 3.*

 *The TX1's menu only offers Face Detect (either On or Off), not AiAF.*

## AF Frame

Some PowerShots do not have an AiAF setting. In these cases AF Frame controls how the camera achieves autofocus. AF Frame offers AiAF, Center AF and FlexiZone options. When FlexiZone is selected, you can use the 4-Way Controller to position the focus area within the scene.

 *The S5IS's Record menu lists only FlexiZone (either On or Off), not AF Frame*

## Flash Sync

The Flash Sync camera setting is advanced, but it can be useful for creating some fun night shots. To understand Flash Sync you need to understand how a shutter works. A good analogy is to imagine that the image sensor is behind a window. The window has two sets of drapes. The first set of drapes is closed and the second set is open. When you press the Shutter release button to take the picture, the first set of drapes opens to let light into the image sensor. When the time specified by the shutter speed setting has elapsed, the second set of drapes closes. Oftentimes, with a slow enough shutter speed, the flash is only on for part of the exposure. Flash Sync lets you select which part of the exposure the flash illuminates.

You can choose between 1st curtain and 2nd curtain. The choices refer to the curtains of the shutter. When setting the shutter to 1st curtain, the flash fires at the beginning of the exposure so motion early in the shot is frozen. When you select 2nd curtain, the flash fires immediately before the 2nd curtain closes, so the later motion is frozen.

You can tell which setting you used by looking at moving objects in your image. If you have something moving left to right and use the 1st curtain setting, the image trails appear ahead of the object because the flash fires at the beginning of the exposure. The 2nd curtain setting creates images that look more like natural motion because the flash fires last, creating a trail behind the image.

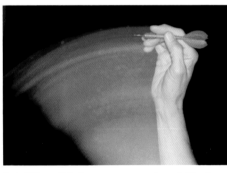

2.2 When this image was captured, Flash Sync was set for 1st curtain so it looks like the arm is going backwards.

2.3 This image looks more appropriate because Flash Sync was set to 2nd curtain, so it fired at the end of the dart throw.

## Slow Synchro

Because the amount of time that a flash illuminates a scene is short, when flash is enabled, the camera's shutter speed is set to match the flash's duration. This means that most of the illumination in the scene is from the flash itself.

With Slow Synchro turned On, you can use a shutter speed that is slower than the flash to capture some of the scene's natural illumination. Consider trying this mode when taking indoor people shots so you can avoid the mug-shot look that can come with some flash pictures.

 *Chapter 6 describes some scenarios where Slow Synchro flash is suggested.*

Because the shutter speed is longer with Slow Synchro, you may need a tripod. On the other hand, a little bit of camera movement can add excitement to an image, so don't be afraid to use Slow Synchro without additional camera support.

## Flash Adjust

The Flash Adjust menu option lets you select from Auto or Manual. When Manual is selected, you can adjust the strength of the flash output. Use Manual when you want to overcome scenes where the flash is overpowering the existing light in the scene.

## Red-Eye

Red-eye is a common affliction with flash photography. You have the option to turn it On or Off, but normally you should leave Red-Eye Reduction On.

 *On some PowerShots, Red-Eye Reduction is not a menu setting, but is set by cycling through the various flash modes using the Flash portion of the 4-Way Controller.*

A very bright LED creates a pre-flash flash, which helps to constrict the wide-open pupils of the subject. This illumination can be distracting to some subjects and can destroy the moment, so depending on the situation you are shooting, you might want to turn it Off.

## Safety FE

Turning Safety FE (flash exposure) On allows the camera to take control of the shutter speed or aperture to avoid overexposing the shot. They call it *safety* because it only engages if the camera meter senses the overexposure. It also is only effective during flash photography.

 *For a good explanation of shutter speed and aperture, see Chapter 4.*

Tip *If you are in a rapid-fire type of shooting situation, it is a good safeguard to leave Safety FE on.*

## Safety Shift

Safety Shift helps adjust the shutter speed in conjunction with an acceptable aperture so that you get the best possible exposure for your shot. This feature is a good safeguard to keep on as long as you remember what it is doing. You can turn it On or Off from the Record menu.

## Light Metering/Metering Mode

Metering is the camera's way of measuring the amount of light coming into the lens in order to achieve proper exposure. Depending on the PowerShot model, metering settings are called either Light Metering or Metering Mode. Choose from three different types of metering: Evaluative, Center Weighted Average, or Spot. Although the icons representing metering aren't very intuitive, they are common among all camera manufacturers.

 *Learn more about Metering modes in Chapter 3.*

## Spot AE Point

Use Spot AE Point to further specify how Spot metering is achieved. Choose from Center or AF Point. The default setting is Center and that's how Spot works on any PowerShot. But when you set Spot AE Point to AF Point, the exposure reading is taken from where the Auto Focus point is locked. This is almost like taking the best parts of Evaluative and Spot metering and combining them.

## MF-Point Zoom

If you have difficulty seeing focus when you use Manual Focus, MF-Point Zoom may help. Turn it On to magnify a section of the composition on the LCD so you can see small details and adjust focus. MF-Point Zoom can be distracting when you compose your shot, however, so if you use this setting, get in the habit of depressing the shutter release halfway to turn off the focus so you can compose your shot. Then release

the shutter, set your focus manually, and press the shutter release halfway again to double-check your framing, to set your exposure and, finally, take your shot.

## Safety MF

Similar to Safety FE, Safety MF (manual focus) fine-tunes your Manual Focus adjustment. It can be difficult to see enough details on an LCD to check your focus, even if your camera has MF-Point Zoom and it is turned On. Safety MF can sharpen the focus for you.

## Self-Timer

The Self-Timer delays the shutter release so you can set up the camera to take, for example, a group portrait that you are in. You can also use the Self-Timer to control camera shake when your PowerShot is mounted on a tripod. This is a trick for getting sharp images that even the pros use. You can choose from 10 seconds or 2 seconds. There is also a Custom Timer setting. It allows you to choose both the delay between shots and how many shots are taken when the timer goes off. Choose from 0-10, 15-20, or Shots: 1-3-10.

 **Note** *The Self-Timer adjustments for some PowerShot models are located in the Function settings or are accessed through the 4-Way Controller.*

## Auto ISO Shift

When Auto ISO Shift is turned On and the camera shake warning appears, the Print/Share button starts to flash. If you push the Print/Share button, your PowerShot automatically selects the lowest ISO that allows a shutter speed that minimizes camera motion blur. Because Auto ISO does not

override the ISO setting until you press the Print/Share button, it makes sense to leave this feature on all the time.

 **Cross-Reference** *Learn more about ISO setting in Chapter 4.*

## AF Mode

AF Mode lets you select from Continuous and Single. When set for Single, the camera only focuses when you depress the shutter button half-way. When you choose Continuous, the camera keeps focusing whenever it is powered on and in Shooting mode.

 **Note** *Continuous focus helps you capture candid shots quickly but it does use up batteries faster.*

## AF-assist Beam

When a scene is too dark, the PowerShot's Auto Focus can not see detail. In these situations, the Red-Eye Reduction LED turns on to do double duty as an AF-assist Beam providing enough illumination to the area so the Auto Focus system can work. You can turn this feature On or Off.

2.4 The AF-assist Beam is a high-power LED located above the lens on the front of the camera.

## Safety Zoom

If you use Digital Zoom, check to see if your camera has Safety Zoom. Safety Zoom is not a menu setting but a special function added to some PowerShots. Turn it On when your image resolution is set to something other than the highest setting and Digital Zoom is on. As you zoom in, the zoom stops at a point where there isn't any image degradation at that image resolution setting. If you zoom beyond that point, the zoom number turns blue indicating the image is beginning to deteriorate from the digital magnification process.

For example, if your camera has a 3X optical zoom and you shoot at the L resolution with Digital Zoom turned on, the moment you zoom past 3X to 4X or higher, the zoom numbers turn blue. If you capture the image and then print it, you will notice pixelation or blockiness because the Digital Zoom crops and then magnifies the image from the image sensor.

Here's a quick way to see if your camera has Safety Zoom. Use the Record menu to turn on Digital Zoom. Set the resolution to M2 or M3 and start zooming. Look for a special icon where the zoom X-factor is displayed on the LCD. The icon is a large right-facing arrow next to a vertical line, followed by a small right-facing arrow. This represents the "line in the sand" where the image starts to degrade based on the final print size.

Tip

*If you photograph in a dark area and want to be unobtrusive or capture something candid, turn the AF-assist beam Off. In dimly lit areas, the LED is a fairly powerful light.*

## Digital Zoom

Digital Zoom crops the center section of the image and magnifies it to simulate the effect of zooming in on a scene with your lens. The Digital Zoom setting allows you to turn this feature On and Off.

In addition to the standard On and Off, your camera may have other settings. These additional options act like the telephoto extender you can add to some PowerShot models as an accessory. However, unless you shoot at lower resolutions, I suggest avoiding these settings. They are 1.4X, 1.5X, 1.6X, 1.9X, 2.0X, and 2.3X.

## Review

Review is when the camera displays the image immediately after the picture is taken. This menu option sets the time the review is held on the LCD before going back to a live image. The default Review setting on a PowerShot is two seconds. You can choose from:

✦ **Off.** The camera does not display a review image.

✦ **2-10 sec.** You can choose any number of seconds in this range.

✦ **Hold.** This setting keeps the image up on the display until you change modes. Use the Hold option sparingly to save battery power.

You can exit the review at any time by pressing the shutter halfway, and you are ready to start shooting again.

*Learn how to keep your image displayed longer in Chapter 3.*

## Save Original

Shooting in a special shooting mode such as Color Accent or Color Swap causes a dramatic special effect to be applied to the captured image. Turn Save Original On before you shoot if you want to preserve both the original image and your special effect.

*Chapter 3 explains what Color Accent and Color Swap do and how to use them.*

I recommend you keep Save Original On for two reasons:

✦ **Revisions.** If you decide later that you don't like the way an effect modifies your picture or if you want to further enhance the effect, you can go back to the original and use an image editor on your computer to refine the effect.

✦ **Accidents.** If you are rushed, you might mistakenly engage Color Accent instead of Color Swap (or vice versa). You might also forget to turn the feature off before capturing that "once-in-a-lifetime" shot. Save Original can save the shot.

## Reverse Display

If your PowerShot has a flip-out LCD and a Reverse Display feature, turn Reverse Display On so when you rotate the LCD to face forward, the image flips upside down and reverses left to right. When you look at

the image from the front of the camera, it is right side up. Turn Reverse Display Off if you have to shoot above your head or from another difficult angle.

*Reverse Display affects only the image and not any characters or icons displayed on the LCD.*

## Auto Category

When Auto Category is On, your PowerShot can help you by placing photographs in categories based on your shooting mode. For example, if you shoot in Portrait mode, the images are assigned to the People category. If your camera supports categories, you can manually assign them to your images through the Playback menu.

*It is a dangerous practice to keep a lot of images on your memory card rather than downloading them to a computer for archiving. If something should happen to the memory card or camera, you could lose all your images. A friend of mine who accidentally left his PowerShot in a taxicab never to be found again said, "While I hate losing the camera, it can always be replaced. The pictures can't!"*

## Grid Lines

When Grid Lines are turned on, the LCD is blocked into nine areas to help you create photos that are well composed, according to the Rule of Thirds.

*For more information on good composition and the Rule of Thirds, see Chapter 4.*

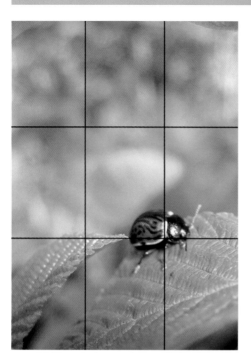

2.5 Gridlines help you follow the Rule of Thirds.

## Display Overlay

The Display Overlay is a 3:2 Guide. A 4 × 6 inch print (or, more appropriately, 6 × 4 inch in horizontal mode) has an aspect ratio of 3:2. So, when you turn on the 3:2 Guide, the LCD displays gray bars at the top and bottom of the image to show you what your image looks like as a 4 × 6 print. Keep this on if you print a lot of 4 × 6 inch images. Choose from Off, Grid Lines, 3:2 Guide, and Both.

When the camera is in Movie mode, the only options available are Off and Grid Lines.

## IS mode

Image Stabilization (IS) is a feature that some PowerShots have to reduce camera shake blur in photos. There are several options in this mode in addition to Off:

✦ **Continuous.** This keeps the stabilization on at all times.

✦ **Shoot Only.** In this mode, IS engages only when the Shutter release button is pressed.

✦ **Panning.** If you take a lot of action shots where you *pan* the camera (move the camera on a horizontal plane), use this mode.

When the camera is in Movie mode, the only options are Continuous and Off.

## Converter

Some PowerShots can use accessory lenses that will affect optical image stabilization. In these cases, the Converter menu setting lets the IS system know what lens is attached to the camera. The error correction applied to the lens elements depends on the combined focal lengths of the camera and the accessory lens.

If you use an accessory lens, make sure this feature is set properly:

✦ **On a G7.** None, WC-DC58B, TC-DC58C

✦ **On an A710 IS.** None, WC-DC58N, TC-DC58N, 250D

✦ **On an A570 IS.** None, WC-DC52, TC-DC52A, 250D

© *Carol Guncheon*

2.6 A 3:2 cropping overlay shows up as dark bands at the top and bottom of the LCD. They indicate what will be cut off when the image is printed as a 4 × 6 print.

## Custom display settings

If your camera does not have a Display button, you change the display settings in the Custom Display Settings menu. The options are

✦ **LCD/Viewfinder.** You can choose to turn this On or Off. Even if the LCD is turned Off, the image review will still be displayed after each shot.

✦ **Shooting Info.** Turning this On displays text on the LCD that lists various camera settings. If you do not want to see this text, turn this option Off.

✦ **Grid Lines.** You can turn On or Off the gridlines and the 3:2 Guide in this menu setting.

✦ **Histogram.** Turning the histogram On displays a visual exposure graph called a histogram. The histogram takes up a lot of room on the screen so you can turn it Off.

 Cross-Reference *Learn more about histograms in Chapter 3.*

## Date Stamp

The Date Stamp, which can display the date and time on your image, can only be engaged when the image resolution is set to

Postcard. You can turn this feature Off, or select Date (only the date appears) or Date & Time (shows both date and time in the stamp).

**Caution** *Once the Date Stamp has been applied to the image, it is permanent.*

## Vertical Shutter

The PowerShot SD40 has a Print/Share button that can double as the Shutter release button when the camera is held vertically. This is helpful because when the camera is held vertically, the normal shutter release is in an awkward position. Vert. Shutter must be On to take advantage of this opportunity.

**Tip** *As you start becoming more familiar with your camera, investigate the options for buttons that might have a dual use. They can make it easier to take pictures.*

## Long Shutter

A few PowerShots have a Long Shutter feature that provides access to very slow shutter speeds when the feature is On. With durations measured in seconds rather than the fraction of a second more typical of shutter speeds, you must use a tripod when Long Shutter is on.

**Cross-Reference** *Chapter 6 reveals many instances where you may need a Long Shutter.*

## Set Print/Share button

Set Print/Share button allows you to change the function of this button. After you become more familiar with your camera,

consider carefully the settings you change on a regular basis and determine which of those functions it would be most handy to assign to Print/Share. Depending on your camera model, there are several options to choose from.

## Set Shortcut button

Assign the Shortcut button to get to the menu or setting of an often-used feature quickly. I suggest waiting until you have spent ample time using your camera before you decide which setting to attach to this button. When you are ready to assign this button, you can choose from several different options.

## Stitch Assist

Stitch Assist allows you to shoot panoramas. It is the only menu option that actually involves shooting pictures. To shoot a panorama with Stitch Assist:

1. **Put your camera in Manual shooting mode.**

2. **Press the Menu button and use the 4-Way Controller to navigate to Stitch Assist.**

3. **Press the Func./Set button.**

4. **Use the left/right areas of the 4-Way Controller to select whether you want to start shooting your panorama from the left or right.**

5. **Press the Func./Set button and start shooting your images.**

6. **Press Menu after shooting your last image.**

## Save Settings

A few models use Save Settings to set up custom memories that can store the options you use most frequently. Some models have one memory and others have two. Choose from C1, C2, or Save Settings.

# Setup Menu

Although the Record menu is specifically dedicated to settings you may need when shooting, the Setup menu controls functions that apply to any camera mode.

## Mute

You can choose to turn the beeps your camera makes whenever you change a setting On or Off.

 **Cross-Reference** *Chapter 6 highlights several situations when muting the camera makes sense.*

 **Note** *You can still hear warning sounds even when Mute is on.*

## Volume

Rather than muting the beeps entirely, another approach is to adjust the volume of the various sounds your camera makes. You can adjust the sounds for Start-Up, Operation, Self-timer, Shutter, and Playback. Choose from Off, 1, 2, 3, 4, and 5.

 **Tip** *If you do large group shots with the Self-Timer, it is useful to increase the volume so everyone can hear the countdown.*

## Audio

When recording audio, some PowerShots give you the ability to control audio manually. You have three options.

✦ **Mic Level (Auto or Manual).** You can choose from letting the camera adjust audio levels or controlling them yourself.

✦ **Level.** Check playback to see if there is audio distortion caused by overdriving the microphone.

✦ **Wind Filter.** Engage Wind Filter to reduce low frequency noise. Try using it anytime there is a low rumbling noise, not just for wind, to help reduce it.

## Info Display

If your PowerShot model doesn't have a Display button, you can choose whether to overlay shooting information on the LCD. Choose from:

✦ **Shooting Info.** Turn On or Off shooting info text overlay while shooting.

✦ **Review Info.** Turn On or Off shooting info text overlay during review right after shooting.

✦ **Replay Info.** During playback you can choose from Off, Standard, and Detailed.

 **Note** *After you change a shooting setting, the shooting info appears for a short time regardless of this setting.*

## Touch Icons

You can activate a touch-activated 4-Way Controller pad on your LCD. When the

Touch Icons feature is On, every time you touch the 4-Way Controller, a touch pad icon appears on the LCD.

**2.7** The Touch Icons display gives you a visual cue as to which function you are selecting.

## Start-up Image

The Start-up Image setting does not have any effect on your picture taking. Having a start-up image appear when you first turn on your camera does not slow down the camera's boot-up time. But, if it *feels* like it does, shut it off with this option.

> **Note** Some models control this setting through the My Camera menu.

## LCD Brightness

You can create better images if you can see the image properly on the LCD. The default setting for LCD Brightness usually works well in most situations. Try dialing it down a bit to avoid blinding your eyes at night. If you run it at full brightness, you may use more power. You can set it anywhere from -7 to 0 to +7.

## Power Saving

There are two power saving options to choose from.

✦ **Auto Power Down.** Unless you are ready with extra batteries or have an optional AC adaptor for your PowerShot, use Power Saving and make sure Auto Power Down is set to On.

✦ **Display Off.** The Display Off setting turns off your LCD display after a predetermined amount of time. Choose from 10 sec., 20 sec., 30 sec., 1 min., 2 min., or 3 min.

> **Note** Be careful not to mistake an LCD that is off with a camera that is off. For that reason alone, I'd suggest a longer Display Off setting time.

## Time Zone

You can choose to set your Time Zone to Home or World. If you travel a lot, setting Time Zone to World can assure you that the time attached to your images is correct.

## Date/Time

This option brings you to a Date/Time screen. Here you can set the current date, time and whether Daylight Saving Time is being observed.

> **Cross-Reference** The Quick Tour explains how to set the date and time.

## Clock Display

Many PowerShot models let you quickly check the current time of day by pressing and holding the Func./Set button. Clock Display sets how long the clock appears on

the LCD. Tap the Shutter release button to cancel it early. Choose from 1-10 sec., 20 sec., 30 sec., 1 min., 2 min., or 3 min.

**2.8** The animated clock display shows time only when holding the camera in the horizontal mode. Holding the camera vertically shows date *and* time.

## Format

Format is probably the most important item on the Setup menu. Memory cards should *always* be formatted in the camera in which they are used. You can perform either a regular format or a low level format from this menu option. Low level formatting rebuilds the file structure on the memory card and marks off any bad sections on your memory card. When you select Format from the Setup menu, you see the Format screen on the camera's LCD.

> **Tip** *While low level formatting takes a little longer than regular formatting, you should do a low level format after every few regular formats to keep your memory cards in good shape.*

✦ **Regular.** Choose regular formatting for a quick re-build of the directory structure on your memory card.

✦ **Low level.** Before you want to perform a low level format, make sure there is a check mark in the Low Level Format box. Use the 4-Way Controller to navigate to the box, press the right area of the 4-Way Controller until you see a check mark in the Low Level Format box. Navigate to OK and then press the Func./Set button.

> **Caution** *Low level formatting resets both the directory and the file area of the card. Even a professional service would find it difficult to recover images. There is no "undo" when you format a card.*

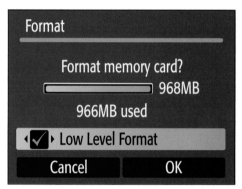

**2.9** Make sure there is a check next to Low Level Format when formatting your memory card.

## File Numbering

This menu setting allows you to choose how your files are numbered. When you turned on your PowerShot for the first time your first picture started at 0001.

✦ **Continuously.** Continuous numbering starts with 0001 and numbers consecutively until you have taken 9999 images, even if you change the memory card.

✦ **Auto Reset.** If you choose Auto Reset, each time you change your memory card, the file numbering starts over at 0001.

Tip  *Even with an embedded capture date, it can be confusing if you have several files named IMG_0015.JPG. So, Continuously is a good option to avoid duplicate files.*

## Create Folder

Use the Create Folder menu selection to help you organize your images. If you use a card reader to look at your PowerShot's memory card, the first folder you see is named DCIM. Within the DCIM folder you find at least one, and possibly more, folders, such as 100CANON, with the "100" changing to 101 or 102, and so on. The Create Folder selection brings you to the Create Folder screen where you choose:

Note  *DCIM stands for Digital Camera Images and is a standard folder for most digital cameras.*

✦ **Create New Folder.** Use Create Folder to create a new folder manually. By using the right area of the 4-Way Controller to place a check mark in the Create New Folder item you can create a new folder when you shoot your next image.

✦ **Auto Create.** You can have the camera create folders for you on a regular basis:

• **Daily.** The camera creates a folder every day at the time you specify.

• **Monday - Sunday.** The camera creates a folder on a specific day at the time you specify.

• **Monthly.** The camera creates a folder on the first day of the month at the time you specify.

Tip  *If you are shooting regular photos and then switch to shoot video or panoramas, you may want to create a new folder.*

## Auto Rotate

If you turn the Auto Rotate feature On, the camera determines whether you are holding the camera horizontally or vertically. If you hold it vertically, the system can even determine if the left or right side of the camera is at the top. The image is then embedded with data that tells the picture's orientation so that the image is rotated correctly even when reviewing the image on the LCD.

Note  *Image orientation data is used by many (but not all) image editing applications, including those supplied with your PowerShot. When you download your files, vertical images will appear vertical.*

## Distance Units

On models with Manual Focus you can display the focus distance in meters or feet. Choose from m/cm or ft/in.

## Lens Retract

You can set the lens to retract immediately when switching from shooting to playback, by setting this option to 0 sec., or you can choose to leave the lens extended by using the default 1 min. option.

## Language

You can change the Language setting from English, which is the default, to a variety of other languages, including French, Spanish, Polish, Danish, and Italian.

> **Tip** *If you accidentally switch to the wrong language and get lost in the menus, put the camera in Playback mode and press and hold the Func./Set button. Then press the Menu button to bring up the Language setting.*

| | | |
|---|---|---|
| English | Svenska | Türkçe |
| Deutsch | Español | 繁體中文 |
| Français | 简体中文 | 한국어 |
| Nederlands | Русский | ภาษาไทย |
| Dansk | Português | العربية |
| Suomi | Ελληνικά | Română |
| Italiano | Polski | 日本語 |
| Norsk | Čeština | |
| Українська | Magyar | |

**2.10** With so many language choices, it is easy to get lost if you decide to select a different language.

## Video System

If you travel outside of North America and you want to play back images via a video monitor you may run into a different video system. This menu setting allows you to choose between NTSC — the North American system — or PAL , which you may encounter outside of North America. Because these systems have different resolutions, you should set Video System to the correct television system for proper playback.

## Print Method

It is rare that you would need to switch the Print Method setting from Auto, which is the default. However, if you have taken a photograph with the camera in Widescreen mode and want to print the image on wide paper using Canon's compact photo printers (CP5120/CP710/CP720/CP730) take this setting off of Auto.

## Reset All

If your camera just isn't working like it used to, you can try the Reset All option. Engaging this function resets just about everything to its default value — some things that may not be reset include the Shooting mode, date/time, language, and video system. Press Func./Set after navigating to Reset All. The Reset All screen appears giving you a choice between cancel and OK.

>  **Note** *You can't reset the camera when it is connected to a computer.*

# Play Menu

The Play menu is only accessible when the PowerShot is in Play mode. Some of the Play menu's choices are used to set parameters for image playback and others actually perform camera functions.

## Transition

When you advance your images using the 4-Way Controller during Play, Transition provides several options for how the images move onto the screen. Choose from a standard display, the current image fades out and the next fades in, or the next image comes in from left or right. The fastest way

to review your images is to set Transition to standard display.

Having an image fade in each time slows down the access to your images. If you want to run a slide show with transitions, then set up your camera for a slide show as noted in the next section.

 *Cross-Reference* *Chapter 7 gives you details on how to create a slide show on your PowerShot.*

## AutoPlay

If you turn the AutoPlay feature On, all the images on your memory card will play on the camera's LCD as a slide show.

## Slide Show

If your camera model has a Slide Show setting, you are offered several options for creating a custom slide show containing all or just a select few of your images. Choose from the following:

✦ **All images.** Plays all the images and movies in the order they appear on the memory card.

✦ **Date.** Plays only those images and movies with a specified date.

✦ **Folder.** Plays only those images and movies in a specific folder.

✦ **Movies.** Plays all movie clips in order.

✦ **Stills.** Plays all images in order.

✦ **Custom 1-3.** Allows you to select images throughout the memory card and assemble them into different playlists.

*Cross-Reference* *Slide Show setup and options are detailed in Chapter 7.*

## My Category

You can add or remove category designations manually with the My Category option. Once categorized, you can select groups of images by category for printing, protecting, erasing, and playing slide shows. Choose from People, Scenery, Events, Category 1-3, and To Do. You can tag images with multiple categories. To attach a category to your images:

1. **Put your camera in Play mode.**

2. **Press the Menu button and use the 4-Way Controller to navigate to My Category.**

3. **Press the Func./Set button.**

4. **Use the left and right areas of the 4-Way Controller to scroll through your images and find one you want to categorize.**

5. **Use the up and down areas of the 4-Way Controller to scroll through the categories displayed on the left side of the LCD.**

6. **Press the Func./Set button to place a check mark next to the image's category designation.**

2.11 Remember that you can have more than one category assigned to an image.

7. **Repeat steps 4 to 6 to categorize more images.**

Tip *Try using a category like the To Do category to mark images that you want to print later. Or, use category 1-3 for slide show images.*

# Red-Eye Correction

Red-Eye Correction allows you to take care of a red-eye problem after the picture is taken. Red-Eye Correction uses Face Detection to get the red out. To remove red-eye using the Red-Eye Correction feature, follow these steps:

1. **Put your camera in Playback mode.**

2. **Press the Menu button and use the 4-Way Controller to navigate to Red-Eye Correction.**

3. **Press the Func./Set button.**

4. **Scroll through your images and find one containing red-eye and press the Func./Set button again.**

5. **Press the Func./Set button again to Add Frame.** Frames are used to tell the camera where red-eye reflections are visible. You can add several frames if there is more than one set of eyes in the image.

6. **Use the 4-Way Controller to move the frame over the eyes in the image.** The camera places the first frame where it thinks red-eye needs to be corrected. If it can't find it, you have to move the frame with the 4-Way Controller. A magnified version of that section appears on the LCD to help you see the frame. Use the Zoom control to make the frame smaller or larger.

7. **Repeat steps 5 and 6 until you have added and positioned all of the frames needed for all the eyes in the image.**

8. **Navigate to highlight Start using the 4-Way Controller and press the Func./Set button.** The camera displays a Busy indicator and then shows you the corrected image.

9. **Save the corrected file.** You are given the option of creating a new file, overwriting the old file or canceling and starting over again.

**Tip** *If you have a large memory card, do not overwrite the old file just in case you see something that should have been corrected differently once the files are transferred to your computer.*

# My Colors

The My Colors feature allows you to add color effects to your images, either while shooting or as an effect added after the shot is taken. Choose from Vivid, Neutral, Sepia, B/W, Positive Film, Lighter Skin Tone, Darker Skin Tone, Vivid Blue, Vivid Green, and Vivid Red.

**Cross-Reference** *Chapter 3 explains more about My Colors while shooting and Chapter 7 explains how to use My Colors after you've taken the shot to make some in-camera adjustments.*

# Sound Memo

If you occasionally forget where you took a picture, the Sound Memo feature can be a big help. You can include information to fill in the "what, why, who, and how" of a location, instead of just the "where" that a picture of a sign provides. Each image can have a Sound Memo up to one minute in length. But remember that Sound Memos take up room on the memory card, so keep your notes succinct.

**Cross-Reference** *For a detailed explanation of how to add a sound memo to an image, see Chapter 7.*

Be aware of the following when creating a Sound Memo:

✦ **Sound memo icon.** When a sound memo is attached to an image, a musical note icon appears next to the file number on the LCD.

✦ **Volume control.** The volume control only affects playback; it has no effect on recording volume.

✦ **Microphone location.** Make sure you know where your PowerShot's microphone is (see Chapter 1 if you aren't sure). For maximum clarity, speak toward the microphone, but do not get too close to it.

✦ **Camera noise.** The microphone can pick up sounds caused by handling the camera, so keep the camera steady. If you are holding the camera, once you start recording avoid moving your fingers onto the camera's body.

## Sound Recorder

The Sound Recorder feature allows you to record sound. Unlike Sound Memos, these are not directly connected to a photo. Depending on the size of your memory card, you can record up to two hours of sound. You can adjust the audio resolution by using the 4-Way Controller to cycle through the options. Choices are 44.100kHz (the high-quality audio resolution you find on a CD), 22.050kHz, and 11.025kHz (something you might hear on a Web site). To record sounds, follow these steps:

1. **Put your camera in Playback mode.**

2. **Press the Menu button and use the 4-Way Controller to navigate to Sound Recorder.**

3. **Press the Func./Set button.** The camera displays tape recorder icons that represent Record, Pause,

Play, Fast Forward, and Rewind buttons. There are also buttons to Exit and Delete the memo. The indicator on the right gives a read-out of the recording's length and a volume adjustment.

4. **Use the up and down areas of the 4-Way Controller to select the audio recording quality.**

5. **With Record highlighted, press the Func./Set button to begin recording.** Speak into the camera's microphone to make your recording.

6. **Press the Func./Set button again to stop recording.**

7. **Using the 4-Way Controller, navigate to Play, and press the Func./Set button to start playback.** Use the 4-Way Controller's up/down areas to adjust the playback volume.

## Erase

While you can put your camera into Play and, one by one, delete images you don't want to keep, PowerShots that use My Category provide Erase so you can delete images based on:

✦ **Select.** Files that you individually select.

✦ **Select by Date.** Deletes only those files with a specified date.

✦ **Select by Category.** Deletes files in a specific category.

✦ **Select by Folder.** Deletes files in a specific folder.

✦ **All Images.** Deletes all images on the card.

Note  *Selecting Erase does not delete protected images.*

Caution  *There is no undo for erase!*

## Protect

Protecting your images prevents them from being accidentally deleted. This function is a good choice for those once-in-a-lifetime special shots, or just images that you don't want to lose if someone accidentally presses the wrong button when reviewing the images on your camera. When playing back your images, a key icon indicates that an image is protected.

Tip  *Use Protect to quickly delete a lot of images. For example, if you have 100 images on your card, but only 10 of them are "keepers," rather than deleting 90 images, you can protect 10 and then Erase All to delete those that were not protected.*

Cross-Reference  *Chapter 7 explains how to protect your images from accidental deletion.*

## Rotate

If you didn't have the Auto Rotate function turned On when you shot the picture, you can "rotate" your images after you shoot them. Rotate is in quotes because the image isn't really rotated, a notation is made in the image file that the image should be rotated. If your image editing software doesn't understand that notation, the image does not appear rotated.

## Erase All

If your camera doesn't support the My Category feature, then your camera uses Erase All. Executing this function deletes all images that aren't protected. If you don't have any protected images, use format instead. Formatting the card helps achieve trouble-free recording.

## Transfer Order

Before connecting the camera to a computer for downloading you can specify which images you want to download using the Transfer Order menu option. The options are:

✦ **Order.** Select this option to bring up the image playback screen and mark individual images to be transferred by pressing the Func./Set button. Use the Menu button to exit.

✦ **Mark all.** By choosing this option you can select all the images for transfer.

✦ **Reset.** This selection deselects any images that have been marked for transfer.

## Set Play Button

Some PowerShots that have a Play button let you program an additional function to it using Set Play Button. When you are shooting and you press Play, it switches the camera to Play mode. If you press Play again, it engages one of these optional functions: Slideshow or Sound Recorder. Unless you do a lot of sound recording, leave Set Play Button in Standard.

## Set Movie Button

When in Play mode, the Movie button on some PowerShots has no function. Set Movie Button lets you add a function to the Movie button. The options are Not Assigned, Sound Recorder, and Sound Memo. Sound Memo is a good choice as it lets you quickly add audio notes to your images.

# Print Menu

Canon PowerShot cameras support the DPOF (Digital Print Order format) industry standard developed for use among digital camera manufacturers and printers. When you use your PowerShot's DPOF features, you can select the images to be printed, the number of copies, whether to print the date and file name of each, and whether to print an index print of the images on your memory card.

> **Note** *Although you can use DPOF with many home photo printers, some retail photo processors also support the standard. Support among photo kiosks is not widespread.*

> **Note** *If your PowerShot model does not have an option called Print menu, look for printing functions under Print Order in Playback mode.*

✦ **Print.** Unless the camera is connected to a printer, Print is dimmed and you can't select it. When the camera is attached to the printer using the supplied USB cable, the blue Print/Share light appears and you can access the Print menu.

> **Cross-Reference** *For a step-by-step look at printing from your PowerShot, see Chapter 7.*

✦ **Select Image & Qty.** Before you print your images, you can use Select Image & Qty. to mark which images, and how many, you want to print. Once you choose this option, you scroll through your images, pressing the Func./Set button to make your selections. Make sure you press the Func./Set button before you try to change the number of images to print. If you press the up area of the 4-Way Controller before you press the Func./Set button, you enter the Jump mode for image playback.

> **Cross-Reference** *For detailed instructions on how to select and print your images, see Chapter 7. Learn more about jumping quickly through your images in Chapter 3.*

✦ **Select by Date.** You can mark images for printing based on a particular date you choose.

✦ **Select by Category.** You can mark images for printing by category. For example, you may select all of your People category pictures.

✦ **Select by Folder.** You can mark images for printing by folder.

> **Note** *When you select by Date, Category or Folder, you are just marking images to print. Although you can't combine options from the Date, Category, or Folder selections (they overwrite previous selections) you can combine one of these selection methods with individual selections. The quantity of prints per image is preset to 1. To combine one of these selection methods with Select Image & Qty. selections, make the individual selections last.*

✦ **Select All Images.** If you want to mark all of your images on the memory card, use Select All Images. There are no additional options and only one print is ordered for each image. This function overrides any individual selections you may have made.

✦ **Clear All Selections.** Use Clear All Selections to delete all prior print orders. There is no undo.

✦ **Print Settings.** The Print Settings menu allows you to control several printing options:

• **Print Type.** The Print Type menu offers you three choices: Standard, Index, and Both.

• **Date.** You can embed the date the picture was taken on the print. Turn this feature On if you want the date to print, leave it Off to prevent the date from printing.

 **Note** *If you embedded the date in the image and you also select to print the date, the two may overlap on the print and be difficult to read.*

• **File No.** This option gives you the opportunity to print the file number on the print. Choose to turn it On or leave it Off.

• **Clear DPOF data.** If you turn Clear DPOF Data On, once the prints have been made, the DPOF information — selection of images to be printed and number of copies — resets.

**Cross-Reference** *Print settings are described in detail in chapter 7.*

# My Camera Menu

Some PowerShots models offer the My Camera menu so you can personalize your camera.

✦ **Theme.** This setting changes all the other My Camera options as a group. For example, when you select the third theme option, all the other settings are changed to option three, as well.

✦ **Start-up Image.** When you first turn on your camera the LCD displays a start-up image. The first option is no start-up image at all. The second, third, and fourth options are Canon-supplied images. You can overwrite the third and fourth images with your own by pressing the Display button and browsing through your images. Press Func./Set when you have chosen your image.

✦ **Start-up Sound.** When you first turn on your camera, it plays a start-up sound. The first option is no start-up sound at all. The second, third, and fourth options are Canon-supplied sounds. You can overwrite the third and fourth sounds with your own by pressing the Display button and recording your own sound. Highlight Register Sound and press Func./Set to store your sound.

✦ **Operation Sound.** Each time you access menus or change camera settings, the operation sound is played back. The first option is no operation sound at all. The second, third, and fourth options are Canon-supplied sounds. You can

overwrite the third and fourth sounds with your own by pressing the Display button and recording your own sound. Highlight Register Sound and press Func./Set to store your operation sound.

✦ **Self-Timer Sound.** The Self-Timer gives an audible countdown before the shutter is snapped and you can assign the sound for the count-down using this option. The first option is no Self-Timer sound at all. The second, third, and fourth options are Canon-supplied sounds. You can overwrite the third and fourth sounds with your own by pressing the Display button and recording your own sound. Highlight Register Sound and press the Func./Set button to store your Self-Timer sound.

✦ **Shutter Sound.** Every time the shutter is released the camera acknowledges with a sound to let you know the picture has been taken. The first option is no shutter sound at all. The second, third, and fourth options are Canon-supplied sounds. You can overwrite the third and fourth sounds with your own by pressing the Display button and recording your own sound. Highlight Register Sound and press the Func./Set button to store your shutter sound.

Caution

*Once you overwrite the Canon-supplied images or sounds they are erased from your camera's internal memory. The only way to get them back is to hook up the camera to your computer and use ZoomBrowser EX (Windows) or ImageBrowser (Mac) to restore the images and sounds.*

Have fun with the settings but keep a few things in mind:

✦ **Go easy on the sounds.** It can be fun to play with various sounds included with the PowerShot, but they may be distracting.

✦ **Self-Timer sound should stand out.** The default sound for the last seconds of the self-timer can be too subtle. Although I wouldn't use the animal sound, the louder, more intense phone sound can cut through noise.

✦ **Funny sounds can work.** When I talk about shooting a group with the Self-Timer, I bring up the idea of using the custom self-timer to take several shots, including some after the group has finished their pose. These candid after-the-picture shots can be enhanced if you use a nontraditional shutter sound.

# Getting the Most Out of Your PowerShot Camera

If you are a reader who jumps to the last page to see how the story ends, this is not the chapter to skip. Yes, you could leave the camera in Automatic mode and have a good time capturing images, but you might not have much fun looking at the results. This chapter takes a detailed look at using more advanced features to give you additional control over your camera and at adjusting settings to gain greater control over your photography.

I have grouped similar adjustments by topic rather than by the order in which they appear on the camera because the order and placement varies from PowerShot model to PowerShot model. It makes sense to keep all exposure controls and settings together.

## Auto Exposure Lock

If you ever struggle with how your PowerShot determines exposure, AEL (Auto Exposure lock) can help. Take the situation where you capture images of someone and there is a bright window in the background. The camera's meter will key in on the bright window, setting an exposure that might cause your subject to become a silhouette. While you could use the flash to light your main subject, there might be enough light in the room so you don't have to. The problem is not that there isn't enough light; it is a metering problem.

**Note** *AEL is available on many, but not all, PowerShots.*

AEL to the rescue. You recompose the shot — temporarily — to remove the window from the scene and take a meter reading. Then you lock in the reading, recompose the original shot, and capture the image. You might end up with a better shot than one with flash. Sure the window will be overexposed, but the window isn't the important part of the picture.

Here's how to use AEL:

1. **Put your camera in Manual mode.**

2. **Compose your shot, leaving out the meter-confusing light source.**

3. **Press the Shutter release button halfway and hold it there.**

4. **Press the ISO area of the 4-Way Controller.**

5. **AEL appears on the LCD to confirm Auto Exposure lock.**

6. **Release the shutter button.**

7. **Reframe your composition and press the Shutter release to take the picture.**

It may be difficult to hold the Shutter release button halfway while pressing the 4-Way Controller, so a bit of practice is in order. If you accidentally take a picture (welcome to the club — I've done it many times), just delete it. This is such a great tool for adjusting exposure quickly that it is worth a little frustration while you practice your technique.

To turn off the AEL, either press ISO again while your finger is not holding the Shutter release button, or adjust the zoom in or out. I generally use the zoom; otherwise I end up

accidentally pressing ISO twice and the ISO setting screen appears.

**Note** *AEL is available only when the flash is not set to fire.*

# Flash Exposure Lock

You can use FEL (Flash Exposure lock) to control how much light the camera's flash produces. The process is similar to using AEL as discussed in the previous section, but there is a difference in how you compensate for flash over or under exposure.

Unlike metering a scene for AEL (where distance doesn't matter), if you try to light a scene with the on-camera flash, distance is critical. The flash output drops dramatically the farther the flash is from the subject. If the flash overpowers the scene, when you use FEL, point the camera at an object that is closer to the camera. Conversely, if you want stronger light from the flash, focus on a distant object. Because the meter measures light, make sure the objects you choose to focus on are similar in brightness to your main subject.

**Note** *FEL is available on many, but not all, PowerShots.*

Here's how to use FEL:

1. **Put your camera in Manual mode.**

2. **Center the frame on an object that you want to the camera's light meter to measure.**

3. **Press the Shutter release button halfway and hold.**

4. **Press the ISO area of the 4-Way Controller.**

5. **The flash fires and FEL appears on the LCD to confirm Flash Exposure lock.**

6. **Reframe your composition and press the Shutter release button.**

It takes a lot of delicate finger motion to activate FEL. FEL is compounded by the flash going off, which can be quite startling. But just because the flash goes off, it doesn't mean that you took a picture. Pay attention to the LCD and look for the FEL text on the screen.

 *Note* *FEL is available only when the flash is set to fire.*

Turn off FEL either by pressing ISO again while your finger is not holding the Shutter release button, or adjusting the zoom in or out.

# Auto Focus Lock

Think back to the "Quick Tour." When you press the Shutter release button halfway, several things happen: The exposure is set, the white balance is set, and the focus is set. You've just learned how to lock the exposure separately from the focus using AEL. What if you wanted to set the focus separately, too?

Let's take the example where you are at a baseball game and you want to capture the runner touching first base. Everything happens quickly when a ball is hit so you may have problems catching the right moment if the camera is busy adjusting focus. And when you press the Shutter release button, the camera will try to focus on the runner. But if he is fast, by the time the image is captured, the runner might be closer to the camera than he was when the camera

focused. With AFL (Auto Focus lock) you can focus the camera when someone else is on first base or focus on the first base coach. Then you are ready when the next ball is hit.

 *Note* *AFL is not available on all PowerShots.*

Here's how to use FEL:

1. **Put your camera in Manual mode.**

2. **Center the subject in the frame.**

3. **Press the Shutter release button halfway and hold.**

4. **Press the Macro area of the 4-Way Controller.**

5. **The camera sets focus and AFL appears on the LCD to confirm Auto Focus lock.**

6. **Reframe your composition and press the Shutter release button.**

*Tip* *While setting AFL and AEL are powerful photography tools, don't ignore a simple focus and exposure lock you achieve just by pressing the shutter halfway and recomposing the shot. There are many situations where that works just as well.*

Turn off AFL by pressing the Macro area of the 4-Way Controller or adjusting the zoom.

# Function Menu

The Function menu is called a menu, but the settings don't appear if you press the Menu button. Instead, they appear when you press the Func./Set button. The Function menu doesn't look like a regular menu however. It is superimposed over the live image on the LCD and directly relates to features you'd use while shooting.

Although there are different Function menu layouts among PowerShot models and different settings depending on the Shooting mode, the basic layout is the same: A series of settings appears on the left side of the screen and choices for the settings appear at the bottom of the screen. You use the 4-Way Controller's up and down areas to rotate through the settings on the left. As the settings are highlighted, different choices for each setting appear at the bottom of the screen. Use the right and left areas of the 4-Way Controller to select a choice.

*Note*   *On some PowerShot models, the Function menu appears when you change shooting modes via the Mode dial.*

**3.1** The Function menu, with settings on the left and choices on the bottom, is accessed while in any shooting mode.

One of the best ways to understand the Function menu is to turn it on. Set the camera for any Shooting mode, press the Func./Set button and then study the display. Take a look at the icons on the left. Even though some may be grayed out right now (depending on your Shooting mode), you can still examine them.

# Shooting Modes

With the exception of a few PowerShot models, the modes for shooting can be placed into three categories: Auto, Manual, and Presets. More specifically, in most cases they are Auto, Manual, Scene (or Special Scene), and Movie. You access them either through a Mode dial or via the Function menu.

*Note*   *On some cameras, some of the Scene modes are on the Mode dial, so a Special Scene on one camera may be a Shooting mode on another. As you look at all the icons on your camera's Mode dial or Function menu, it can be intimidating.*

## Auto mode

This mode's description is pretty obvious: The camera makes all the adjustments for you. All you have to do is compose the shot and press the Shutter release button. You can make a few tweaks, but for the most part it is a set-it-and-forget-it mode because in Auto mode, the camera is in control!

You have a few chances to modify the camera's settings but for the most part you trust it to create a good picture. You can still control image resolution and compression, access the self-timer, determine if flash fires, make a bit of ISO adjustment, and control macro focusing.

## Manual mode

Manual mode is easy to understand (though not necessarily easy to operate): You have to make several adjustments before you take the shot. Depending on the camera, Manual mode might give you complete control of the camera or limited control.

What follows next is a guide through many of the Manual mode adjustments that appear on the left side of the LCD when you press the Func./Set button. You access these adjustments on some cameras via the 4-Way Controller. While it might be a tad confusing to know where to look at first, have your camera in hand as you read. The adjustment might be in a slightly different place than I describe here, but its function and effect will be the same.

## Exposure Compensation

Sometimes the exposure meter built into the PowerShot is fooled by objects in your scene, causing the captured image to be too bright or too dark. To compensate, you can adjust the exposure using Exposure Compensation. When you select the Exposure Compensation icon, a slider adjustment appears at the bottom of the screen, allowing you to change the exposure in one-third increments from -2 to +2.

 **Note**  *In photography jargon the full increments are called stops. This comes from the term for the lens settings that control the amount of light coming in: f-stop. If a shot is overexposed, photographers say to "stop it down" or "decrease your exposure by a stop."*

If the captured image is too bright, move the setting into the negative numbers and take the picture again. If it is too dark, move the setting into the positive numbers. This is a relatively small adjustment so if your scene is really too dark, use the flash. If the PowerShot is set for Auto, this setting is *not* accessible.

 **Note**  *Some PowerShots may have a separate Exposure Override button on the back of the camera. It is indicated by a +/- icon.*

Exposure Compensation

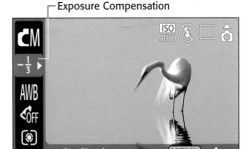

**3.2** Instant feedback from the LCD makes exposure compensation easy to use. Here the setting was reduced by 1/3 of a stop (-1/3).

## Auto Exposure Bracketing

Just a few PowerShots have an AEB (Auto Exposure Bracketing) mode. Bracketing creates one image brighter than the chosen exposure and one image darker. These two extra images "bracket" the normal exposure.

Nowadays digital cameras, and particularly histograms, allow you to evaluate images on the spot. Rather than bracketing, you can delete the original image, correct exposure, and reshoot. But just in case you need it, there are a couple PowerShot models that offer bracketing.

## Long Shutter mode

If you want to gain access to the slower shutter speeds that may be available on your camera, look for a star and moon icon above the Exposure Compensation adjustment slider. This represents the Long Shutter mode.

 **Cross-Reference**  *You might have to turn on Long Shutter in the Record menu. See chapter 2 to learn more.*

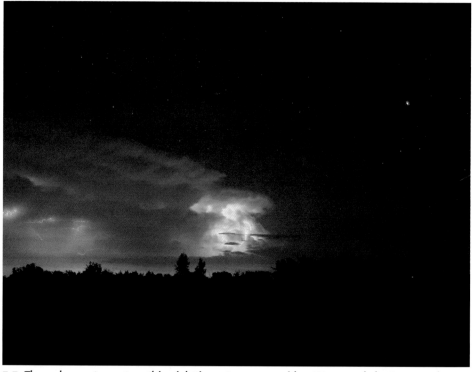

**3.3** The only way to capture this nighttime storm was with a 15-second shutter speed, accessible through Long Shutter mode.

Press the Menu button as indicated and the exposure slider changes to show a shutter speed and left and right arrow. Use the left and right areas of the 4-Way Controller to scroll through the available shutter speeds.

Long Shutter mode speeds are measured in seconds, rather than fractions of a second, so a tripod is a must — unless you are going for an abstract image. Because the shutter is open for a long time (in photography terms), it is also possible that the image will be overexposed.

One of the problems with slow shutter speeds is the amount of noise that builds up in the image. To counter this, Canon has implemented a noise reduction system that takes a second exposure of the same length with the shutter closed. After this blank exposure has been captured, the noise developed in that file is subtracted from the original image. This noise reduction is the reason long exposures take twice as long before the image is available for review — a 10-second exposure takes 20 seconds!

 **Note** *In some PowerShots, you need to turn on Long Shutter mode in the Record menu.*

## +/- (Flash)/Flash Output

This setting has two modes depending on the PowerShot and the camera's shooting mode. The first mode is similar to regular Exposure compensation except it only affects flash output. +/- allows you to fine-tune the balance between existing lighting and the flash. If pictures are consistently overpowered by the flash, dial it down with +/- Flash.

**Tip** *If your model doesn't have flash compensation, you can use regular Exposure Compensation to reduce the overall exposure. If your camera supports FEL, that can help, too.*

The second mode is Flash Output. In this case, you have complete control of the amount of light produced by the flash during the exposure. You can also control the flash output manually, regardless of exposure metering. If you manually control all other aspects of the exposure — such as setting the shutter speed and aperture — it makes sense to adjust Flash Output, too.

**Note** *Some PowerShots have a hot shoe for attaching an external flash. Depending on the model of flash attached, this setting may also control the external flash output.*

## ISO speed

ISO is a setting that adjusts how your digital camera's image sensor interprets and perceives the light that reaches it. Many PowerShots access the ISO speed via the upper area of the 4-Way Controller. When you increase the ISO speed, say from 100 to 200, you double the apparent sensitivity of the camera. I say "apparent" because a digital camera's image sensor has only one sensitivity. In reality the signal from the sensor is being amplified.

However, when you increase the ISO speed, you also increase the graininess of your image, called *noise*. Noise is common in the darker areas of your image. To minimize noise, when the PowerShot is in Auto ISO mode, the ISO setting is automatically adjusted to the lowest possible setting for a proper exposure. This won't always be the lowest ISO number. If, for example, the aperture is wide open and there still isn't enough light, the ISO may have to be boosted.

 **Cross-Reference** *Learn more about ISO and where it came from in Chapter 1.*

The options for setting ISO include Auto, Hi Auto ISO, and specific ISO numbers ranging from 80 to 1600, depending on the PowerShot model. Some tips to consider when choosing an ISO:

✦ **If the scene has a lot of light, either keep it in Auto or manually set the ISO for the lowest setting.**

✦ **If you are in a situation where the light is low, you have to make a decision: Do you live with a low ISO and less noise or high ISO and more noise?**

 **Cross-Reference** *Exposure is a delicate balance between ISO setting, shutter speed, and aperture. If there isn't enough light in your scene, you can set a high ISO, set a slow shutter speed, or open up the aperture. Learn more in Chapter 4.*

**Tip** *If you have difficulty remembering what the downsides to various exposure settings are, think: ISO — noise; shutter speed — motion blur; and aperture — focus.*

The decision is yours to make. Keep in mind that the LCD often hides image problems, so make sure you zoom in while reviewing your image to check for motion blur, poor focus, and increased noise.

Setting a specific ISO speed number is pretty straightforward; however, there is some confusion with Hi Auto ISO. Hi Auto ISO takes the regular Auto ISO setting and boosts it higher so you end up with a faster shutter speed in order to avoid motion blur.

 **Note** *If you are shooting in Auto, you only have the choice between Auto ISO and Hi Auto ISO.*

Is there a recommended ISO setting? During daylight hours, I keep ISO on the lowest setting possible, 80 or 100, until I am faced with slow shutter speeds. If I am in a hurry, I keep it on Auto ISO, but I pay attention to the ISO speed the camera selects. When I shoot later in the day or evening, I am more precise about my settings. I prefer to keep the ISO down one setting from the maximum. If my PowerShot goes up to 800, I drop down to 400. I have found that while pictures taken with the maximum ISO are okay for some, they have a little too much noise for me.

Tip   *Pay attention to the image information displayed during review. There is a lot of useful data that can help explain how the camera interprets your scene.*

## White balance

The color of light around you changes throughout the day. When you wake up, the sunrise bathes the surrounding landscape with a reddish-orange glow. When you walk into an office building, you may be struck by the greenish glare of fluorescent lights. With moonrise, an eerie blue shrouds the night. What changes is the color temperature of the light.

 Cross-Reference   *Color and quality of light are explained further in Chapter 4.*

Dramatic changes in color temperature like those I mentioned previously are easily detected. But there are more subtle changes too. At midday, when you walk from outside to inside where there may be artificial lighting, there is also a color temperature change. You just don't see it. The human vision system automatically corrects for many changes in color temperature; a digital camera cannot.

3.4 The colors in this image are correct because it was shot under tungsten light with a Tungsten White Balance setting.

Enter white balance! By adjusting your PowerShot's White Balance setting, you can compensate for the changes in color temperature. When it is set for Auto White Balance, the camera attempts to evaluate the color temperature of the light in the scene. Unfortunately there are many situations where an overabundance of colors in the scene may fool the camera. In this case you should get used to using the preset White Balance settings:

✦ **Daylight.** Select this setting when you shoot outdoors under bright sunlight, or indoors next to a window.

3.5 The same image as 3.4 with the same lighting. The White Balance was set for Daylight, causing a severe change in color.

✦ **Cloudy.** Choose this setting when the sun goes behind clouds, and the color of the light starts turning blue. This is also a good setting when you shoot in the shade.

✦ **Tungsten.** Tungsten refers to a material used to make lightbulb filaments. Use this setting when you shoot indoors under artificial light.

✦ **Fluorescent.** Photography under fluorescent lights can be a difficult task. Some fluorescent tubes don't emit a wide range of colors, but using this setting can help.

✦ **Fluorescent H.** Newer fluorescent tubes have been designed to overcome some of the older lamps' limitations by emitting a wider

spectrum of colors. If you have problems with White Balance under fluorescent lighting, try using this setting.

✦ **Underwater.** Some PowerShots offer this setting to compensate for the strong blue colors when you shoot underwater.

 *See Chapter 5 for information about underwater cases for PowerShots.*

There is one more option for White Balance, though it is not really a preset: a custom White Balance setting. If you really are fighting a difficult white balance situation, this may be the solution. Here's how to set a custom White Balance setting:

1. **Put your camera in Manual mode.**

2. **Using the up and down areas of the 4-Way Controller, highlight the White Balance setting.**

3. **Using the left and right areas of the 4-Way Controller, select Custom.**

4. **Point the camera at a white sheet of paper and zoom in to fill the LCD with white.** Make sure the white paper is in the light that you are shooting under and not next to some highly saturated colored object. This can give a tint to the paper and cause a false white balance evaluation.

5. **Press the Menu button to set the custom White Balance.**

6. **Check the image on the LCD. It should look neutral in color.** If not, repeat steps 4 and 5.

7. **Press the Func./Set button to exit.** The Custom setting is stored in the camera even if you switch to a White Balance preset.

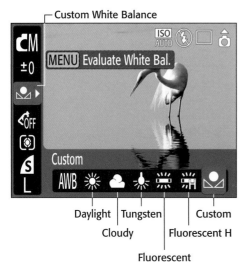

Custom White Balance

Daylight | Tungsten | Custom
Cloudy | Fluorescent H
Fluorescent

**3.6** Note the Custom White Balance icon. Use the Menu button after filling the screen with a white paper.

How do you know whether you have proper White Balance? During image review, look for an overall color shift in the image. Do people's faces appear reddish or blue? Look for anything in the scene that should be white and check to see if it looks white.

**Tip**

*White Balance can be a creative tool. Don't get locked into always matching the type of illumination with the White Balance setting. Experiment using Cloudy White Balance to warm up images or try other combinations. If you don't like the look, you can always delete the files.*

**Cross-Reference**

*Chapter 6 details several situations where you might want to use the "wrong" white balance. It also gives more reasons to use a preset setting versus Auto White Balance.*

## Drive mode

The Drive mode is used to select whether to take a single shot with each press of the

Shutter release button, a series of shots when the Shutter release button is held down, or delay taking the picture when the Shutter release button is pressed. The Drive mode setting offers several options:

✦ **Single Shot.** This is as simple as it gets.

✦ **Continuous.** Multiple pictures are taken as long as the Shutter release button is held down.

**Note**

*When the PowerShot takes a picture the camera doesn't write the image directly to the memory card, it first puts it into a special built-in memory called a buffer. The image is then written from the buffer to the card. This buffer is able to receive data at a much higher rate than a memory card, but it is not very big. In Continuous mode the camera continues to capture images until the image buffer is full. At that point, the time between shots is longer as the images in the buffer are written to the memory card.*

**Tip**

*For best performance, use a high-speed memory card that has recently been low-level formatted.*

✦ **Self-Timer.** The Self-Timer delays the shutter release so you can set up the camera and still be in the picture, or prevent camera shake on longer exposures.

**Cross-Reference**

*For more information on the Self-Timer and the Custom Timer, see Chapter 2.*

✦ **Custom Timer.** The Custom Timer setting allows you to choose how long the delay is and how many shots are taken when the timer goes off.

 **Note** *The Self-Timer adjustments for some PowerShot models are located in the Record menu or are accessed through the 4-Way Controller.*

Many PowerShots access the Drive mode via the bottom area of the 4-Way Controller; others use the Function menu.

## My Colors

My Colors is a way to control the image processing built into the PowerShot. Some models offer a My Colors adjustment during image playback, but if My Colors is turned on in the Function menu, it alters your images permanently when they are shot in this mode. In other words, make sure you really want that image in black and white.

✦ **Vivid.** Produces more saturated colors and heightens the contrast in the image.

✦ **Neutral.** Reduces the contrast and sets the colors to a less vivid appearance.

✦ **Sepia.** Creates a brown tinted black and white image.

✦ **B/W.** Removes all color from the image.

✦ **Lighter Skin Tone.** Makes skin tones paler.

✦ **Darker Skin Tone.** Creates skin tones that are a shade darker.

✦ **Vivid Blue.** Emphasizes blue skies and water.

✦ **Vivid Green.** Makes foliage more vibrant and saturated.

✦ **Vivid Red.** Highlights red areas in the image.

✦ **Positive Film.** Combines Vivid Blue, Vivid Green, and Vivid Red to create an image that replicates color slide film.

✦ **Custom Color.** Allows you to individually adjust Contrast, Sharpness, Saturation, Red, Green, Blue, and Skin Tone.

✦ **Color Accent.** Changes all but a selected color to black and white. To use Color Accent:

1. **Select Color Accent mode.**

2. **Press the Display button.** The image alternates between original scene and Color Accent scene.

3. **Aim the center white outline on the LCD at the color you want to accent.**

4. **Press the left area of the 4-Way Controller to sample the color.**

5. **Use the up and down areas of the 4-Way Controller to adjust the sensitivity of the color selection.** A range of +/- 5 is available. +5 will allow more shades of the selected color to appear in the scene.

6. **Press the Display button to accept the setting.**

7. **Press the Shutter release button to take the picture.**

**Tip** *You can zoom in or walk up to fill the LCD with the color you are trying to pick, and then zoom or walk back when you have sampled the color.*

✦ **Color Swap.** Allows you to swap one color in your scene with another. To use Color Swap:

1. **Select Color Swap mode.**

2. **Press the Display button.** The image alternates between original scene and Color Swap scene.

3. **Aim the center white outline on the LCD at the color you want to swap out.**

4. **Press the left area of the 4-Way Controller to sample the color.**

5. **Use the up and down areas of the 4-Way Controller to adjust the sensitivity of the color selection.** A range of +/- 5 is available. +5 will allow more shades of the selected color to be swapped.

6. **Aim the center white outline on the LCD at the color you want to insert.**

7. **Press the right area of the 4-Way Controller to sample the color.**

8. **Press the Display button to accept the setting.**

9. **Press the Shutter release button to take the picture.**

**Cross-Reference** *To learn how to apply a color change during playback, see Chapter 7.*

**Tip** *It is difficult to evaluate a My Colors choice on an LCD. If you just aren't sure about the results, try printing an image or two and evaluate the color that way.*

**Note** *A few PowerShots use the term Photo Effect instead of My Colors.*

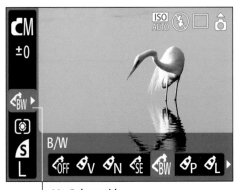

My Colors with Black and White selected

**3.7** Black and White is the selected My Colors setting here. Make sure the My Colors setting you choose when shooting is really what you want, because there is no going back.

Some PowerShots have a Custom setting at the end of the My Colors options. Within Custom are a range of adjustments that allow you to fine-tune contrast, sharpness, saturation, red, green, blue, and skin tone. I find that in high-contrast shooting conditions — outdoors at midday — reducing the contrast can help a little bit. So I keep the Custom setting for that use. Once set, the parameters are stored even when you power the camera off.

## Metering mode

A few PowerShots let you run on full Manual, where you explicitly set both the shutter speed and the aperture. Unless that is available, the camera's metering system measures the light level of the scene for you. If you plan to select the metering mode, there are three different types to choose from:

✦ **Evaluative.** Keep the camera on Evaluative metering until you start running into challenges. This is the most common type of light metering and it works in a majority of situations. The image frame is broken down into zones that are

measured individually. Then, with input from the Auto Focus system, the meter determines which parts of the image are important and it sets the exposure accordingly.

**Tip**    *A good combination to learn is setting your camera to Spot and using Auto Exposure lock (AEL) to set a custom exposure. Spot metering can also be effective in night shots and for macro photography.*

✦ **Center Weighted Average.** Center Weighted Average has limited use but can be helpful if bright objects near the edges of the frame are throwing off the exposure. With this mode the entire frame is evaluated with more priority given to the center of the frame. The thought is that people usually frame the most important part of the image in the center of the picture.

✦ **Spot.** If you shoot a lot of backlit objects and start underexposing the foreground, move on to Spot metering. Spot metering ignores everything but the center of the frame.

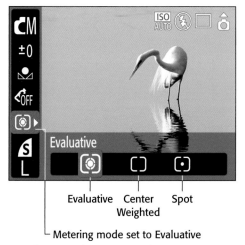

Evaluative    Center    Spot
              Weighted

Metering mode set to Evaluative

3.8 There are three options for exposure metering. Evaluative is the most sophisticated.

**Tip**    *Spot metering may also be effective in night shots and for macro photography.*

## Compression

Compression is where you select how much data will be thrown away when the image is stored on the memory card. I know that sounds a little drastic but it is important that you understand what this setting does. You can't be sure about an image's quality by viewing it on the LCD — choose based on your needs for the end use of the photo.

The PowerShot offers three levels of compression:

✦ **Normal.** While the name is Normal, the icon is a more appropriate representation of the results of normal compression. Notice how the arc has a lot of stair steps. Normal compression will have a lot of artifacts. If you keep the image small, however, you won't notice many of them. The often-repeated advice I hear is that this is a good setting if you plan to e-mail your pictures. While that can't be argued, what usually happens when you send someone a picture via e-mail? The recipient loves it and wants a print! So now you have to try to print from a highly compressed file, and it won't look very good. Remember that you can always compress a file later, but once you've thrown data away it is gone forever.

✦ **Fine.** This is the middle ground. It does a good job of reducing file size without sacrificing much image quality — as long as you keep the final print size low.

## About JPEG

PowerShots use JPEG compression. JPEG is specifically designed with photographic images in mind (the P stands for photographic). The idea behind compression is to reduce redundant data. For example, if you take a picture of a solid blue sky, there are hundreds of pixels that are the same color. Rather than storing hundreds of identical pixels, you could store one pixel and then say that hundreds of pixels around the stored one are the same color.

Although this is a simplistic explanation, JPEG compression uses a similar methodology. And because the human vision system is not as precise as we think it is, you can get away with throwing out some "apparently" redundant data.

A common question is "How many images will fit on my memory card?" JPEG compression is variable and there are no exact numbers. Some images compress very well and produce small file sizes; others are difficult to compress and create larger files. Any specification of the number of files that can fit on a card is just an estimate. You may notice this with your PowerShot. Sometimes it will look like you can only record one more image, but after you take a shot there is still room for one more. This is due to the variability of JPEG compression.

✦ **Superfine.** If you are going to make prints that go beyond the 4 x 6 inch size, you should stick with this mode. Superfine uses the least amount of compression and the files that you end up with make your PowerShot images shine.

Tip: *Think of compression as a quality setting. The higher the setting, the higher the quality and the lower the amount of compression applied to the image.*

Obviously there are tradeoffs with compression settings; otherwise you would just leave it at Superfine. Superfine compressed files take up about twice as much room on a memory card as Fine compressed images. Similarly, a Fine setting produces files that are about twice as big as Normal files.

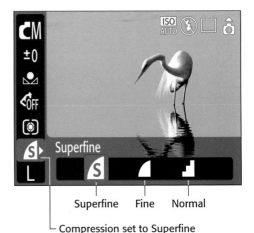

Superfine    Fine    Normal

Compression set to Superfine

**3.9** The icons indicate the amount of compression. With larger memory cards, stick with the least amount of compression.

Note *Even though it might seem that Fine is twice as good as Normal and Superfine is twice as good as Fine, that really isn't the case. The change in image quality from Normal to Fine is dramatic, while the change from Fine to Superfine may be difficult to see on many images.*

Memory cards are getting bigger and bigger and they cost less and less. If you can, stay with Superfine. But if storage space gets to be a problem, move down to Fine. At all costs, avoid the advice of shooting Normal for images to be sent via e-mail.

You may decide to switch between different compression levels depending on what you shoot. For example, when I travel, sometimes I will take a shot of a street sign as a visual note of a place I am visiting. The shot isn't a beautiful image, it is just a reminder, and in that case I can lower the quality. The trick is to remember to set it back!

Tip *Depending on the speed of your memory card, if you want to shoot in Continuous drive mode, you may need to use a lower quality compression level.*

## Recording Pixels

The Recording Pixels setting has an effect on your image quality, just as compression does. The PowerShot has a fixed number of pixels that are produced from the image sensor. Recording Pixels sets your final image's resolution — how many of those pixels actually make it to the memory card.

The age-old question that falls into the resolution category is, "How big a print can I get from an image?" Simply put, the more resolution, the bigger the print. Compression

also comes into play. The larger the final image is, the more noticeable and distracting compression errors are.

While there are some who give specific answers about file size and print size, it is difficult to do so with the varied PowerShot models covered in this book. High resolution for one camera might be 5.0 megapixels, but for another it might be 7.0 megapixels. Final print size also boils down to an individual's tolerance for image quality. Two people may look at the same print and one will see all the artifacts; the other will see the cute baby playing with a toy.

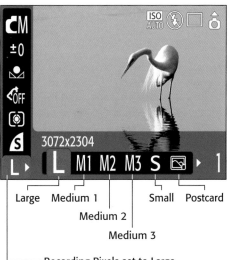

Large    Medium 1               Small    Postcard

Medium 2

Medium 3

Recording Pixels set to Large

3.10 If you change your Recording Pixels from Large, don't forget to set it back.

The resolution options are:

✦ **Large.** This should be your default setting. It makes sure that you get all you can from your image sensor. Unless you really struggle with storage space, keep the camera set on Large.

✦ **Medium 1.** A little smaller than Large, Medium 1 can still produce a good snapshot print.

✦ **Medium 2.** Typically Medium 2 produces a file that is about half the size of a Large file.

✦ **Medium 3.** Depending on the PowerShot, this can produce an average 4 × 6 inch print or, with some models, it can only be used for something smaller than 4 × 6 inches.

✦ **Small.** If you display a Small image on your computer, it will probably cover about one-third of the screen. If you couple this with normal compression, it will be the smallest file that is produced by a PowerShot.

✦ **Postcard.** This setting adjusts more than just file size. Setting Recording Pixels to Postcard also adjusts compression to Fine. If date embedding is turned on, the date will be embedded in the image too.

✦ **Widescreen.** Canon has printers that can print on wide paper so this Widescreen mode is useful. Given that widescreen resolution has an aspect ratio of approximately 16 × 9, this mode can also be used for images that may be displayed on an HDTV.

| Note | *Not all PowerShots have all these resolution settings.* |
|------|-----------------------------------------------------------|

Unless I shoot something specifically for Internet use, where I know for a fact I won't need a better sized image, I leave Recording Pixels set to Large. If you shoot for an auction site, it is tempting to shoot at Small or Medium. If you keep it Large, however, you have the opportunity to crop in on details using your image-editing software.

Probably the biggest reason to keep Recording Pixels on Large no matter what, is the possibility of forgetting to set the resolution back to Large. The idea of shooting a series of images and then realizing the resolution is set for small scares me! If you really need a hard and fast rule for image size versus print size, the Canon guidelines in your manual are a good starting point. Look at the section on changing Recording Pixels.

 *Recording Pixels settings for video recording are covered in Chapter 8.*

## Focus-BKT

Focus-BKT (focus bracketing) is similar to Exposure Bracketing, which was discussed earlier in the chapter, but it deals with focus not exposure. It is found on a few PowerShot models and can be a useful tool when you shoot in areas where it is difficult to check focus. Once you have a Manual focus set, the Focus Bracket takes a series of three shots: one at the Manual Focus setting, one with focus set nearer and one set farther.

When you choose the Focus-BKT setting in the Function menu, a slider appears in the bottom of the screen so you can adjust the range of the focus bracket.

## ND Filter

A few PowerShots have a built-in Neutral Density filter (ND filter) that helps reduce the amount of light that hits the sensor. When you shoot moving waters, use ND filter so you can use a slow shutter speed without overexposure. With long exposures, you must mount the camera on a tripod.

## Movie Mode Function Menu

There are several settings in the Function menu when you are in Movie Mode that deal with recording movies. Depending on

the model of PowerShot they may include Frame Rate, Recording Pixels, Shooting Interval, and Aspect Ratio.

**Cross-Reference** *Chapter 8 covers the Movie mode settings and shooting video with the PowerShot.*

## Stitch Assist

Stitch Assist allows you to shoot panoramas. To shoot a panorama with Stitch Assist:

1. **Put your camera in Manual Shooting mode.**

2. **Press the Func./Set button**

3. **Use the 4-Way Controller to navigate to Stitch Assist.**

4. **Use the left and right areas of the 4-Way Controller to select whether you want to start shooting your panorama from the left or right.**

5. **Press the Func./Set button and start shooting your images.**

6. **Press the left area of the 4-Way Controller if you want to reshoot the previous image.**

7. **Press the Func./Set button after shooting your last image.**

# Preset modes

Preset modes cover all the Scene or Special Scene modes. These are the various settings that are scene dependent. For example, each PowerShot has a Portrait mode where various settings are locked-in to produce a good picture of a person. Where writing this field guide got a little tricky is that some PowerShots consider Portrait mode a Special Scene that you access through the Function menu. Other models make it available as a separate setting on the Mode dial. Those cameras also have a Special Scene area on the Mode dial, but Portrait mode is not in it.

Does it matter whether Portrait is a Special Scene or a Shooting mode? No. Does it work differently? No. The only difference is how you access it on different camera models. Given that you probably own just one PowerShot, it is only an issue when you are going through this guide. So whether they are called Scenes, Special Scenes, or "presets," they are the same, they just might be found on a dial or in a menu. Depending on your model, you can choose from these Scene modes:

✦ **Portrait.** This scene is useful when taking pictures of one or two people from a close distance. Exposure settings are chosen in order to focus on the people and to try to make the background softer (or more out of focus). If the flash is needed, red-eye reduction is turned on.

✦ **Kids & Pets.** This scene optimizes the camera settings for a fast shutter speed and quick focusing. Red-eye reduction is turned on (but can be overridden). This setting may increase picture noise in order to increase sensitivity.

✦ **Sports.** Continuous shooting is selected in this scene. Along with a fast shutter speed, rapid autofocus is used to capture all the action.

✦ **Indoor.** In order to capture images with little camera shake, higher sensitivity is set on the image sensor. This mode is a good way to balance existing light with the built-in flash. If flash is needed, red-eye reduction is used. Auto White Balance zeros in on getting good color in tungsten and fluorescent light.

✦ **Foliage.** Color saturation is increased in order to produce vivid foliage. Flash is turned off and white balance leans toward outdoor light.

✦ **Snow.** Normally, people's faces are darkened when photographed in snowy locations. In this setting, exposure is geared to reduce that tendency. White balance is adjusted to remove bluish tints. Flash is used if needed, but without red-eye reduction.

✦ **Fireworks.** In order to capture fireworks displays, this setting sets the shutter speed in excess of a second. The flash is turned off and enhanced noise reduction is used to compensate for the long exposure.

✦ **Beach.** With this scene, exposure is geared to minimize over-exposure and to keep people's faces from going dark. Flash is used if needed, but without red-eye reduction.

✦ **Night Scene.** Here the flash is used in combination with a slower shutter speed to balance ambient light with the flash. Red-eye reduction is engaged when the flash is fired.

✦ **Night Snapshot.** When you take pictures at night, this scene reduces blur by increasing sensitivity so a faster shutter speed can be used.

✦ **Landscape.** The aperture is closed down in order to increase the range of objects in the scene that are in focus. White balance is optimized for outdoor light.

✦ **Aquarium.** Flash is turned off to avoid reflection on aquarium glass. White balance and color are optimized to capture accurate color. Higher ISO is selected to reduce blur.

✦ **Underwater.** White balance is adjusted to reduce bluish-green tints. Flash is engaged if needed and red-eye reduction is turned off.

*PowerShots with an Underwater Scene mode can be used with a specially designed Canon underwater case for shooting underwater or in wet conditions. Check out Chapter 5 for more information and learn about underwater options for all PowerShots.*

✦ **Color Accent.** This is a special-effect mode that turns the image black and white except for one color that you choose.

✦ **Color Swap.** This is another special-effect mode that allows you to replace one selected color with another.

## Creative Zone

The previous settings are available in the Manual shooting mode. Some PowerShot models have other shooting modes that you access via the Mode dial in a section of the dial called "Creative Zone". While you can still change settings like White Balance, metering, and compression through the Function menu, these shooting modes are a bit different—they just deal with exposure settings.

### P

P is the Program AE (Auto Exposure) shooting mode. Program AE is similar to any PowerShot's Auto mode. It automatically sets the appropriate shutter speed and aperture to achieve a good exposure. The difference between Program AE and Auto is that Program AE only automates exposure settings. This means you still have full control over White Balance, ISO, and metering via the Function menu.

# Tv

Tv stands for *time value* and is referred to as Shutter Priority. As the name suggests, to achieve proper exposure, the photographer first sets the shutter speed; the camera adjusts the aperture and ISO. Tv is just like Program except you set the shutter speed.

When would you use Tv? If you want to make sure there isn't any motion blur caused by camera shake, you might set the shutter speed to 1/125 or 1/250 and then let the camera worry about the rest. Or if you shoot high-speed action, you might set the shutter speed faster to freeze the action.

# Av

Av stands for *aperture value* and is commonly called Aperture Priority. Aperture Priority is the opposite of Shutter Priority. Set the aperture and the camera sets the shutter speed and ISO.

 **Note** *Both Tv and Av are considered Auto Exposure modes given that the camera controls the overall exposure.*

When should you use Aperture Priority? Aperture controls both the amount of light hitting the image sensor and the depth of field. In photography, there is really only one distance or plane that is truly in focus or sharp. As you move away from that plane, the image becomes less sharp. The human vision system can't pick up subtle changes in sharpness. When you look at something that is less sharp you may not notice the difference. Depth of field is the distance — measured from in front of the object to behind the object — that appears acceptably sharp.

 **Cross-Reference** *For more about depth of field, see Chapter 4.*

3.11 This image was shot with a large aperture opening of f/2.8. Notice how little of the ruler is in focus.

**3.12** The only change was the aperture being closed down to f/8.0. This increases the depth of field so more of the ruler is in focus.

**Note** *While it is not a technically correct definition, depth of field can be described as the distance from front to back of your subject that is in focus.*

For example, let's say you focus on a person standing 20 feet away. If you have a wide depth of field, objects that are 5 feet away and 50 feet away would also be in focus. A narrow depth of field may only be in focus between 15 and 25 feet. The smaller your aperture opening, the wider your depth of field.

Getting back to when you should use Av, although a PowerShot's aperture range is pretty small, if you use a large aperture (f/5.6) for portraits, the background will be nicely out of focus. If you shoot for details as you would for an online auction, shoot with the smallest aperture (f/8) available so as much of your item as possible will be in

focus. Keep in mind that a small aperture may require a very slow shutter speed and a tripod.

## M

While the M stands for Manual, this is different than the Manual shooting mode found on most PowerShots. This is Manual *exposure*. When you use this setting, you explicitly set the shutter speed, the aperture, and the ISO speed. The camera meter is not involved. So if you want total control, this is it.

There are a few occasions when you may want to use M. If you shoot panoramas, use M to help keep the exposure consistent from shot to shot. If your photography is for the Internet, you may want your shots to have consistent backgrounds so they appear on a Web site with that same consistency.

**Cross-Reference** *Chapter 6 provides details on how to shoot panoramas.*

# Histogram

The Display button is used to cycle through various LCD options: It can simply turn off the display to save power; it can display just the images; or it can turn on a whole host of data superimposed over your image. Depending on your PowerShot model, the data can include ISO speed, shutter speed, and exposure compensation as well as others. One of the more important displays most PowerShots have is the histogram.

The *histogram* is a graph that displays the tonal values in the captured image. The left side of the graph represents the darker areas of the image; the right, the lighter areas. The histogram is a great tool for evaluating exposure.

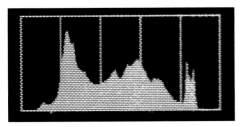

**3.13** This histogram represents a good exposure because most of the area on the graph is in the middle.

The general rule for evaluating exposure using a histogram is to avoid *clipping*, which is indicated on the histogram by spikes on the far ends of the graph. The spikes represent loss of detail. For example, if you take a picture of a scene with a bright, cloudy sky and your exposure causes a spike on the extreme right edge of the histogram, you may have lost subtle details in the clouds. If, on the other hand, you capture an image in a dark forest and a spike appears on the far left edge of the histogram, you may have lost details in the shadows.

Keep in mind that while you may adjust your exposure to avoid loss of detail, there are situations where the contrast in the scene is just too high. Unless you use artificial lighting, you'll have to accept some detail loss.

While in many cases, the best exposure is one that displays a uniform set of values across the entire graph, this is not always the case. Take, for example, a scene of morning mist over a swamp. In this situation, there may not be any dark tones on the left side of the histogram. They simply don't exist in your image. As a rule, however, be careful of images that graph only on the left half of the histogram. This indicates underexposure, which can overemphasize noise in the image sensor.

Is there an ideal histogram? Not really – it's really image dependent. Unless it's what the scene requires, if you stay away from a histogram that is heavily weighted to one end – particularly the far left – and you avoid clipping, you are on your way toward achieving good exposure.

# Memory cards

The PowerShot cameras use one of the latest developments in flash memory – Secure Digital (SD) cards. *Flash memory* is nonvolatile, meaning that it does not require power to retain data – there is no power source or power storage built into an SD card. Because SD cards are not susceptible to damage from magnetic fields or X-rays, you can travel through airports with your PowerShot without any problems. And, many SD cards contain a write-protect switch that you can use to prevent a card from being used. If you are traveling with several cards, you can use this switch to indicate when a card is full.

Your PowerShot likely came with a memory card, but it probably has a limited capacity and is considered a starter card. As you begin to use your PowerShot more often, you'll find you need more memory cards or cards with larger capacity. I recommend that you purchase name-brand cards for optimum performance and reliability.

**Tip** *Store extra cards in a carrying case or pouch so the electrical contacts don't become contaminated. Although I have put several cards through the wash and they have survived, I don't recommend testing a card's ruggedness.*

There is also a type of SD card called SDHC (the HC stands for High Capacity). In size and shape the card is identical to the original SD card but electrically the two are not the same. How do you know if your PowerShot supports SDHC? Look for an SDHC logo. Or look in your instruction manual for a description of the memory cards you can use.

It is important to note that SDHC cards are *not* backwards compatible with SD cards, meaning that while they are the same physical size, electrically they are not the same. Here are the compatibility rules:

✦ **You can use an SD card in any SDHC slot.** In other words, if your PowerShot supports SDHC you don't need to throw away your old SD cards, as they will work just fine.

✦ **You cannot use an SDHC card in any SD slot.**

**Caution** *There are some very rare situations where an SD device might be able to access an SDHC card. Even if it's successful, it may only have access to a portion of the storage. This type of access is not even worth considering — with digital images you need a consistent, reliable data memory system. So stick with SD cards for SD devices and SDHC or SD cards for SDHC devices.*

Elsewhere in this book I highly recommend the use of a card reader to download your images. The SD/SDHC compatibility issue extends to card readers, too. I know I might be redundant but I want to make the issue clear. If you are heading down the SDHC path, you must purchase a new card reader, too.

Don't forget to consider all the devices in your digital imaging chain. If your printer has an SD card slot, it might not support SDHC. You will have to stick with SD cards in your SDHC-capable camera in order to print using the printer's SD slot.

**Caution** *The official largest capacity SD card is 2GB. If you see SD cards that are larger, test them out before you buy them. Also, don't assume that a larger card — like 4GB — is automatically an SDHC card. Make sure you see the SDHC logo.*

Regardless of which type of memory card you are using, here are a few tips for getting great performance out of your memory card:

✦ **Formatting.** This is the most important memory card tip I can give you. Format the card in the camera you will be using. Although it is possible to format the card in a computer via a card reader, you are asking for trouble. In my years of getting letters from digital photographers, the biggest mistake regarding memory cards (besides not having enough and accidentally erasing them) is formatting the card in the wrong device. Nine times out of ten you won't have a problem, but that one time when things do go wrong, you may find you are missing images or they are corrupt.

✦ **Formatting.** No, this isn't a repeated tip. When you have a card full of images that you have downloaded to your computer, it is tempting to erase the images. The PowerShot gives you that ability and it is very easy to do. But simply erasing the images may not erase *protected* images. You might not discover this until you have almost filled up the card again and are starting to run out of room. At that point you will have to search through the images to find the old ones, unprotect them, and erase them individually. Formatting your card eliminates all of the data on the card.

✦ **Formatting.** I know this is sounding like the real-estate catch phrase of "location, location, location" but formatting a card instead of erasing images rebuilds the card's file structure. I wouldn't keep harping on it if I hadn't seen the results of people using a card for months on end without refreshing the memory by formatting.

✦ **Low-level formatting.** If you have the time and the battery power, I recommend you do a low-level format at least every other time that you format your memory card. A low-level format closes off any bad storage areas that might lead to corrupt files. It takes a bit longer but it is worth it.

**Tip** *Physically mark your memory card(s) with a marker so you know which cards you have been using the most. You might mark a card that you use for recording movies, or one you use for shooting panoramas. Marking cards can help keep you organized while shooting.*

# Creating Great Images with Your Canon PowerShot

# The Fundamentals of Photography

**A**lthough understanding how to set up your PowerShot is a good first step, the key to great images is understanding how to compose your photo and using the camera's sensor to capture the vision you have in mind for your photograph.

Merely pointing the camera and shooting doesn't make great images. Good photography takes practice, patience, and perseverance. Practice means carrying your camera everywhere and taking pictures — lots of them. You need patience to wait for the right light or for a scene with moving subjects to form properly. Perseverance is needed to keep trying different exposures and different compositions in order to capture a great shot. Also, do not be discouraged if the shot that looked great on the LCD doesn't make a good print. Learn from your mistakes and also from any happy accidents.

## Keep It Simple

Think of some of the great photographs of the twentieth century: the Marines raising the flag on Iwo Jima or the Afghan girl with the piercing green eyes who stared out from the cover of National Geographic. While the message each image conveys may be complex, the photos are created using the same basic techniques. Your message can be as simple as "Rowen's Birthday" or as complicated as "A man walking alone at sunrise thinking about the world around him." *Your* viewpoint and a simple composition can more clearly present your vision.

# Telling the story

Before you press the shutter release, think about what you are trying to say. Get into the habit of asking yourself a few questions. Much like a journalist, you should ask "who or what? why? where? how? and when?"

✦ **Who or what is the main subject?** Is there only one subject? Is it the shopkeeper or her wares? Is it the bride or the sneakers she's wearing under her wedding dress? Determining who or what the subject is helps you focus your composition and your message.

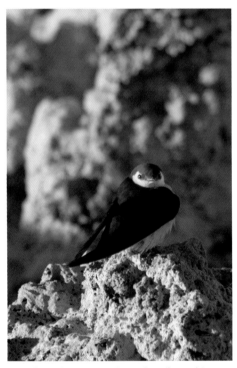

4.1 There is no question what the subject of this photo is.

✦ **Why am I taking this picture?** Is this just a "snapshot" or am I trying to capture my mood at the time I took the photograph? Is this photo for me or for my friends or for a card I send to relatives?

✦ **Where is the best location to shoot?** Am I standing in the best place? Because the world is seen from all different heights, should I be lower, should I be higher? Should the sun be behind me or to the side? Is a vertical shot, rather than a horizontal one, more appropriate for the subject matter?

✦ **How do I want people to react to this scene?** Do I want them to be happy or sad? Do I want them to grasp my idea quickly or do I want them to explore the image? Perhaps I don't want them to see my thoughts. Maybe I want them to create their own.

✦ **When is the best time to press the shutter release?** Sometimes it is earlier or later than you think. Consider the football player who missed catching the winning pass. Does waiting for the expression of defeat tell more of a story than reaching for the ball? Everyone has seen the image of the child blowing out the candles, but what about the look of anticipation on their face beforehand?

There is a lot to think about before picking up your camera and shooting. Practice with small steps. Try asking just one or two of these questions until it becomes a habit. With continued practice, the process becomes second nature.

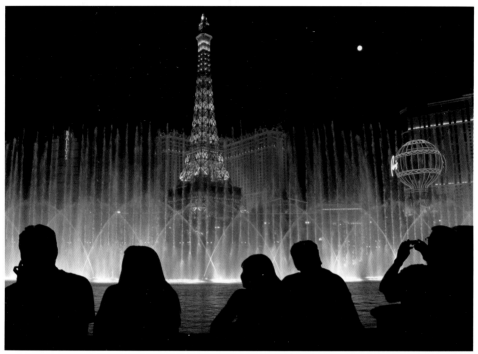

© *Marianne Wallace*

**4.2** Everybody wants to get a shot of the fountains. By standing back and getting the silhouette of the crowd, this image tells a different story.

## Filling the frame

Remember that you are trying to convey a message with your image. Take the time to fill the frame with the elements that are necessary and eliminate those that are not. You may need to do more than just zoom in or zoom out. Walk around the scene and see if there is another angle that provides a better shot. Also, just because you are at the end of your zoom range doesn't mean you can't walk closer. Don't merely lock your feet down in one location and point your camera around to find a shot. That is a perfect way to miss that great shot.

# Composition Basics

Composition is more than just a set of rules. It is understanding what makes a photo interesting. One of the best ways to learn composition is to ask yourself why you like a particular photo. Flip through the images in this book and pick a couple that grab your attention. Then really look at them. Ask yourself where your eyes are drawn to, and what the images say to you.

## The rules

Probably the most famous of all photography rules is the Rule of Thirds. Imagine a tic-tac-toe grid over your LCD, or, if you'd prefer

**4.3** Pay attention to the intersections of the lines for placing your subject.

not to, just turn on Grid Lines in the Shooting menu on your PowerShot and the Rule of Thirds guides appear.

In theory, you place your subject at any of the four points where the lines intersect. This works for both horizontal and vertical shots. In practice, your subject may be too large or you might have multiple subjects, preventing you from using the guides as intended. In situations like these, avoid placing your subject in the exact center of the frame.

Here are some other rules to consider:

✦ **Watch the horizon.** If there is a horizon in your shot, make sure it doesn't cut through the exact center of the frame. If it *is* in the center, it acts like a seesaw, causing the viewer's eyes to dart from top to bottom, searching for an anchor point in your image. If the sky is important, then move the horizon down from center; if it is not, move it up.

✦ **Watch the background.** Make sure it is not too busy. Even if it is out of focus, a busy background can distract from the subject of your scene. Also, watch out for background elements that appear to grow out of your subject. This can occur with pictures of people. It is not uncommon to see an image where the subject appears to have a plant growing out of his or her head.

✦ **Watch the edges of your frame.** Make sure you avoid objects that draw your viewer's eyes away from the subject. The intersection of object and frame edge quickly draws your viewer's eyes away from the interior of your photo. Instead, have the object continue off the image or make sure that the object is fully contained in your shot. This photograph of the gull, shown in figure 4.4, might have worked better as a horizontal so the tail would not be touching the edge of the frame.

4.4 The tail of this drinking gull just meets the edge of the photo—a horizontal composition might have worked better here.

✦ **Pay attention to brightness.** Our eyes are attracted to bright objects. When we look at a photo we look first at the brightest area of the image. If you have a nice scene of a lonely tree on a hillside, for example, the inconsequential white rock in the very corner of your image screams "look at me" and your message about the tree is lost.

✦ **Pay attention to color.** Not only are our eyes drawn to brightness, they are also attracted to saturated colors. Just as a bright-red stop sign calls out to us from a busy roadway, colors in a photograph can draw our eyes in. Make sure that your main subject doesn't have to fight with strong hues elsewhere in the image.

4.5 The purple bear stands out in a sea of brown. There were other colored bears in the scene, but the shot was composed to limit the colors to brown and purple.

✦ **Use shapes and lines to direct the eye.** When you look at a photo of train tracks moving off into the distance, the sharp, bold geometric shape of those two lines converging, forces your eyes to follow the

tracks into the distance. We call these "leading lines". Use leading lines to your advantage. If you photograph a scene with a gracefully curving tree branch that points to a small stand of flowers, for example, you can arrange your composition so that the viewer's eyes follow that branch.

✦ **Think about balance.** While the viewer's primary focus has been discussed previously, at some point the viewer's eyes will move on to secondary objects. This is where balance comes in. If your primary object is in the right side of your image, consider composing the shot so that a secondary object is in the left. This forces your viewer to look at the entire image, not just the main focus.

**Note** *Composition tips for specific photographic categories can be found in Chapter 6.*

## Breaking the rules

Now that you know a number of photographic rules, you can break them! I could easily fill a book with famous images that didn't follow the rules. Sometimes you can't get to the right place to take the picture. Other times the background doesn't allow for following the rules. Take the picture that works for you. For example, in figure 4.6, the bird doesn't fill the frame, there is no counter balance, and while not centered horizontally, the bird is centered vertically, so it breaks the rule of thirds. However, the shot works — the open space to the left speaks to both the bird's fishing and the silence of the environment.

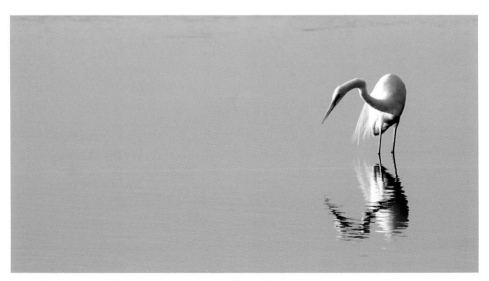

4.6 This image breaks a lot of rules, yet it still works.

# Make It Sharp

Nothing can destroy a great composition more than an image that isn't sharp. The goal for photographers, both professional and amateur, is a photograph that is "tack sharp." The two most likely culprits for blurry images are a shaky camera and moving subject matter.

Having an LCD on the back of a camera is great when you review your images or compose your shots. When it comes to keeping your camera steady when taking a picture, however, the LCD can be a problem. Here are some ways to minimize camera shake while using the LCD to compose your photographs:

✦ **Use a tripod.** This is the best way to ensure a steady camera. Make sure the tripod is properly set up. Place the legs on solid footings. Ensure the camera is secured to the tripod head. If your tripod has telescoping legs, make sure they are securely locked.

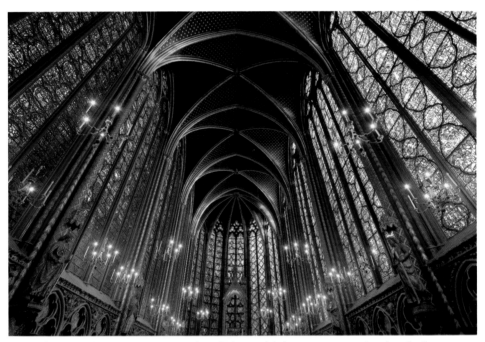

4.7 A flash simply isn't strong enough to light up this huge space. A tripod and a long shutter speed is the only way to capture this image.

✦ **Watch your handholding techniques.** Obviously you can't bring a tripod everywhere you go, so good habits while handholding your camera are essential. This takes some practice. Support the camera with both hands. Make sure that your fingers do not interfere with anything on the front of the camera.

✦ **Act like a tripod.** Practice keeping your elbows tucked in to stabilize your upper body and keep your legs apart, feet planted firmly.

✦ **Use a substitute tripod.** Use the world around you for support. Look for stable objects to set your camera on. Your most logical choices are horizontal surfaces, but you can also use vertical surfaces. Just press the camera against the surface while taking the picture.

✦ **Slow down.** Rushing to capture an image generally results in an unusable image. Scurrying around for that one perfect image may lead to disappointment. Sometimes it is best just to let *the* shot go and settle instead for a snapshot.

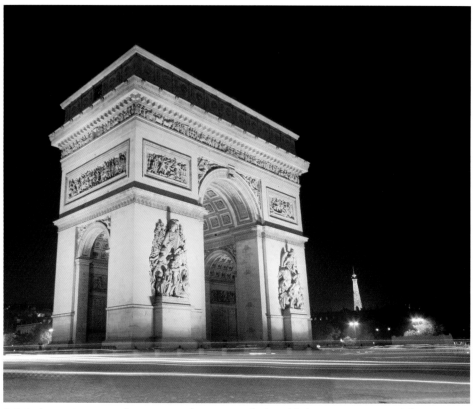

4.8 A signpost was used to support the camera during this long exposure at night.

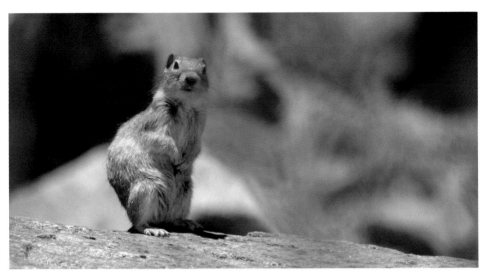

4.9 This guy appeared out of nowhere. The challenge was not composition, but settling down before taking the shot.

## Know Your Shutter Release Button

Even with some camera support, your image may still be blurry. Although the blur may come from movement in the scene, it is also possible you still have camera shake. Some camera shake can be caused by pressing the shutter button too hard. Here's an exercise to give you a feel for a light touch on the Shutter release button. This is not how you should take a picture, but with practice, it can help develop your skills at limiting camera movement.

1. Hold your camera as you would normally hold it to take a picture.

2. Place your index finger on the Shutter release button.

3. Now, as slowly as you can start applying pressure to the Shutter release button. Take several seconds to do this, trying to press as slowly as you can. You should be surprised when the shutter releases.

4. Repeat this several times, and then start increasing the speed at which you press the Shutter release button. You want to develop a gentle pressure, rather than a strong jerk.

# Understanding Light

There is much more to light than how much of it is in your scene. Light has a color, a quality, and a direction that affects your image.

## Color

If you think about the color that comes from a single candle burning in a darkened room, you are likely to imagine the soft orange glow. Now imagine that same scene as it would appear when illuminated by your PowerShot's flash. The light and color of your image would be very different between the two.

Your eyes can automatically compensate for changes in color temperature, whereas digital cameras use a system called white balance to correct for changes in color temperature.

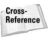 **Cross-Reference** *For more about white balance and your PowerShot, see Chapter 3.*

Artificial light sources also have color temperature changes, though less obvious. For example, the light from a lamp on an end table looks very yellow compared to that of a fluorescent lamp, which is more blue. The feeling your photo evokes is directly influenced by the type of light.

The White Balance settings on the PowerShot can help prevent extreme color balance problems, but recognize that if you try to white balance the camera to neutralize, say, a single burning candle in a darkened room, you also neutralize the feeling you were trying to convey through the scene.

## Quality

By quality of light I don't mean that one type of light is better than another, but rather that the light is hard or soft. Light coming from an overcast sky is soft because the normally harsh rays of the sun are diffused by the clouds. But if those clouds dissipate and the sun is overhead, the scene changes to one of simple opposites: Either the object is brightly lit or it is hidden deep within the murky shadows.

But you can affect the quality of light. For example, pulling down a window shade or closing a sheer drape when taking someone's picture near a window can dramatically change the quality of light that is entering the room.

## A Bit about Color Temperature

Color temperature is actually measured on a scientific scale called Kelvin. And, although your eyes might not detect it, daylight from the sun changes color temperature all through the day. If you are in a room lit by a fluorescent light the color is different than a room lit by a tungsten light. Each type of light has its own color and color temperature.

To learn more about Kelvin and color temperature, see http://en.wikipedia.org/wiki/Kelvin.

# Direction

The direction of light controls how much detail you might see in a scene. As light changes direction, shadows decrease or increase or they may fall on different areas of the scene. There are four main types of lighting:

✦ **Front.** Light shining straight on to your subject is great if your subject is, for example, a historical document, because it won't cast shadows to obscure any important details. However, it also removes the details that shadows bring out in a scene, resulting in a flat-looking image.

✦ **Top.** You have experienced top lighting when you have been out in the sun at noon. Unless you turn on the flash or use a reflector, the strong narrow shadows can be a problem. If the sky is overcast, then the direction of light becomes more omni-directional.

✦ **Side.** Here the light comes from either side of the camera. It offers detail-producing shadows that can bring interesting character to a scene.

✦ **Back.** This type of lighting can be very dramatic but it is also very difficult to photograph under. The path of the light is often directly into the camera, which can lead to difficulty metering the exposure. Often it leaves the subject as a silhouette, hiding detail; however, sometimes this may be what you want.

Tip    *Consider using a flash to complement top, side, or back lighting. If your PowerShot allows for Flash Output adjustment, use it to let the flash just fill in some of the dark areas of the scene. Chapter 3 talks more about Flash Output adjustment.*

# Understanding Exposure

Cameras are nothing more than tools for capturing light. You can control light either by making adjustments to your camera — called setting your exposure — or by controlling the light — choosing when and where to shoot, or adding light, as with a flash. Much like composition, you can use light and exposure to control the viewer's experience.

## Controlling exposure

Exposure is the amount of light hitting your image sensor. You can control exposure by controlling the amount of light in the scene. Carefully select your shooting position or your subject's position so you can add or subtract light. For example, you can try to combat an overly bright sky by moving a subject into the shade. You can also add artificial light by turning on your flash.

Once you have done what you can to control the amount of light in the scene, the last step is to control the amount of light passing through the lens past the shutter and landing on the image sensor. You do this by adjusting

two of your camera's controls: Aperture, and Shutter Speed. When you adjust the aperture and shutter speed settings, you are said to be setting your exposure.

A third control, ISO speed, controls how the image sensor interprets the amount of light hitting its light-sensitive surface.

## Controlling light in the lens: Aperture

When light passes through the lens, it goes through an adjustable diaphragm called the *aperture*. The aperture is similar to the pupil in your eye. When you open the aperture, you let more light through the lens and into the camera. Aperture settings are described in terms of *f-stops*. The f-stop number represents a fraction, so a smaller number — f/2, for example — is a wider opening that lets more light pass through; a higher number, such as f/4, is a narrowing opening that lets less light through.

Cross-Reference

*Some PowerShot models do not allow you to manually control aperture or shutter speed. But certain scene modes give priority to aperture over other exposure controls. See Chapter 3 for more on Special Scene modes.*

Every exposure adjustment has trade-offs and aperture is no exception. Aperture affects depth of field. *Depth of field* is the range in your scene where objects are in focus. When you stop down the lens from f/2 to f/5.6, you let in less light but you increase your depth of field. The wider the depth of field, the larger the area where things are in focus. If you focus on something that is 20 feet away, depending on your aperture, your depth of field may keep objects from 10 feet to 40 feet in focus, or only those between 15 and 25 feet in focus.

4.10 Adjusting depth of field helps isolate the distant foliage from the nearby foliage. This image has a narrow depth of field.

Tip

*Use depth of field to your advantage. If you have a busy background, try decreasing your depth of field to blur out the background.*

## Controlling light in the shutter: Shutter speed

Once the light has passed through the aperture, the shutter controls how long light hits the image sensor. The shutter may be open for mere fractions of a second or for multiple seconds, but the longer the shutter is open, the more light reaches the image sensor.

Like changing the aperture, changing the shutter speed has trade-offs. The shutter speed changes how motion appears in your

photo. The faster your shutter speed, the more any moving objects appear crisp.

> **Tip** *Use shutter speed as a creative tool. While freezing the action is desirable in many situations, a little bit of motion blur from a slow shutter speed can evoke more movement.*

On some PowerShots you can directly change the shutter speed but on others you can achieve similar effects by paying attention to scene modes. For example, a Scene mode that is for children and pets or sports will have faster shutter speeds in order to capture the action.

> **Cross-Reference** *Chapter 3 explains more about changing the shutter speed.*

### Controlling light in the image sensor: ISO

Once the light gets through the shutter, its final destination is the image sensor. The CCD image sensor in your Canon PowerShot works by converting light into small voltages. The ISO setting on your camera adjusts the light-to-voltage ratio.

The term ISO comes from photographic film. If your camera used film, you would use a roll of ISO 100 film for normal, sunny day photography, and the more sensitive ISO 400 to shoot in low light. Unlike film, you can't change the actual sensitivity of your PowerShot's digital sensor. But you *can* change the amplification of the tiny amounts of voltage coming off the chip. This is what you are doing when you increase the ISO on your PowerShot.

Once again, trade-offs come when you change the ISO setting. When you increase the ISO, you increase the noise or "digital grain" which appears as tiny colored flecks in your image. An image taken at ISO 400 may appear grainy compared to one taken at ISO 100.

## The exposure equation

While I have explained some of the trade-offs with adjusting aperture, shutter-speed, and ISO, there is one key point to remember: These three settings are all part of the equation that makes up a properly exposed scene.

One way to think of exposure is like a balance scale (from the halls of justice) except instead of 2 arms (one on each side), there are three. In order to achieve a good exposure the three items have to be in balance. For example, let's say that a particular scene looks great if the aperture is f/5.6, the shutter speed is 1/60 and the ISO is 400. If you decide that the high ISO adds too much noise to the image and you want to lower it to 200, that means you need to either take the shutter speed down to 1/30 or open the aperture to f/4. Likewise if you want to increase depth of field by changing aperture to f/8, you need to lower the shutter speed to 1/30 or increase the ISO to 800.

## When to shoot

Oftentimes the difference between a good photograph and a great one is time: the time the photographer spent setting up the shot and what time of day she or he snapped the picture. All you have to do is look at the Grand Canyon at dawn versus noon to see a dramatic difference in a picture and, more importantly, to feel a difference in mood.

The time of day you shoot affects the kind of light you are shooting. As the sun travels across the sky, both the color of the light and the depth of the shadows change. Use this to your advantage.

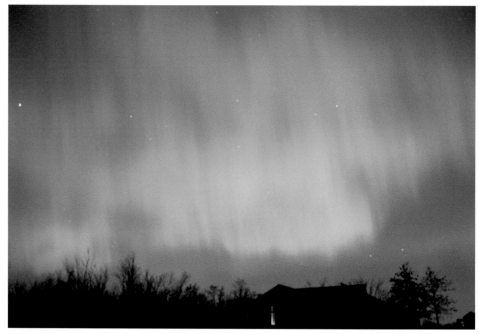

**4.11** The image of the northern lights was captured with a high ISO setting. Noise due to amplification is visible throughout the image, but without the high ISO, the image probably wouldn't have the saturated colors.

✦ **Dawn.** Getting up early and photographing before and right after sunrise can be a rewarding experience. With the sun at a low angle, colors are vibrant and shadows are long. Skies light up with reds and blues while the landscape takes on the colors of the early sun.

Tip   *Early light is dramatic and can change fast, so it is best to be prepared. Don't be caught changing batteries or cleaning your lens while great light is happening.*

✦ **Midday.** The midday light has always been considered poor for photography. This type of light is harsh and pictures appear with very little middle tones, just harsh blacks and bright whites. If you photograph people at this time of day, they squint or, worse, are wearing sunglasses. However, midday can be a good time to shoot macros. Also, look for places where narrow shadows occur. Seek out shady spots or use objects to block out the sun. If the sky is overcast, the midday light becomes softer or more diffuse so outdoor portraits can work well.

✦ **Twilight.** Like sunrise, sunsets offer incredible lighting. Don't get trapped into thinking the main subject is the sun. The brilliant colors that a sunset creates light up the whole landscape, giving you opportunities to capture dramatic images. Patience is a virtue when shooting in diminishing light. A

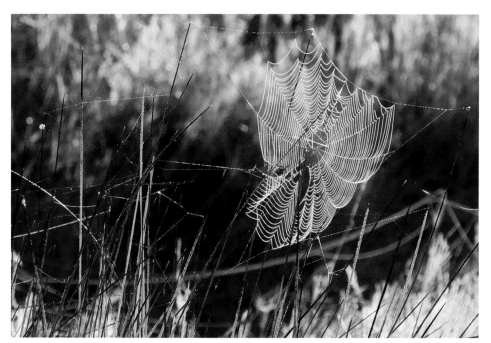

4.12 Sunrise lights up the whole landscape. While the sun is clambering for attention, look around for different scenes.

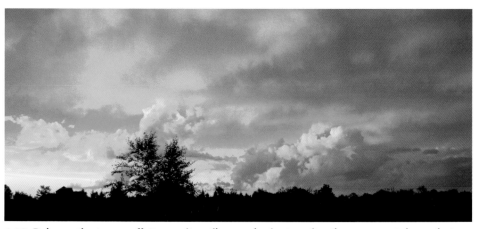

4.13 Being patient pays off. It wasn't until several minutes after the sun went down that the clouds lit up in this shot.

common mistake is to put away the camera too early. A lot can happen after the sun goes down.

> **Note** *In photography the hour or so when the sun rises and sets is often called the "golden" hour.*

✦ **Night.** Don't put the camera away just because the natural light is gone. Cityscapes and night photography produce some great shots. A tripod or other support is a must, as is a longer shutter speed and often a higher ISO.

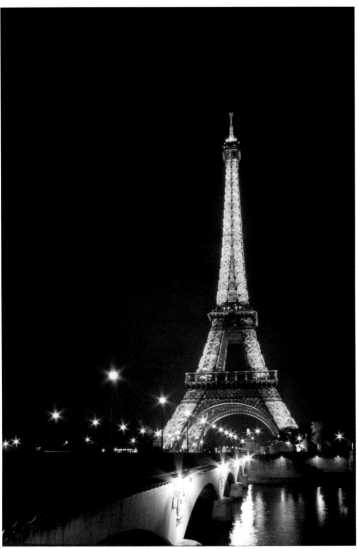

4.14 The sun went down but there were other scenes left to shoot. Look around for supports if you don't have a tripod.

# Accessories

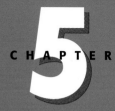

W hen you first open your PowerShot box, it includes everything you need to start taking pictures. This chapter explores additional things that may improve your photography or enhance your photography experience. Some of the items can make a dramatic change in images, others only subtle modifications. There are also a few that might not affect your pictures, but help make the process fun and keep your camera healthy.

With a few exceptions I do not suggest that you immediately run out to buy every available   photographic accessory for your camera model. Instead, take a walk through this chapter to see how some of these items might address your specific needs.

## Tripods

Over the years I have viewed hundreds of images taken by photo enthusiasts. One accessory could have helped the vast majority of those images — a tripod. Most of the images had the telltale blur of a handheld shot. I am sure they looked good on the camera's LCD. When printed at 4 × 6 inches, some looked okay, but many did not. When printed at 8 × 10 inches, they really showed the motion blur associated with an unsteady camera.

While there are situations where a tripod is logistically imprac- tical, generally that is not the case. Besides keeping your cam- era steady, a common side effect of tripod use occurs: It makes you slow down or even stop and think. Too often peo- ple grab a camera, turn it on, and start shooting. Photography

is a creative process, like writing. When you sit down to write an important letter (okay, an e-mail) do you just start hitting keys or do you sit for a bit and think about what you want to say? Setting up a tripod, leveling it, and mounting your camera gives you a chance to slow down and think about what you are trying to say photographically.

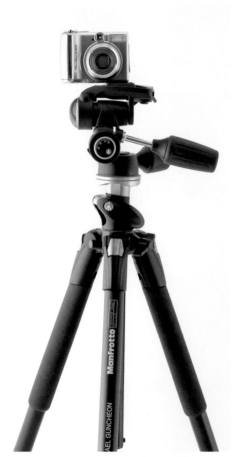

**5.1** You can create steady shots with a sturdy tripod.

When you shop for a tripod, consider how often you will use it and whether you will travel with it. A good tripod can last a lifetime, so if you are serious about improving your photography with nice steady shots, don't skimp on the tripod.

If you will shoot movies, take a look at a tripod that can also double as video tripod. Yes, there is a difference. If you place a photo tripod and a video tripod side by side, at first glance you may not be able to tell the difference between the two: Both have three legs, both use some kind of swiveling head. But the difference lies in the head. Once you level a video head, the only directions you can move it are horizontally (panning) and vertically (tilting). A typical photo tripod head, once loosened, will allow for movement in an arc around the center of the head. That is not a typical movement for video. Photo tripods that double as video tripods often have a way of limiting the arc motion when shooting video.

Another option is to get a tripod with one leg—a monopod. While they can't stand on their own like a regular tripod they can be useful for giving extra support and removing camera shake. Look for tripods and monopods at:

✦ **Manfrotto.** www.manfrotto.com

✦ **Gitzo.** www.gitzo.com

You can also purchase mini tripods. These small tripods are easy to carry and can support many of the smaller PowerShots. Be careful with these tiny guys, however; they don't have much mass and can easily tip over.

A few mini tripods are from:

✦ **Manfrotto.** www.manfrotto.com

✦ **Joby.** www.joby.com

✦ **Slik.** www.slik.com

So while there are many things you can do to improve your photography—understand and practice good composition, learn proper exposure—if you want to add an accessory to take your photography to the next level, support your camera with a tripod.

# Lighting

PowerShots can produce great images in low lighting using variable ISO. But there are times when you need to supplement existing lighting. The flash built into the camera offers a good deal of light, but just for a short distance and only from one direction. There are a few options you can consider for additional lighting.

✦ **Common household lamps.** You don't need special photographic lighting to add light to a scene. Common household lamps do a great job. Just make sure they emit light with similar color temperatures. In other words don't mix a fluorescent desk lamp with an incandescent floor lamp. That mix of color temperatures can't be solved by any type of custom white balance.

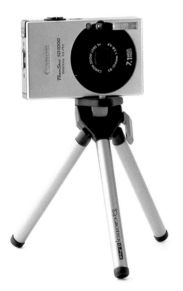 

5.2 These lightweight mini tripods aren't as sturdy as a full size tripod but they fit into tight places.

## Other Support Options

There is another support accessory that can be useful when you don't want to lug around a tripod. The best description I can give is that it is like a beanbag with a camera-mounting bolt attached to it. Called THE pod, it is lightweight and doesn't take up much room. Check out `www.thepod.ca` for more information.

✦ **Speedlight flash.** For those PowerShots that have a hot shoe for an external flash, check out Canon's series of Speedlight flashes. They produce an incredible amount of light in a small battery-operated package that works well with the PowerShot. Flash Exposure Compensation is communicated directly to the external flash, so you have automatic control, even of the external flash. Check out www.usa.canon.com for more information.

✦ **Slave flash.** There is also an accessory flash solution, called a *slave* flash, for PowerShot cameras that don't have a hot shoe. A slave flash doesn't have to be physically connected to the camera. A sensor built into the slave reacts to the flash fired by the PowerShot so the slave flash can fire when the PowerShot does. Check out Metz slave flashes at `www.metz.de`.

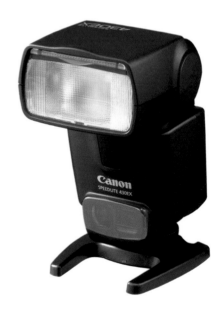

*Image courtesy of Canon.*

5.3 Canon's 430EX can attach to PowerShots that have a hot shoe.

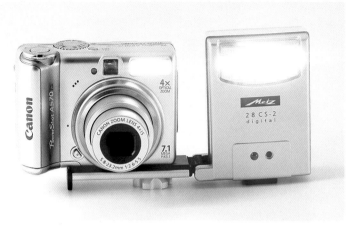

**5.4** This slave flash from Metz doesn't have to be mounted on the camera.

When mounted next to a PowerShot, a slave flash can double the output of the built-in flash. However, it can also be used at a distance from the camera, even across the room. This offers some creative lighting opportunities. By placing the slave flash to the side of the subject, you can achieve some great portrait light instead of the harsh "mug-shot" look common with on-camera flash.

## Lenses

Several PowerShots can accept accessory lenses. The Canon options for add-on lenses are a wide-angle converter lens, a telephoto converter lens, and on some models, a close-up converter lens.

**Note** *In order to attach any converter lens to a PowerShot, a lens adaptor is required.*

The telephoto converter lens allows you to zoom in farther than the normal PowerShot lens.

✦ **TC-DC58B.** This is for the S5 IS and zooms in 150%.

✦ **TC-DC58C.** This is for the G7 and is a 200% zoom.

✦ **TC-DC58N.** This 175% zoom is for the A630, A640, A700, and A710 IS.

✦ **TC-DC52A.** This 175% zoom is for the A570 IS and A540.

The wide angle converter produces a wider view of your scene. The wide angle converters include:

✦ **WC-DC58A.** This is for the S5 IS and provides a 75% wider view.

✦ **WC-DC58B.** This is for the G7 and gives a 75% wider view.

✦ **WC-DC58N.** This is for the A630, A640, A700, and A710 IS and it provides a 70% wider view.

✦ **WC-CD52.** This is for the A570 IS and A540 and it provides a 70% wider view

The Canon 500D close-up lens for the S5 IS, A710 IS, A700, and A570 IS lets you shoot at

closer distances than the normal Macro settings.

There are several options for non-Canon accessory lenses:

- ✦ **Tokina.** www.thkphoto.com
- ✦ **Raynox.** www.raynox.co.jp
- ✦ **Opteka.** www.opteka.com
- ✦ **Bugeye Digital.** www.bugeye digital.com offers accessory lenses for PowerShots that don't normally accept an accessory lens.

On some PowerShots, when an accessory lens is attached to the camera, you must let the camera know — through the Record menu — which converter lens has been attached. Once attached, you can only compose the image with the LCD. The optical viewfinder doesn't show the results of adding the accessory lens to the camera lens.

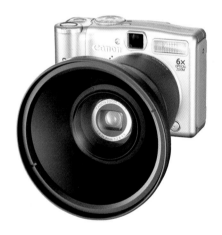

*Image courtesy of Canon.*
**5.5** This is an A700 with a wide-angle converter lens attached (WC-DC58N).

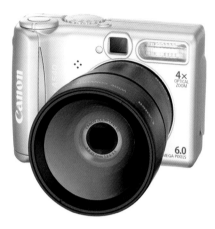

*Image courtesy of Canon.*
**5.6** This is an A540 with a telephoto converter lens attached (TC-DC52F).

# Underwater Gear

In the past, only the pros could take their cameras underwater. Huge underwater housings with complicated setups were the norm. Today there are easier ways to shoot underwater. Several PowerShot models can be used in waterproof cases (or housings). These housings give you access to the camera controls so that, even underwater, you can make adjustments to your exposure. There are a few companies that manufacture housings, including Canon.

The Canon cases provide protection for depths up to 130 feet. If you want to go deeper or want a more advanced underwater housing take a look at Ikelite housings at www.ikelite.com.

However, if you aren't going that far — perhaps you are only doing some snorkeling — there is another option. A cheaper and less bulky solution is an Aquapac waterproof camera case. Simply put your PowerShot

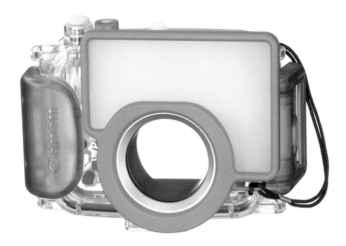

*Image courtesy of Canon.*
5.7 This is the Canon underwater housing for an SD850 IS (WP-DC15).

into the submersible bag, seal it up, and head for the water. The Aquapac case protects down to 15 feet. Find more on Aquapac products at www.aquapac.net.

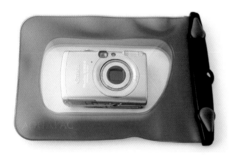

5.8 The Aquapac comes in several sizes to fit all PowerShots.

Underwater cases aren't just for diving or snorkeling. They can be a great way to protect your PowerShot while boating, at the beach, or even skiing. Think about a waterproof case whenever you take your camera into harsh weather.

# Batteries, Chargers, and AC Adaptors

Some PowerShot cameras take AA-sized batteries that you can buy just about anywhere. Other PowerShot models use a custom designed lithium-ion (Li-ion) battery. The Quick Tour reminded you to make sure your battery is charged and installed correctly, but it is important to understand how to take care of your batteries and how to select additional batteries.

If your camera uses AA batteries, you have the option of using one-time-use batteries or rechargeable batteries. Rechargeables save you money and time because you don't have to go out to buy new batteries when you run out of power. But there is a tradeoff: Rechargeable batteries don't give you the same longevity that high-performance non-rechargeable batteries do.

**Caution** *If you want to purchase rechargeable AA batteries, make sure you select Nickel Metal Hydride, or NiMH, batteries. You may come across an older technology called Nickel Cadmium, or NiCds (pronounced "nicads"). NiCd batteries have less capacity than NiMH batteries and are toxic to the environment. If you own NiCds, please make sure you recycle them properly.*

You have two options for rechargeable batteries: name-brand batteries that you can find in most stores and lesser-known batteries that you may find in specialty stores or on the Internet. The name-brand units work great, and if you have a couple sets you should be fine. If you do a little shopping you can find batteries that have a larger capacity. They will be more expensive, and may or may not come with a

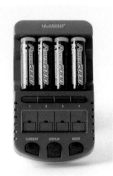

5.9 This high-performance battery charger includes an LCD readout for each battery.

charger. So if you want to get a few more shots per set of batteries, you'll need to do some work.

**Tip** *For best performance, keep batteries grouped in sets. When you buy a new set of rechargeable AAs, the first thing you should do is label them with a marker. I use a letter-number combination like C1, C2, C3, C4.*

You don't have many options when it comes to Li-ion batteries for PowerShots. You can either use the Canon brand batteries or a third party battery. I have used both without problems, but I tend to stay with the Canon batteries.

Here are some tips for getting good performance from your batteries:

✦ **Temperature.** Heat and cold are a battery's worst enemies. Keep your camera out of a hot car. When it is cold, keep an extra set of batteries in your pocket, close to your body heat. When you are shooting, you can exchange the warm batteries for the cold ones, and then put the cold batteries back in your warm pocket to revive them.

✦ **Charging.** Follow your camera's manual for instructions on how to charge Li-ion batteries. Pay particular attention to the maximum length of time you can leave the battery on the charger.

✦ **Chargers.** If you opt for rechargeable AA batteries, make sure you purchase a matching charger. Chargers you already have on hand might be made to charge a different type of battery and in a short time could destroy the capacity of your new battery cells.

✦ **Sets.** If you use multiple AA batteries, it is important that you use them — and replace them — as a set. Don't replace just one of the batteries. Uneven charges in a set of battery cells can quickly damage the good batteries. Treat non-rechargeable batteries as a set too.

✦ **Spares.** Having spare batteries can help keep you taking pictures day after day. If your camera takes AA batteries, I recommend that you have some high-performance Li-ion AA batteries tucked away as spares.

## Chargers

Always make sure that you match the battery with the proper charger. Although there are too many options to detail in this field guide, a good rule of thumb is to try to buy batteries with a matching charger.

 **Caution** *Using an improper charger can lead to battery damage, charger damage, fire and injury, or death. With the advent of higher performing batteries comes more risk. There is a lot of power stored in those little packages, so be careful.*

If you are determined to maximize battery performance, you can use third-party electronic chargers specifically designed for maintaining batteries. They are expensive and a little more complicated to use.

## AC adaptors

If you shoot video using the time-lapse feature, make long video recordings, or present a slide show, you may need an AC adaptor. Canon sells accessory AC adaptors specifically for PowerShots. Stick with the Canon-branded adaptor so you don't damage the camera.

## Cases

Although I consider some of the accessories covered in this chapter to be optional and others may be considered luxuries, a camera case is a necessity. A camera case keeps your PowerShot in good shape. You can browse cases for your PowerShot at www. lowepro.com or www.kata-bags.com.

✦ **Protect from scratches.** Look at that large LCD screen. It is critical to your ability to capture good images. If you don't protect it, a scratch or two will soon impair your ability to evaluate your images. I have seen scratches on camera LCDs that never saw the inside of a camera

**5.10** A couple camera case options for PowerShots.

## Card Readers

A card reader doesn't improve your photography, but it is an important accessory in your photography experience. A card reader that is always attached to your computer is a must.

I recommend that you pick a name-brand card reader. Look for one that has indicators that show when a memory card is accessed. The indicator lights are good reminders not to pull out the card when it is being read.

A good card reader is one that gives a tight fit when the memory card is inserted. If there is a lot of play when the reader is new, it will only get worse with the cycles of inserting and removing cards. What looks like a bad memory card that is unreadable might just be a card reader problem.

I am hard on card readers because I travel and each day have multiple card insertions. The cheapest card readers don't last very long.

case and a Function menu that was difficult to set because it was impossible to read the text through all the scratches.

✦ **Protect from dust.** The enemy of a camera lens is dust. Throwing your camera into your pocket without a case is a great way to attract dust or lint. Even though the camera lens may be behind a protective cap, the dust hangs around the front of the camera waiting to get into the lens.

**Tip** *Clean out your camera case on a regular basis. It doesn't take much time and is easy to do with the attachments on a vacuum cleaner.*

✦ **Protect from falls and drops.** A camera case can help protect the camera from accidental drops. Many PowerShots are fairly rugged cameras but a fall or careless drop onto a hard surface can cause significant damage. A well-built case provides a surprising amount of protection and still offers a small-sized package.

 **Caution** *Don't ignore the wrist strap or any case straps. Attach them as instructed. They can be a true safety line if you lose your grip on your camera.*

While it's nice to have the small size of a compact camera case, the case doesn't hold much. If you plan to travel with your PowerShot, consider getting a large case to carry extra batteries, a battery charger, and other accessories I mention in this chapter.

# Camera Care

A PowerShot is an amazing bundle of technology, but if you don't take care of it, image quality will begin to deteriorate. It doesn't take much time to clean your camera, but you have to do it right. Camera care accessories can help.

✦ **Microfiber cloth.** Microfiber cloth absorbs dirt and oils without leaving lint. Every camera care kit should have one. However, a cleaning cloth is only successful if

it is clean. Rubbing a dirty cloth on any surface can lead to serious scratches. Pay attention to the cleaning instructions that came with your cloth.

✦ **Lens brush.** This may be a simple soft camel's hair brush that you purchase at an art supply store, or it may be a specific retractable brush sold for photographic use. When you clean a lens, make sure you remove as many particles as possible from the glass surface before you use any other cleaning method. Some photographic lens brushes have a cleaning pad on the flip side of the brush that contains a special cleaning compound.

 **Caution** *Don't blow or breathe on your lens. The moisture vapor in your breath can cause particles to stick to the lens.*

**5.11** The bristles on this lens brush are retractable to keep them clean and in good shape. A cleaning pad is under the cap opposite the brush.

✦ **Lens cleaning fluid and tissue.** The last resort for stubborn spots on your lens or LCD is lens cleaning fluid and tissue. These are available at any camera store. Make sure that you *never* put the cleaning fluid on the lens; just put a drop or two on the tissue and then use the tissue to clean.

# Capturing Great Images

**Y**ou can master all your PowerShot's settings; you can grasp the fundamentals of composition. Now it is time to put both into practice in specific situations. This chapter provides a host of photographic challenges, with sample pictures and tips to get you started.

If there is one theme that runs through this chapter it is *practice*. Practice doesn't have to be a chore; it just means you should take lots of pictures. The pictures in this chapter didn't happen overnight; they came from my years of carrying a camera and viewing the world around me through a frame.

> **Note** This chapter provides tips that can be used with the entire PowerShot series. If you have a PowerShot that offers you greater manual control of shutter speed or aperture, experiment with them rather than using Scene modes.

## Abstract Photography

Abstract painters drive their viewers' emotions by showing them a different viewpoint of the world around them. A PowerShot camera offers you some of the same tools to create abstract images. You know you have succeeded when your viewer doesn't know what you shot, but still draws a message from the image. If a viewer asks, "What is it?" your best response is to ask the viewer what he or she thinks it is.

Abstract images can be full of unusual shapes, myriad colors, or blurred motion. They can be extreme close-ups of everyday objects or distant shots of clouds. Abstract photography requires you to *create* the image. Unlike many of the subjects in the chapter, you can create abstract photography just about anywhere and at any time.

6.1 The roof on an Italian villa makes for a soothing repetition.

## Inspiration

6.2 Tall grass on a winter morning creates a natural abstract.

Abstract images abound. Think in terms of shapes. They may be physical objects like wrought iron fences or flaking paint on an old barn door. Or they can be shadows on the pavement or in the woods. Stop and look at a scene, then find the object that first catches your eye. Imagine it in another location. Next, think in colors. Too often in the real world our eyes deal with subtle changes of color in a scene. Treat your viewer to an image awash in vibrant colors. The close-up of the tops of crayons or a bowl of marbles can bring the smile of childhood to your audience.

Close-ups are a popular abstract technique. Here's where the LCD can give you a good preview of your image. Look at the display to determine if you should remove the rest of the environment from your view. Camera movement, on purpose, can create images that are more like modern art paintings than photographs.

Photograph abstracts when you have few other photography options. If the light isn't good, if you can't get to the right place to take your shot, or if your lens just isn't long enough, then start thinking abstract.

# Abstract photography practice

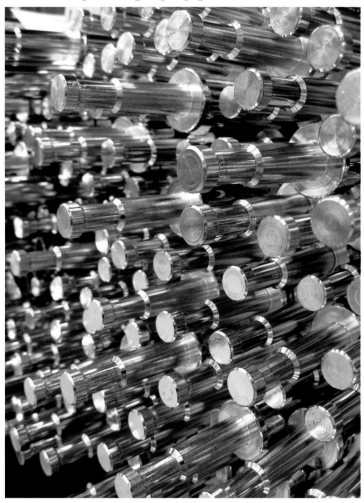

**6.3** These parts, ready to be assembled into lighting supports, become a study in depth.

## Table 6.1
## Taking Abstract Pictures

| Setup | **Practice Picture:** For the image in figure 6.3, I found these parts waiting for assembly. It was important to capture this at an angle, rather than straight on, because the individual pipes were at various depths. |
|---|---|
| | Many times you can take something ordinary and make it abstract by looking at it from a nontraditional perspective. |

*Continued*

## Table 6.1 *(continued)*

| | |
|---|---|
| | **On Your Own:** Start by using Macro mode and see how things look up close. Get in tight so you eliminate distracting objects. Use the LCD to help you remove the object from the rest of the scene. |
| **Lighting** | **Practice Picture:** The highly reflective tubes help bounce the light in the factory. This was near a loading dock, so I was able to wait a few minutes for a truck to pull out to let in additional daylight. |
| | **On Your Own:** Illumination depends on what you are trying to capture. If you are shooting in Macro, the flash may be too intense or it may be so high that the bottom of the image is underexposed. Use an accessory flash to create unusual shadows. Tint your flash with colored pieces of plastic — colorful candy wrappers work well. If you are setting up your own abstract scene, you can use ordinary household table lamps to light your composition. |
| **Lens** | **Practice Picture:** I used Auto Focus Lock (AFL). I shot this photograph at medium telephoto. |
| | **On Your Own:** If you use Macro, make sure you zoom all the way out. You'll never focus close enough if the lens is zoomed in. Move the camera close to the image and press the Shutter release button halfway to see if the camera can focus. If not, move back; if it *can* focus, move closer to see how much you can fill the frame. |
| **Camera Settings** | **Practice Picture:** Manual mode. Because of the mix of light, I used Auto White Balance. |
| | **On Your Own:** Set on Macro for close-ups. If you are shooting on a tripod, consider using the Self-Timer to avoid jarring the camera and blurring your shot. In order to enhance colors, set My Colors to Vivid. Set White Balance to match your illumination. Auto White Balance can be thrown off by a scene comprised entirely of highly saturated colored objects. |
| **Exposure** | **Practice Picture:** Evaluative Metering, ISO 80, Exposure compensation +1. It took three shots to get this; the first two were underexposed, due to reflections. |
| | **On Your Own:** Pay attention to your histogram to control exposure. Set metering to Spot in order to evaluate more closely the light level in your scene. Focus on the bright part of the scene and use Auto Exposure lock (AEL). |
| **Accessories** | Depending on the exposure, a tripod may be necessary. For some extreme close-ups, it might be useful to have a white card or paper to reflect light into your abstract scene. An accessory flash might be useful too. |

## Abstract photography tips

✦ **Get close.** Abstract scenes may not be obvious. Use your camera's Macro setting to capture small parts of objects. Fill the frame with small details. If you shoot a birthday, how about an extreme close-up of the swirls of frosting?

✦ **Use color.** Move the feeling of your image into the surreal by experimenting with the wrong white balance—just remember to set it back. While shapes are the subject of many abstract images, pay attention to contrasting colors.

✦ **Break the rules.** The Rule of Thirds might not apply when you start looking at the world through "abstract" eyes. Consider rotating the camera so you are looking at an object from a different perspective.

✦ **Create your own scene.** Don't just wait for abstracts to appear. Create you own with objects close at hand. Use a desk lamp to add light and a piece of white paper to reflect light into the shadows.

# Action and Sports Photography

Action is all around you, not only in sports but also on the street, in an amusement park, or in your own backyard. Sometimes a single image can better capture the feeling of action than a five-minute video. By selectively choosing the *right* moment, that single frame ceases to be still.

There are two methods of capturing action. The first is a technique frequently used in sports photography. The action is frozen in time and the image is crisp. The profes-

**6.4** A little panning with the motion together with a fast shutter speed freezes parts of the action.

sional sports photographer uses this method to lock in on the action and capture the effort the athlete puts into her event.

The second is a technique where you try to capture a little bit of the motion. By using a slower shutter speed, the camera's eye is open longer and the moving objects begin to blur. The overall effect is quite different than freezing the action. When you shoot a sporting event, the focus moves from the individual athlete to the event itself.

Sometimes you can combine both methods by *panning* the camera, which means moving the camera, together with the moving object. Doing this and using a slow shutter speed freezes the action but blurs the background. This helps to isolate the object in the scene.

## Inspiration

Action photography really tests your knowledge of when to press the Shutter release button. Because digital cameras have an inherent shutter lag, it is critical to be fast, but smooth, on the trigger. The luxury of reviewing your images immediately and deleting the bad ones means you can always capture the great shots.

With sports photography, it is important to know a bit about the event you are shooting. You must be ready with your camera pointing in the right direction, so knowing the flow of the event is critical.

**6.5** Bright sunlight helps to increase the shutter speed to stop the subject in mid jump. Using the flash helps to fill in some of the shadows.

 **Caution** *Action photography can take place in dangerous environments. Always be aware of where you are and where the action is heading. Don't be so focused on capturing the football play from the sidelines that you get run over by a player or end up interfering with the game.*

## Action and sports photography practice

6.6 Background advertising signs disappear into streaks when panning.

| Table 6.2 |
| :-: |
| **Taking Action and Sports Pictures** |

| Setup | **Practice Picture:** For figure 6.6, I wanted to capture both the speed and the colors of a nighttime horserace. The lighting wasn't strong enough to freeze the action, so I panned with the horses. Luckily there were a lot of races, so I was able to practice many times. During the first race, I only captured the tip of the horse's nose throughout the whole pan. By the fourth race, I was able to keep the horse centered for at least two frames. |
| :-- | :-- |
| | **On Your Own:** Scout the location for the best viewpoint. Remember that your lens might not have as great a range as a professional's so your location may have to be at a less typical viewpoint. While some photographers might be at the 50-yard line, you may be better off on the goal line. Get up high if it is important to see where the action is in relation to the field of play. |

*Continued*

## Table 6.2 *(continued)*

| | |
|---|---|
| **Lighting** | **Practice Picture:** I was too far away for flash, so I used the track's lighting. They turn on a special light at the finish line that would only have partially illuminated the path, so I moved to a location well before the finish line. |
| | **On Your Own:** For outdoor action, shoot with the sun to your back or to your side. Pay attention to backgrounds that may fool your camera's meter into underexposing your image. If you are close enough, experiment with flash to fill in harsh shadows. Indoor action can be troublesome. Make sure your flash doesn't interfere with the event. Be aware of the effective distance of your flash; if it is not going to be useful, turn it off. |
| **Lens** | **Practice Picture:** I was zoomed in all the way to capture just one horse. I used Auto Focus Lock (AFL) to lock focus on the rail because I didn't want a delay while waiting for the camera to focus. |
| | **On Your Own:** You will most likely be at the far end of your zoom. Quick wide-angle shots might be needed to establish the event. |
| **Camera Settings** | **Practice Picture:** Manual mode. The track's lights were the only illumination, so I set my white balance for them. I knew I would pan with the horse to blur the background, so I set the camera for Continuous shooting. I was able to get three shots before the horse was out of range. |
| | **On Your Own:** White balance is dependent on the location. If shooting indoors and not using flash, set a custom white balance if your camera supports it. Avoid using Automatic White Balance, as this increases the shutter lag. Set the camera on Sports to freeze the action. Set the Drive mode to Continuous to capture several frames at a time. |
| **Exposure** | **Practice Picture:** Spot Metering, ISO 800, AEL. The first still had some sun that overexposed the sky and was very distracting. By the time I had the panning matched to the horse's speed (race 4), the sun had gone down and the track's lighting was the only illumination. I increased the ISO, which increased the noise. Fortunately the blur helps hide some of it and the rest fits the shot. Because of the bright signage, I had to lock exposure while framing some of the dirt and the signs. Once the exposure was locked all I had to worry about was the panning. |
| | **On Your Own:** If your camera supports manually setting the shutter speed, set it to a high speed that still gives you a good histogram. If you can't adjust shutter speed directly, switch to a higher ISO to boost shutter speed. Use Auto Exposure lock (AEL) to reduce shutter lag or pre-focus and pre-meter by pressing the Shutter release button halfway and waiting until the action takes place. |
| **Accessories** | Depending on the exposure, a tripod may be necessary. |

## Action and sports photography tips

✦ **Don't forget the details.** Try using wide angle to catch spectators watching the event. Shoot the lonesome images too, like the football dropped on the ground or a baseball bat lying in the on-deck circle.

✦ **Lock your settings.** The delay between pressing the shutter release and capturing the image is caused in part by the camera's setting exposure, white balance, and focus. Minimize this delay by avoiding Auto white balance and by locking focus and exposure.

> **Cross-Reference** *See Chapter 3 for instructions on setting focus and Auto Exposure lock.*

✦ **Lead the action.** Get your camera moving to follow the action. Just as a quarterback leads a receiver when he passes the ball, keep your camera a bit ahead of the action and let the action come into your framing.

✦ **Practice.** There are a lot of opportunities to shoot action. Consult your local newspaper to find out where local grade school and high school athletic teams compete. These are great opportunities to test out different locations when you shoot an event. These are also good times to practice your panning technique.

✦ **Pan with the action.** Take your camera out of Sports mode and try panning with the action. Practice panning while taking pictures of cars on a busy street. Follow your subject and try to keep it a little ahead of the center of the frame. This can be a difficult technique to master, but given you can erase images from your memory card, practice is free!

✦ **Cut down on the angle.** Avoid situations where the action moves horizontally across your field of view. For example, if you shoot a runner going to first base from the home plate, stand beyond first base – toward right field. Not only does the runner appear to run to the camera, but you also have more time to capture the subject.

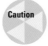

> **Caution** *Flash photography at sporting events can be distracting and even dangerous for athletes. If in doubt, ask an official, scorekeeper, or one of the coaches.*

# Animal and Wildlife Photography

Photographing animals can be a challenging experience, but also a rewarding one. The animals can be as common as a cow on a farm or as exotic as an emu at a zoo. Zoos provide an abundance of exotic animals to photograph and give you a good opportunity to practice. Today, as never before, zoos showcase their collections in settings that resemble the animals' habitats.

Patience is a necessity when photographing wildlife. When at a zoo, wait until the animals are close enough for your composition. What are the animals' feeding times? Feeding times can produce a lot of action to capture.

6.7 Knowing where and when to look helped me capture this marmot sunning herself on the warm rocks.

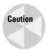

**Caution** *Wildlife can be dangerous. Do not put yourself in harmful situations just to get the shot. You've seen examples of unwary amateur photographers getting too close to a moose or a bear. Sometimes this is a fatal mistake. If your lens can't zoom in enough, just enjoy the sight and capture it in your memory.*

## Inspiration

Although the zoo is a good place to practice, your wildlife shots look more natural when the animals are in their own habitats. Although it would be great to head to the Serengeti, you may be surprised what you can find in your own neighborhood. Safari or not, you still need the patience to track down the sometimes-elusive animals.

6.8 Adding a little out of focus foreground element gives some depth to this shot.

Check out birdfeeders, parks, and lakes. Pay attention to the seasons. Spring, for example, is a good time to photograph hatchlings as they stretch their wings. If you still have difficulty finding wildlife, visit a farm to capture cows in a pasture. Visit a state or federal park and check with the visitor center for good places to see wildlife.

Wildlife shots aren't limited to large animals. Look down and around for insects, frogs, or other small critters. This can be an opportunity for using your PowerShot's Macro capabilities.

## Animal and wildlife photography practice

6.9 Keeping safe was the watchword. I shot this from an open car window.

### Table 6.3
### Taking Animal and Wildlife Pictures

| Setup | **Practice Picture:** I shot figure 6.9 just a little after sunrise. These guys can be hard to find in the murky water. Patience to scan the water helped. |
|---|---|
| | **On Your Own:** Early morning and late afternoon are good times to catch wildlife in action. These are also great times for light. At zoos, the crowds might be smaller. Take time to watch the animals to see how they act and react. |

*Continued*

## Table 6.3 (continued)

| | |
|---|---|
| **Lighting** | **Practice Picture:** I really like the golden reflections in the water that offset the blueness of the shadow area. At any other time of day this shot would not have been as dramatic.<br><br>**On Your Own:** A flash won't be of much use unless you are very close. Avoid shooting in the middle of the day, when the light is harsh and detail-producing shadows disappear. |
| **Lens** | **Practice Picture:** I had to zoom in to get this shot. Zooming in also forced the background reflections to go out of focus.<br><br>**On Your Own:** To bring the animals closer, zoom in. Remember for macro shots of insects to put your lens on wide angle to focus close. Use Auto Focus lock (AFL) if the camera has difficulties focusing on the animal in your scene. |
| **Camera Settings** | **Practice Picture:** Manual mode. I chose a Daylight White Balance to keep the coolness of the shadows.<br><br>**On Your Own:** If possible, use a preset white balance setting rather than Auto White Balance. Set your camera for continuous shots if you're shooting animals in action. Try setting My Colors to Vivid to enhance the scene. |
| **Exposure** | **Practice Picture:** Evaluative Metering, ISO 200, Exposure compensation -1/3. I had to boost the ISO a bit because I was shooting so close to sunrise. Luckily I didn't have to worry about movement.<br><br>**On Your Own:** When shooting animals in motion, set the scene mode to Sports in order to engage a faster shutter speed. If you still can't freeze the motion, increase the ISO setting. |
| **Accessories** | A tripod allows you more flexibility when shooting—you can use slow shutter speeds when the light is low. If you're not using a tripod, consider a small monopod to give you stability. |

# Animal and wildlife photography tips

✦ **Think low.** Most of the wildlife you shoot is probably smaller than you are. Consider getting down on your knees to get the shot. If you can't get down low enough, try shooting blind. Put the camera in Continuous mode, hold the camera low, and start shooting. After a few shots, replay the images and check your framing, exposure, and focus. Delete the bad ones and do it again.

✦ **Patience and timing.** Animals are unpredictable, so you may have to wait for that one shot. You may have to wake up early to capture a bird feeding during the stillness of the morning, or wait until twilight to photograph animals that wait until evening to come out of hiding.

✦ **Include nature in the environment.** When shooting around your neighborhood, where backgrounds may be more man-made than natural, try shooting from a different perspective to include some nature in your photograph.

✦ **Move slowly and be quiet.** If you are photographing in the wild, slow movements help to avoid scaring the animals. Even when you are making adjustments to your camera, force yourself to act as if you are in slow motion. Turn off all the sounds on your camera, too.

# Architectural Photography

Photographing buildings is a great way to understand how shape guides our man-made environment. When you travel, you can learn a great deal about the history of an area by capturing its architecture, both new and old. When you stop to photograph an old castle, you have the opportunity to see the building as a whole, as well as to examine the small details that are essential to its character.

Architectural photography can be exteriors or interiors, complete vistas of a neighborhood, or geometric studies in shapes, reflections, and shadows. Nighttime shots can give a dramatic look to buildings, emphasizing shapes that might not be apparent during the day.

The doorknocker in figure 6.10 was down a narrow street in Italy. The light wasn't great for shooting other parts of the street so I concentrated on details. This is an example of how many of the categories in this chapter overlap, so consider investigating all of the techniques in this chapter.

**6.10** When the light isn't great to shoot full buildings, pay attention to details like doorknockers.

## Inspiration

Before picking up your camera and shooting, walk around the architecture to see what interests you. How much of the existing environment is important to your composition?

For practice, pick a building near where you live and visit it during different times of the day. Look at how the shadows land in the morning and afternoon. Do the windows reflect more at a particular time of the day? Consider taking photos throughout the day or even throughout the seasons and then create a photomontage of your images. Your images can even focus on a unique characteristic of the building, such as the stained glass windows in a church, rather than the whole building itself.

It is in the details that an architect adds to a building's character. Pay attention to little things like handles, doorknockers, gutter spouts, and carvings. In some situations they may be the least photographed, but most interesting, features.

**Caution** *Some buildings may be on private property. Be sure you are on public property unless you ask for permission first.*

6.11 This museum offers many opportunities to capture disorienting angles.

# Architectural photography practice

**6.12** These support structures seem to go on forever. Composition rules are made to be broken; sometimes centering the scene works.

## Table 6.4
## Taking Architectural Pictures

| | |
|---|---|
| **Setup** | **Practice Picture:** For figure 6.12, I visited a Milwaukee museum that is full of interesting shapes. Unfortunately it was a very gray day so the exterior shots weren't working. I stepped inside and found dozens of repeating shapes throughout the building. The challenge was to wait for people to leave the area so that I could get the shot. |
| | **On Your Own:** Look at the surrounding area to find a good viewpoint. If possible, don't shoot up or down. Find a location that puts you midway in the building's height. |

*Continued*

## Table 6.4 *(continued)*

| Lighting | **Practice Picture:** While the light wasn't great for exterior shots, it worked well for the interior ones. The light was even and consistent so that getting the right exposure was easy. |
| --- | --- |
| | **On Your Own:** If you are shooting glass structures, take advantage of interesting clouds reflected in the glass. If shadows conflict with architectural details, wait for cloud cover or shoot on an overcast day. You can also use shadows to your advantage. When you shoot late in the day, you can add detail to your composition. |
| Lens | **Practice Picture:** I zoomed in just a bit to eliminate some nearby light fixtures. |
| | **On Your Own:** Use wide angle for large compositions and zoom in if necessary to keep distracting elements from your frame. Zoom in to capture the details. Some details might require you to use Macro. Unless capturing details, set the camera to Infinity focus mode if you are shooting the building from a distance. Infinitiy focus mode essentially tells the PowerShot to ignore objects in your scene that are close when it is trying to set focus. If shooting a panorama shot, avoid extreme wide-angle as it is hard to stitch together. |
| Camera Settings | **Practice Picture:** Manual mode. Because the color of the structure was a muted white throughout, I set a Custom white balance by shooting one of the walls. |
| | **On Your Own:** While Auto White Balance works most times, use Daylight White Balance for midday shots and Cloudy for morning and afternoon. |
| Exposure | **Practice Picture:** Evaluative Metering, ISO 100, Exposure compensation +2/3. There were so many bright walls I used Exposure compensation to increase the exposure a bit, adding more brightness to the scenes. |
| | **On Your Own:** Pay attention to the histogram to avoid overexposures. Use Exposure lock to control your exposure. Set Exposure compensation if you consistently underexpose or overexpose the scene. If shooting at night and using a tripod, use Fireworks Scene mode to lengthen your shutter speed. |
| Accessories | Depending on the exposure, a tripod may be necessary. If your PowerShot accepts filters, attach a polarizing filter to your camera to cut down on glare and reflections. If your camera doesn't accept filters, you can hold a polarizer in front of the lens while you take the picture. |

# Architectural photography tips

✦ **Keep it level.** Pay attention to how straight your composition is. Because architecture can contain lots of straight lines (both horizontal and vertical), even if your image is just slightly tilted, it is magnified.

✦ **Capture the shapes.** Sometimes you won't be able to find a location from which to capture the entire building. Don't give up. Try creating compositions that are filled with shapes that are the essence of the building.

6.13 Don't overlook the small details; this carving was about the size of a hand.

✦ **Go inside.** Don't forget the interior. That's where you can find more details. If you have access to go inside, bring a tripod and start looking for wonderful details that passersby often miss. Look up to see what the ceiling provides. If you can't use a tripod, set your camera for Self-Timer and place it on a table, chair, or even the floor, and then step away. I have captured many ceilings in this way.

✦ **Avoid severe angles.** If you are at the base of the building shooting up, the composition may be weak. Try to find higher ground.

# Child Photography

Watching children grow up through photographs can be a priceless treasure. Capturing that moment in time when they are simply enjoying life without a care creates an image that is timeless. Lasting family histories are more often captured in still photographs than any other media.

Take advantage of the PowerShot's size to keep your camera with you so that it is always available when that perfect moment arrives. Also, by practicing you will be able to choose the right settings quickly, and avoid missing a tender moment.

6.14 The distraction of a book keeps these girls from posing for the camera.

## Inspiration

Let the children be themselves. Don't try to force something that isn't going to happen. While patience may be the key in other types of photography, taking lots of pictures is the key when photographing children. Remember that a child's life is filled with many emotions. Capture images that represent the whole spectrum.

However, the camera can be a barrier to communicating with a child. Practice using the camera when it isn't held up to your eye. This way the child can look at your eyes and start to ignore the camera. Avoid the constant patter of "smile" and "what do you have there." Get involved with the activity to get the most natural, candid shots as they occur.

**6.15** A simple conversation about how big toes are led to a game of "hide and feet."

# Child photography practice

**6.16** It took multiple shots to get away from a posed look that was all teeth and no charm.

## Table 6.5
## Taking Child Pictures

| | |
|---|---|
| **Setup** | **Practice Picture:** In figure 6.16, my challenge was to avoid the smile-for-the-camera look that seems to be ingrained in most children's brains. The trick was to continue talking to my subject while I took pictures. I quickly turned the LCD off so she wouldn't ask to see the picture. |
| | **On Your Own:** Shooting outdoors where there is more light can help produce more candid shots. Know your camera settings so you don't play with adjustments while the great scenes occur. |
| **Lighting** | **Practice Picture:** Daylight coming in through a window provided the light. The day was overcast so the lighting was very even, without harsh shadows. If it had been sunny I might have closed a sheer drape to reduce the harshness. |
| | **On Your Own:** Indoors, flash can be distracting so try to use available light. If you use flash, consider adding an accessory flash to avoid the harsh shadows. Outdoors, avoid bright light that causes everyone to squint. Turn on flash to fill in harsh shadows. |
| **Lens** | **Practice Picture:** I wanted to be far enough away so my subject could still play with her pen, but I needed to be close enough that I could continue to talk to her. |
| | **On Your Own:** Shoot from a distance and zoom in to fill the frame. Try wide angle and get in close. One technique is to put the camera down on a book or the seat of a chair and use the Self-Timer so you become the focus of the child's attention, not the camera. Get used to locking the focus via Auto Focus lock (AFL) if the child's activity is causing the camera to focus improperly. |
| **Camera Settings** | **Practice Picture:** Manual Mode. Because it was an overcast day, I used a Cloudy White Balance. I used Continuous shooting and muted the camera sounds so she didn't know when I was taking the picture. |
| | **On Your Own:** Turn off camera sounds so your shooting is silent. Turn on Continuous shooting so you don't miss that special moment. Set a preset white balance rather than using Auto White Balance. By locking focus and using a preset white balance, you reduce shutter delay. |
| **Exposure** | **Practice Picture:** Evaluative Metering, ISO 100, Exposure compensation +1/3. I took a few shots without reviewing them, then left the room to check the histogram. It was underexposing, so I increased the Exposure compensation by one-third and started shooting. |
| | **On Your Own:** When outdoors, lock exposure on the child's face. Use Hi ISO when indoor to avoid using flash. Experiment with Portrait and Kids & Pets Scene modes. Portrait helps to de-emphasize the background, while Kids & Pets helps to freeze action. |
| **Accessories** | An accessory flash is useful to reduce harsh shadows. |

## Child photography tips

✦ **Turn off the LCD.** Have you noticed how taking pictures has changed with digital? What happens after you take the picture? The kids coming running to see the image on the back of the camera. Although reviewing images right after you press the Shutter release button is great when evaluating whether you got the shot, it can ruin an otherwise delightful moment of kids at play.

✦ **Avoid flash.** Although there are times that you can't avoid using flash, child photography is all about the moment and trying not to interrupt it.

✦ **Shoot from a distance.** Try to be inconspicuous. Try shooting from around a corner or behind a plant.

If kids start paying more attention to you than to what they were doing, it is time to put away the camera.

✦ **Be at the right level.** People connect with photographs more easily if they are not looking down on the subject. Get down to the child's level. Even if they are distracted by the camera, looking into the lens on their level can turn an otherwise boring image into a cute portrait.

✦ **Be ready.** Have the camera set properly long before you start shooting. Before an event like a birthday, take some practice shots so you know what white balance and Scene mode to use. Start with an empty memory card so you have plenty of room.

# Fireworks Photography

Community celebrations can bring out fireworks displays in all shapes and sizes. Painting the sky with fire, these visual concerts offer a unique opportunity for the photographer: an all-black canvas that is infused with all the colors of the rainbow.

Digital has been a great boon to fireworks photographers. Instant review to check exposure and focus leads to great shots. Timing is critical. Listen to the explosion of the charges that lift the shells and watch the light trails. Use these audio and visual cues to trigger when to press the Shutter release button. It may take several tries to get it right and even then the shells might go higher or lower than the previous ones!

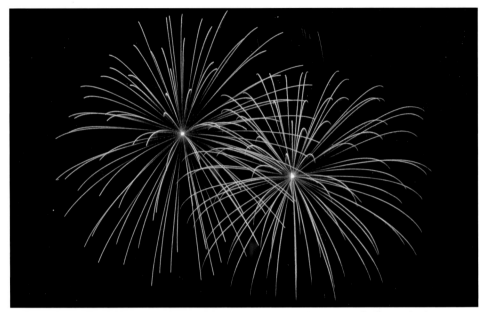

**6.17** Capturing fireworks is a little bit of luck. Framing for these two shells worked out great.

## Inspiration

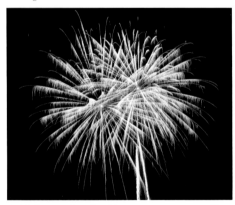

**6.18** Increasing the Exposure compensation makes for longer trails. Note that some shells are much brighter than others, so check your histogram and try to find a happy medium.

Your shot may be a single starburst or a compilation of several. It just depends on what part of the display you are shooting. Early on you'll see single starbursts that can fill the frame. During the finale there is so much up in the air it can be difficult to know when to shoot.

Your shooting location determines the approach you want to take: In the viewing stands like everyone else, your images are of just the display across a dark sky; however, at a distance you have the opportunity to capture buildings lit up by the exploding shells.

Caution    *When shooting any fireworks display, concentrate on your safety above all because fireworks are really just controlled explosions.*

# Fireworks photography practice

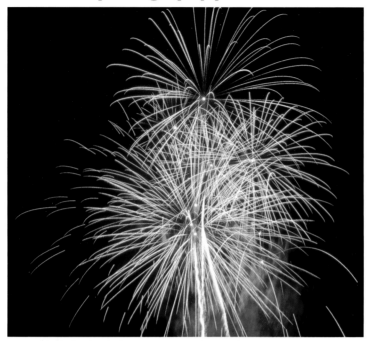

**6.19** When the finale began, I zoomed out a bit to capture its raw power.

| Table 6.6 Taking Fireworks Pictures | |
|---|---|
| Setup | **Practice Picture:** For figure 6.19, I arrived at the location early and was able to talk to a few people about where the fireworks would be set off. I checked the wind, picked my spot, and set up my tripod. I didn't extend the legs too far because I would be sitting on the ground and I wanted to be able to operate the camera in a comfortable position. I checked my framing after the first few shells and made a slight adjustment; then I started shooting. |
| | **On Your Own:** When you start looking for a spot, consider the background. If streetlights or some other illumination might be in your shot, look for another angle. Also look for tree branches or power lines that might ruin your shot. And, you don't want to be right in front of an aisle where people might walk in front of your shot. Think about all this when setting up, because it is difficult — if not impossible — to move once the show starts. |

*Continued*

## Table 6.6 *(continued)*

| | |
|---|---|
| **Lighting** | **Practice Picture:** The pyrotechnics take care of all the lighting you need. |
| | **On Your Own:** Make sure you avoid any local lighting in your shot. |
| **Lens** | **Practice Picture:** I zoomed in a bit, which meant that the percentage of bursts I was able to capture in my framing was low. |
| | **On Your Own:** Wide angle is the most forgiving when shooting fireworks. If you want to fill the frame, zoom in a bit. Zoom in all the way to capture abstract shots. Some luck is involved to get the explosions in the frame. |
| **Camera Settings** | **Practice Picture:** Fireworks mode. I started shooting as soon as I heard the first shell. I quickly reviewed the shots to see how sharp they were. |
| | **On Your Own:** With most PowerShots, Fireworks mode locks in Auto White Balance and Focus. If you have difficulty keeping a steady finger on the Shutter release button, use the Self-Timer. Set the Self-Timer to Custom Timer and then set the duration to the time between when you hear the shell launched and when it explodes. Set the number of shots to 3. |
| **Exposure** | **Practice Picture:** Fireworks mode automatically sets ISO and metering. I used Exposure compensation +1/3 to increase the shutterspeed. |
| | **On Your Own:** Use Fireworks mode to lengthen the exposure beyond one second. Adjust Exposure compensation to shorten or lengthen the exposure to capture more bursts. Consider shortening the length during the finale, as the number of shells in the air tends to overexpose the image. If your camera can set a slower shutter speed, then give that a try. |
| **Accessories** | A well set-up tripod is a must. It might be useful to have a small flashlight as well, not to illuminate the scene but to help you see your camera's controls. |

# Fireworks photography tips

✦ **Practice.** Depending on the holiday, fireworks displays may be scheduled on more than one evening. Check the newspapers and go to several displays.

✦ **Start with an empty memory card.** If you think about what you are trying to do, it can sound a bit daunting. You are composing an image in the dark, without knowing where your subject will be, without knowing what light level you will have to deal with, and without having anything on which to focus. A large empty memory card is a must.

✦ **Stay put.** Resist the temptation to keep resetting your framing. Recognize the shells aren't all aimed in the same direction and that you will definitely miss a lot of explosions. Widen out your lens if you are zoomed in and reframe after the first couple of bursts, but don't reframe wildly during the show. Things happen quickly and you could soon become frustrated. When the show is over, evaluate what did or did not work and make notes for next time.

✦ **Consider the wind.** A lot of smoke is produced during a fireworks display. If you are downwind, you might have a difficult time during parts of the show. If you are upwind, the smoke will drift out of your view and you could have good contrast for the display. If you are at right angles to the wind, the smoke will drift out even faster.

✦ **Set up early.** Once you've found your spot, set up your tripod right away. I've found it helps to prevent people from blocking your shot with portable chairs and so on. You don't have to extend the tripod much — just so you are able to operate the camera comfortably and review some of your shots.

# Flower Photography

Flowers are beautiful in their own right. They don't need makeup or wardrobe. You don't have to wait for them to do something funny or cute. They are more patient than you are. In short, flowers are excellent subjects. The colors and shapes can span from traditional to modern art.

Look for opportunities to photograph in public gardens or in your own backyard. If you go the public route, call ahead to find out what is in bloom. When you arrive, stop in the visitor center to map out flower locations. Don't ignore the wildflowers or even weeds. Remember that weeds are just a plant or flower that someone doesn't want. Even though dandelions and thistles are bothersome to most, you can take beautiful pictures of both.

6.20 Against a bright but overcast sky I used flash to give an interesting look to this early flower. I used a layer of handkerchief over the flash to soften its light.

## Inspiration

If there are no blooms outside in winter months, stop at a local florist and purchase a few to take home to photograph. Make the blooms last longer by printing out your flower pictures or creating custom greeting cards that say more to the recipient than any store-bought version.

Use Macro mode to capture a single bloom. With patience, you may be able to capture a bee getting that last bit of pollen in a shrub rose, or a butterfly sunning itself on a daisy. Don't ignore foliage to offset the saturated colors of some blooms.

6.21 Shooting down on this flower highlights the strong colors.

# Flower photography practice

**6.22** The background adds much needed color to this composition.

## Table 6.7
## Taking Flower Pictures

| | |
|---|---|
| **Setup** | **Practice Picture:** I had not planned to shoot the flowers in figure 6.22 on this day, but I ended up in a public garden in Germany. There were multiple rows of flowers that made for a nice background. The challenge was waiting for the wind to die down because the lighting didn't give me a shutter speed that could freeze the flowers blowing in the wind. |
| | **On Your Own:** Shoot early in the day, when plants haven't been beaten down by the sun. First find the right flower, and then spend time picking the background. Try blocking the wind with your body to minimize flower movement. Get down low to avoid casting a shadow. One of the most difficult aspects of this type of shooting is reviewing your pictures on the LCD in bright daylight. |
| **Lighting** | **Practice Picture:** This was shot later in the day so the sun wasn't too harsh. |
| | **On Your Own:** Most of the time you won't need additional light, but a bounce card which can simply be a small white card might be useful to add light if needed. Experiment with flash on a bright sunny day. |

*Continued*

## Table 6.7 *(continued)*

| | |
|---|---|
| Lens | **Practice Picture:** I was able to get relatively close to the main flowers and then zoomed in. This caused the background flowers to go out of focus. You may need to use Auto Focus lock (AFL) before you set your composition. |
| | **On Your Own:** Pay attention to composition when photographing flowers. You will be on the telephoto end of your lens for many shots (except when using Macro mode), but don't ignore opportunities to take wide-angle shots of fields of flowers. |
| Camera Settings | **Practice Picture:** I used Portrait mode to ensure the background was soft. |
| | **On Your Own:** When shooting in the wind, use Continuous shooting mode. If shooting in Manual mode, set My Colors to Vivid to make the flower colors pop. Use Foliage mode if there are a lot of greens in your shot. If you capture a single blossom, try Portrait mode. |
| Exposure | **Practice Picture:** I used Auto Exposure lock (AEL) on the white flower, and then recomposed the shot. I did not use flash. |
| | **On Your Own:** White flowers can easily be overexposed, so pay attention to your histogram. Practice with AEL to create a good exposure. Try using a flash when shadows are severe. |
| Accessories | A tripod is useful for some shots. Consider bringing a small white card to bounce light into the flowers when shadows are harsh. The card can also be used to block the wind so the images aren't blurred. |

## Flower photography tips

✦ **Look for the right flower.** If you are photographing close-ups, take some time to find flowers that are in good shape. Some blooms last only one day and the constant bombardment of sunlight can take its toll. Try shooting early in the day, when the flowers have just opened.

✦ **Watch the background.** Try to use other flowers or foliage for the background or to help frame the edges of your composition.

✦ **Lighting matters.** When you shoot without flash, a beautiful flower may appear dull. Experiment with flash to illuminate a flower against a bright sky.

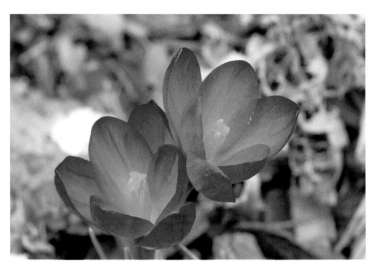

**6.23** Getting down close makes these crocuses bring color to an otherwise dreary winter day.

 **Cross-Reference** *Refer to Chapter 3 to learn how to control the strength of your flash.*

✦ **Change your perspective.** Look for unusual viewpoints. Get down on your knees or even your stomach to capture flowers from their level.

# Landscape and Nature Photography

Here is an opportunity to test several of the skills you learn in this chapter. Shooting nature and landscapes can use your animal and wildlife, flower, macro, sunset and sunrise, and winter photography talents. It is also a chance to immerse yourself in the subject matter.

Despite what you might imagine, nature photography isn't confined to Yosemite or Yellowstone. It is all around you and closer than you think. You might have to drive a bit but the journey is well worth it, not only in potential scenes to photograph but also in the opportunity to be surrounded by nature.

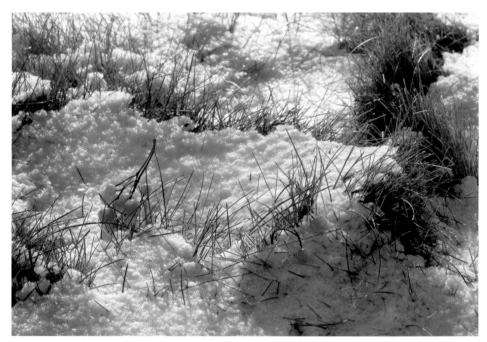

6.24 The red berries are striking against the bright snow. Using Snow Scene mode came in handy.

## Inspiration

Look for nature photography to capture a mood — the cold barren windswept landscape of a winter prairie. Or it might capture a time — the misty sunrise of a marshy bird sanctuary. Images might even evoke a sound — the gentle rustle of fall leaves.

Choose an interesting location and shoot at the first spot that presents itself to you. Now try to find five other viewpoints that show a different perspective, that present a different idea. Try to think of new ways to look at the scene. Are there close-ups that show new seedlings in the floor of a forest or spider webs dripping with dew?

 Caution    *Be safe. Always look where you are walking. Watch out for weather changes and don't head into unfamiliar territory.*

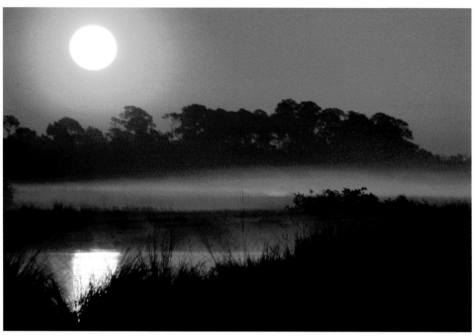

6.25 This Florida marsh was enhanced by the early morning fog.

## Landscape and nature photography practice

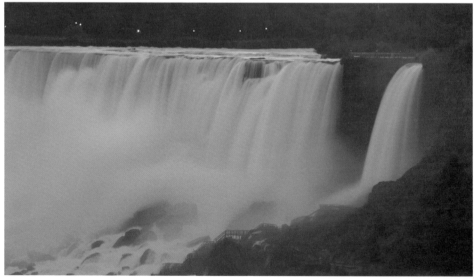

6.26 It pays to get up early. I was the only one at the falls when I took this picture.

## Table 6.8
## Taking Landscape and Nature Pictures

| Setup | **Practice Picture:** The Niagara Falls region is beautiful as you can see in figure 6.26. The trick is to get there before the crowds arrive and while the lighting is good. Because I arrived early in the morning when there was very little light, the only way to get this shot was with a tripod. I had to be careful that the mist didn't get on the camera lens. |
|---|---|
| | **On Your Own:** Be flexible with your choice of location. Give yourself the chance to shoot from many different directions. Use foreground objects to give your composition a sense of depth. Pay attention to the Rule of Thirds and avoid the common mistake of placing the horizon line right in the middle of your frame. Don't forget vertical shots to emphasize tall trees or interesting cliffs. |
| Lighting | **Practice Picture:** There was very little light when I took this shot. |
| | **On Your Own:** Take control of the light by choosing when to shoot. Get up early to get that early sunrise picture. Stay late to capture the golden light of sunset. |
| Lens | **Practice Picture:** I was a fair distance away, so the lens is almost completely zoomed in. Because it was so dark, the camera had difficulty achieving autofocus. I used Auto Focus lock (AFL) and then reframed. |
| | **On Your Own:** For wide vistas, set your lens to wide angle and set focus mode to Infinity. But don't get stuck on wide-angle shots. Zoom in to capture details. |
| Camera Settings | **Practice Picture:** Manual mode. I used the Cloudy White Balance preset. |
| | **On Your Own:** If your camera supports it, use the Landscape setting. Otherwise use Foliage Scene mode to enhance greens. Keep the landscape experience quiet by turning off all your camera's sounds. |
| Exposure | **Practice Picture:** Evaluative Metering, ISO 200, shutter speed 4 sec. A Manual shutter speed of 4 seconds gave me the blur motion. The exposure was longer than two seconds. If I had used a PowerShot that didn't have manual shutter speed adjustment, I would have used Long Shutter. If I didn't have access to Long Shutter I would have used the Fireworks scene mode to get a slow shutter speed. |
| | **On Your Own:** Getting the proper exposure is tough in certain cases. For example, the sky might be too bright. Use the Beach or Snow settings if you consistently overexpose your image. If your foreground is underexposed, use Auto Exposure lock (AEL) on the lower part of the landscape and then reframe. |

| **Accessories** | A tripod can be useful for panoramas. Bring an umbrella or wet weather gear for when the weather turns bad — it will. If you frequently shoot in wet weather, consider an underwater housing or a waterproof case. A polarizing filter can help eliminate glare or darken skies. |

## Landscape and nature photography tips

✦ **Follow the seasons.** Choose a nearby scene and return throughout the year to see how the landscape changes. Make note of your shooting location and try to shoot at least one shot from the same area each time.

✦ **Follow the sun.** Check the newspaper or go online to learn when the sun rises and sets. Get to the location ahead of time and wait for the light to happen.

✦ **Use your time wisely.** Though the best times to shoot are early or late in the day, you can shoot at other times. Use midday light to photograph details such as wildflowers or moss on trees.

✦ **Clouds are a good thing.** While a cloudless day might be good for skywriters, I look for interesting clouds to help break up a bland blue sky. Clouds also give you a chance to capture details that you might not be able to see under harsh sunlight.

✦ **Get into the scene.** Don't just be an outside observer. Walk in to look for new opportunities. Look up to see what is overhead. Look down to see what is happening at your feet.

6.27 Red canyons make wonderful subjects, especially when lit by a late afternoon sun.

# Macro Photography

We live in a great big world and macro photography lets us get in close. PowerShot cameras excel in shooting close-up images. They beat out a digital Single Lens Reflex (SLR) with a standard lens that might only be able to focus on something that is at least two feet away. Macro subjects can range from abstract, to flowers, to insects, to something you want to sell on an internet auction site.

On one hand, Macro mode offers you the opportunity to shoot when the lighting isn't right for a nature shot; on the other hand, you can use it even at a special event like a birthday or wedding. Perhaps you have already shot the proverbial blowing out of the candles or the cutting of the wedding cake. How about using Macro to capture the swirl of ribbon on a birthday gift or a close-up of the wedding ring?

6.28 Morning dew on a thin leaf catches the morning sun.

# Inspiration

**Caution** *When shooting macro images, you can get the camera lens very close to objects. Be careful that the lens doesn't touch anything.*

There is rarely a time when you can't shoot macros. If you go to a sporting event and recognize you can't get close enough to the action, you could still shoot a close-up of your ticket stubs or textures on the stadium seat. Macro photography can be habit forming, so watch out! As practice, try to include at least one macro shot every time you shoot.

Sometimes it is difficult to reduce the depth of field with a PowerShot camera in order to cause backgrounds to go out of focus; however, the PowerShot's Macro mode reduces that range of focus in an instant. Remember to worry about your total composition, not just trying to get in close.

6.29 This tiny frog was very patient.

# Macro photography practice

6.30 This macro shot captures the gravity defying dew against a brightening morning sky.

### Table 6.9
### Taking Macro Pictures

| Setup | **Practice Picture:** Early morning offers great opportunities to capture dew on leaves and grass, as shown in figure 6.30. I wasn't dressed appropriately to get down on the ground, so I shot without being able to see the LCD or look through the viewfinder. Instead of composing from behind the camera, I could see where the lens was pointing from the front of the camera. Then it was a matter of taking a shot, looking at it on the LCD repositioning the camera and trying again until I got the right framing. |
|---|---|
| | **On Your Own:** Avoid distracting backgrounds when shooting macros. If you want most of your subject in focus, keep it parallel to the camera. Depth of field is a great creative tool, too. |

| | |
|---|---|
| **Lighting** | **Practice Picture:** The sun had just risen, creating a glistening highlight on the dew. I made sure the camera did not point directly into the sun. |
| | **On Your Own:** When you are outdoors, you can use a piece of white cardboard or even a sheet of white paper to bounce in some light to fill shadow areas. Indoors, a flash won't work; the camera is too close to the subject and only illuminates part of the scene. Use a desk lamp or ambient light to illuminate your scene. You can also set up your shot near a window to bring in daylight. |
| **Lens** | **Practice Picture:** Because I was shooting Macro at this close range, I made sure the lens was at full wide angle. |
| | **On Your Own:** To get the closest focusing distance, put the lens at its widest-angle setting. After setting the camera for Macro, press the Shutter release button halfway to engage Auto Focus. Leave the zoom control alone and move the camera closer or farther to adjust your composition. |
| **Camera Settings** | **Practice Picture:** The camera was in Foliage Scene mode. |
| | **On Your Own:** Use the Self-Timer to avoid camera shake. When you shoot outdoors, use Continuous shooting mode — it gives you a chance to capture objects as they move in and out of focus range. |
| **Exposure** | **Practice Picture:** Exposure compensation +1/3. The tricky part was to keep the camera steady while pressing the Shutter release button. You get used to pressing the Shutter release button with a different finger when you shoot this way. The PowerShot I used had optical image stabilization |
| | **On Your Own:** You should have good control of the light, so keep your ISO low. Shutter speed isn't much of a concern unless you shoot outdoors. If shooting outdoors, pick a Scene mode like Pets & Kids or Sports to freeze the action. Use Spot metering to control exposure. |
| **Accessories** | Macro photography magnifies any inadvertent camera movement. Use a full-size or tabletop tripod to lock down that camera. |

## Macro photography tips

✦ **Check your focus.** Macro images may look great on the LCD but they can be blurry when you print them. After capturing the shot, review the image and zoom in to examine various parts of the image.

✦ **Remember composition.** There is more to macro photography than trying to get as close as possible. Frame the subject, and then press the Shutter release button to check focus. If you are too close to focus, back the camera off and start again.

**6.31** These shots only happen if you pay attention to where the bees are and are able to wait and see if they land on the bloom you have chosen.

✦ **Change your perspective.** You can shoot down on some action items, but that technique might not work for a blade of grass or a moth on a wall. Get down to the subject's level. Try the shooting blind technique described earlier.

✦ **Get your body into it.** Focus is so critical in macro work that any movement by your subject can result in a blurry shot. Even the fastest shutter speed cannot compensate, because the blur is not a motion blur; the blur results from being out of focus. Use your body to block any wind. This can be tricky, as you might cast a shadow and block the shot.

# Motion Photography

For years, digital camera users have complained about shutter delay and lack of image sensor sensitivity. They looked at their photos and were quick to point out the motion blur associated with these faults. Motion photography can take these supposed faults and turn them into creative opportunities.

Adding motion to your images is not about freezing the action at a sporting event. It is simply letting the camera or subject move during the exposure. Forget all I have told you about keeping your camera stable with a good grip or a tripod. Handheld, even one-handed, is the way to go.

## Inspiration

There are two methods to create photos in motion. The first is to physically move the camera during the exposure. The movement can be side to side, up and down, a rotation, or a combination of these movements. The second method is to use a slow shutter speed (possibly in combination with flash) to mix movement with action frozen in time.

You don't have the same control over composition and subject matter placement that you had with other photography methods. Instead, think about the final look of the motion. The resulting photo will probably tend toward the abstract, but that is okay. Just as when you photograph fireworks, you will like only a small percentage of the images, but that's okay too. Motion photography should be about having fun with your camera. Most times the image replayed on your camera is a surprise.

6.32 A roaring campfire is difficult to photograph without a tripod. Take the blur even farther by adding a little motion to the camera.

## Motion photography practice

6.33 A good grip is needed to rotate the camera and press the Shutter release button. A quick one-handed rotation of the camera gives this scene a surreal look.

| Table 6.10 | |
|---|---|
| **Taking Motion Pictures** | |
| **Setup** | **Practice Picture:** I was walking through a forest in Germany on my way to take pictures of an old castle. When I looked up, I noticed the high contrast pattern of the leaves against an overcast sky. By itself it made a good picture, but I thought if I rotated the camera, I might end up with a fun image, as shown in figure 6.33. |
| | **On Your Own:** Decide if the motion is coming from you or the scene. Pay attention to the object's path. Timing of the shutter release takes a few tries before you get it. |
| **Lighting** | **Practice Picture:** Natural light was all that was needed. |
| | **On Your Own:** This is one case where it is okay if the light (but not the sun) is shining into the lens. The trails from moving lights or a moving camera add to the composition. Flash can be an option to freeze a bit of the motion. Try it both ways! |

| | |
|---|---|
| **Lens** | **Practice Picture:** I zoomed in a little bit to get closer to the tops of the trees. |
| | **On Your Own:** Zoom in to the scene or get closer and use the lens at wide angle. Either method accentuates the movement. Avoid large light sources close to the camera that may wash out the picture. Small pinpoints of light add great details to the image. |
| **Camera Settings** | **Practice Picture:** Manual mode, Daylight White Balance. This is a one-handed shot. It was critical that I start the motion before I pressed the Shutter release button all the way. |
| | **On Your Own:** Set the camera on Manual and pick a white balance that is close to the main light source. Experiment also with other white balance settings. To reduce shutter delay, avoid Auto White Balance. Turn off image stabilization if your camera has it. If your camera has shutter preferred auto exposure (Tv), set it slower than 1/60 of a second. |
| **Exposure** | **Practice Picture:** Evaluative Metering, ISO 100, Exposure compensation +1/3. The biggest challenge was exposure. I used Auto Exposure lock (AEL) and exposed for the sky so the trees would stay dark. |
| | **On Your Own:** If you want to add flash and your camera supports Slow Synchro Flash mode, put your camera in Manual mode and set the flash to Slow Synchro. After the flash fires, the shutter remains open briefly. |
| **Accessories** | If you want to capture horizontal movements without adding too much wiggle to the motion-blurred horizontal lines, a tripod is required. |

## Motion photography tips

◆ **Start with an empty memory card.** Adding motion to your shots can be hit and miss. If you have an empty memory card to begin with, you have plenty of space to experiment. Don't be disappointed if you don't like what you see; it takes practice.

◆ **Move the camera first.** If you are creating the motion by moving the camera, start the motion before you press the Shutter release button. The sequence is: press the Shutter release button half-way to lock focus and exposure, start camera movement, press the Shutter release button fully.

◆ **Use one hand.** Although you still need a good grip for motion photography, there are more options if you get used to using one hand. A one-handed grip may force you to use a different finger to release the shutter.

◆ **Try Fireworks mode.** If the light level is low enough, set your camera to Fireworks Scene mode to get an extra slow shutter speed.

✦ **Paint with light.** Use a flashlight or key chain light to draw shapes in the air. Set your camera to the slowest shutter speed and lowest ISO to make the exposure last as long as possible.

✦ **Continue camera movement.** Don't try to stop the camera; keep it moving. If you are using Slow Synchro Flash mode, remember that the exposure continues after the flash fires.

# Night Photography

When the sun goes down, photography becomes more challenging. While the flash on a PowerShot can light up a few faces, it can't light up an evening sky. Don't despair. With a little patience and a tripod, there are excellent opportunities to shoot great night-time shots.

Night photography does not refer to shooting in total darkness. Dusk provides some interesting and colorful light. Watch how the colors deepen as the sun sets. Artificial lighting can play some interesting tricks with white balance. An otherwise run-of-the-mill street scene appears on the LCD bathed in an orange glow.

6.34 I waited for the sun to go down enough so that you could see the lights reflecting in the water.

## Inspiration

Look for interesting and bright signs that capture your imagination. Neon provides a rainbow of colors. Use techniques detailed in the section on motion photography to capture some abstract shots.

Use Slow Synchro Flash mode to combine the golden light of the evening with the hustle and bustle of a downtown street. Use the sides of buildings or lampposts to brace your camera if you don't have a tripod handy.

6.35 A tripod and high ISO were needed to capture this full moon. Too often we ignore shooting at night.

# Night photography practice

**6.36** The light trails on the right help transform ordinary nighttime traffic into an interesting element in this shot.

## Table 6.11
### Taking Night Pictures

| Setup | **Practice Picture:** I shot figure 6.36 while looking down the Seine River. The only way I could have gotten this shot was with a tripod or by placing the camera on a bridge ledge. Because the wind was blowing, had the camera been placed on a ledge, it might have fallen into the water. |
|---|---|
| | **On Your Own:** Don't put your camera away just because it is getting dark. Use Night Scene mode to begin with, then expand with Long Shutter mode. Find places to use as temporary supports for your camera. |
| Lighting | **Practice Picture:** There was still a bit of sun left in the sky, so I waited for the colors to appear in the sky before I started shooting. |
| | **On Your Own:** Existing light can be hard to come by when shooting at night, but look for it. Combine existing light with flash. Use Slow Synchro Flash mode. Understand the distance that your flash covers. |

| | |
|---|---|
| **Lens** | **Practice Picture:** I had to zoom all the way out to get the width of the river. I used Auto Focus lock (AFL) so I could keep the scene sharp. |
| | **On Your Own:** You'll use many different focal lengths at night. Let your composition drive your zoom. Focusing can be difficult in the dark. Even though your camera has an autofocus illuminator to help, it might have difficulty finding an appropriate object on which to focus. Use Auto Focus lock (AFL), select the area for focus, and then take the shot. |
| **Camera Settings** | **Practice Picture:** Manual mode, Daylight White Balance. I used a Custom Timer to reduce camera shake. |
| | **On Your Own:** There are many light sources in your scene. Pick a Daylight or Cloudy White Balance and stick with it for a few shots. The color of some nighttime light doesn't balance out to white no matter what white balance setting you use. |
| **Exposure** | **Practice Picture:** Evaluative Metering, ISO 200, Long Shutter 10 sec. When the sun sets, the exposure for the sky can change quickly. I took a picture; then looked at the LCD and the histogram and adjusted my exposure to keep color in the sky. A slow shutter speed was necessary to get the light trails from the cars. |
| | **On Your Own:** A high ISO setting is the norm for night photography. If it is the beginning of dusk, you can start with a lower ISO. |
| **Accessories** | An accessory flash can help with shadows, but shadows can be part of what defines a night scene. A tripod is a must to support the camera during long exposures. |

## Night photography tips

✦ **ISO up.** You must boost the signal coming off your image sensor, so select a high ISO setting if you need it. Although it will be noisy, that may match the feel of an urban street scene or a busy seaport.

✦ **Flash as a last resort.** Although Slow Synchro Flash can give you some cool shots, flash can also be distracting. If you try to capture unique moments with flash, people may focus more on the camera than on what they were doing.

✦ **Wait for the balance.** If you shoot structures that are lit with artificial light against a darkening sky, take a picture and evaluate your histogram and the exposure on the LCD. There is a magic moment when the brightness of the darkening sky matches the man-made lights. After that time, if you try to capture the color of the sky, the artificial lights are overexposed.

✦ **Color your flash.** Nighttime light sources can have strong color casts, so try for some fun shots by adding even more color to the scene. Use colored cellophane.

# Panoramic Photography

The next time you drive down a road and notice a Scenic Vista Ahead sign, consider yourself lucky. Here is an opportunity to use an image-capture technique that has had a resurgence since digital cameras gained popularity – panoramas. The ultra-wide landscape photos are great for capturing a mountain range at sunrise or a farm field at harvest.

You can merely zoom out and then take the shot; however, if you want to get a larger print, the resolution may be insufficient. You might also find that your wide angle just isn't wide enough for the Grand Canyon in the composition to truly become Grand.

Panoramas involve taking a series of shots with your PowerShot and stitching them together on the computer. PhotoStitch, the software that comes with your camera, helps combine the images. You can stitch two images or a whole series. Although most panoramas are horizontal, you can create vertical ones, too.

## Inspiration

You can create panoramas of mountain ranges, large cities, or small towns. Anytime the wide angle on your camera just isn't enough, you can shoot a panorama. Stand in one location – don't move your feet – and shoot two or more shots, panning the camera to the right as you overlap the shots.

**Tip** *Pay attention to unique details in the image, as they are key to lining up your overlaps.*

If at all possible, use a tripod. The goal is to have minimal camera movement in the opposite direction of your pan. In other words, if you pan horizontally, avoid any vertical movement when you set up for the next shot. This is where a tripod comes in.

Use the Stitch Assist Scene mode to help line up your overlap. If you do not use Stitch Assist, make sure you overlap at least 20 percent. Avoid overlapping too much, however, as it creates more work when you stitch the photos together.

**Cross-Reference** *Refer to Chapter 2 to review the Stitch Assist Scene mode.*

**6.37** A Florida bird sanctuary at sunrise was a perfect opportunity for a panorama.

6.38 The sun helped intensify the red rock near the Colorado River.

# Panoramic photography practice

6.39 Without a tripod, I needed to make several attempts at this panorama.

## Table 6.12
### Taking Panoramic Pictures

| | |
|---|---|
| Setup | **Practice Picture:** I shot the German river town shown in figure 6.39 to capture the reflections on the water. In order to make sure I overlapped properly — no tripod was available — I went through the panoramic shooting process three times. When I got home, I discovered only one of the sequences was able to work. I made sure to "anchor" at least one side of the shot with the castle. The steeple on the right helped "end" the panorama. |
| | **On Your Own:** Composition rules are still in effect, so avoid placing the horizon in the middle of the frame. Keep moving elements out of the shots or they may be difficult to stitch. Keep the camera level and use a tripod whenever possible. |

*Continued*

## Table 6.12 *(continued)*

| | |
|---|---|
| **Lighting** | **Practice Picture:** I waited for the sunlight to lessen enough so the reflections in the water became more noticeable. |
| | **On Your Own:** As with any scenic shot, wait for good light. The only special aspect of panoramic lighting to learn is consistency. Make sure the light is the same throughout your sequence. If it is a partly cloudy day, you may have to act fast so the sun doesn't come out on the last shot. |
| **Lens** | **Practice Picture:** I zoomed in about half way so I didn't have to take too many shots. If I had a tripod, I would have zoomed in closer. Without a tripod, it is difficult to stitch panoramas that are made up of more than two or three shots. |
| | **On Your Own:** Wide-angle focal lengths can be more difficult to stitch if the scene is not a distant one. The wide angle adds curvature to the composition, so even if you are successful at stitching the photos, you will still have to crop the images quite a bit. If shooting in Manual mode rather that Stitch Assist, don't touch the zoom control during the shooting sequence. |
| **Camera Settings** | **Practice Picture:** I used Stitch Assist to help line up the shots. I chose the Cloudy White Balance. |
| | **On Your Own:** Choose your White Balance to match the lighting. If you are not using Stitch Assist, use a preset white balance rather than Auto. White balance should not change from shot to shot or the stitched seams become visible. |
| **Exposure** | **Practice Picture:** Evaluative Metering, ISO 200, Exposure compensation –2/3. I took a couple of test shots to see how the exposure looked at the beginning and end of the pan. I ended up adjusting Exposure compensation so that on the end shot the sky would not be overexposed. I could have reversed the Stitch Assist to go from right to left, but I am so used to going from left to right that I feel I am more stable shooting in that direction. |
| | **On Your Own:** Stitch Assist locks the exposure during the first shot and keeps it locked until you are finished shooting. Before you begin, make some test shots of your scene to see if the exposure should be locked on your first shot or somewhere in the middle. Use Auto Exposure lock (AEL) if you need to set your exposure differently. |
| **Accessories** | A tripod helps you avoid difficult stitching. |

# Panoramic photography tips

✦ **Practice.** Before you head out of town to shoot panoramas, capture some close to home, bring them into your computer, and stitch them together. That is the only way to know how well you overlap the images and whether you keep the camera steady as you move from shot to shot.

✦ **Have a beginning and an end.** A specific composition rule for panoramas is to have a strong beginning and a clear-cut end to anchor your panorama. If you shoot a mountain range, start on a high point and end on a tall pine. If you can't have both a beginning and an end, shoot for at least one.

✦ **Start over.** If you think you may have made a mistake when shooting the sequence, start over. Even if you think you can retake that third shot, odds are that it won't work. Just go back to the beginning and start again.

✦ **Don't forget verticals.** While panoramas always seem to be horizontal, verticals can work too. Position yourself a good distance from the subject. Don't expect to start at the base of the Sears Tower to create a vertical panorama all the way to the top — there is too much distortion.

✦ **Mark the panoramas.** If you shoot a lot of panoramas, when you download the images from your memory card it can be difficult to tell when one panorama ends and another begins. I like to shoot a blank frame (I cover the lens with my hand) before and after each panorama sequence. When I look at the photos on the computer, the black images quickly frame the panoramic sequences.

6.40 Taken at the Niagara Falls region at sunrise, the mist on the right-hand side prevented me from making a wider panorama.

# People Photography

PowerShots are probably used to capture people more than any other subject matter. They capture your coworkers, friends, and family. The composition can range from posed group shots to quiet little portraits.

The technologies built into PowerShots are, first and foremost, designed for pictures of people. Features like Red-Eye reduction, Portrait mode, and Face Detection were developed to make people look good when their pictures are taken. Take advantage of the technology to capture great shots.

## Groups

Shooting groups of people can be a daunting task. You are either faced with people that don't want to have their pictures taken

6.41 This family wanted a picture of them all together. Even though it was dark, I still moved them outside under a moon and used flash.

or are having so much fun getting their picture taken that they won't stay still. Here are a few tips:

✦ **Keep groups manageable.** Avoid the group shot with multiple rows of people; narrow it down to two and just go with a wider shot. It is difficult to deal with varying heights of people in just two rows; three and four make it almost impossible.

✦ **Get up high.** If you have a large group, consider taking the photograph from a higher position than the group. This saves you time trying to rearrange people by their height.

✦ **Take a test shot.** You will be wrangling a lot of people so take a few practice shots of one person before the group assembles so that you can have your camera set when the throng arrives.

✦ **Make sure they can see the camera.** Tell people to make sure they can see the camera not just you. If they can't see the camera, the camera won't see them.

✦ **Use existing light.** With a big group the flash output of the PowerShot won't be enough. Try shooting outdoors but avoid shooting directly into the sun or with the sun directly at your back.

## Individuals

With individual portraits, the goal is to come away with a photograph where the person looks natural. Here are few tips that should help you take the best photo possible of your willing subject:

✦ **Use telephoto.** Shooting with the lens at wide angle can distort your subject's facial features. Instead, step back from your subject and zoom in.

✦ **Angle subject to camera.** You aren't shooting a police lineup. People look more natural when they aren't facing directly at the camera. Have them turn so they are facing a little away from the camera.

✦ **Sit or stand?** This really depends on how comfortable your subject is. Try having them stand with one foot a little forward of the other and at a little angle away from the camera. Have them place their weight on their back foot. If they need to sit, pick a chair that doesn't swivel and position it so it is not facing directly into the camera.

✦ **Pay attention to height.** Whether sitting or standing make sure that the camera is close to their eye level. You don't want to be shooting up or down on them.

✦ **Watch out for horizontal lines.** If you were to draw a straight line across your subject's eyes that line should have a little angle to it. So have them tilt their head a little. The same goes for shoulders. If they are standing have your subject rest their hands on something — like a chair back. If seated, have them reposition their feet.

## Inspiration

Eventually someone will ask you, as the family photographer, to take a picture. You line up the group, the grandchildren sit in the appropriate laps, everyone says "Cheese,"

**6.42** Shooting in shade but with enough light reflected from a nearby building made this candid shot at a wedding a success.

and yet another shot is created for the family album. Why not break the mold? Sure, take the snapshot so everyone is happy, but also take some shots when people are setting up — get the one of Mom telling your brother he should kneel down in front because he is so tall or reminding your cousin to tuck in his shirt. Shots like these can capture more intimate, personal relationships among family and friends.

People photography is also more than group shots. Here is your chance to experiment with composition. Capture your subject in a natural setting or an environment that reflects their personality. People photography can allow you to test different lighting methods. Try for natural light — even indoors. The toughest challenge is not composition or lighting; it is trying to get people to forget you are there and to have them act naturally. Use another person to help distract your subject.

## People photography practice

6.43 What began as a way to test my skills using an accessory flash to photograph people turned out to be a great image.

## Table 6.13
## Taking People Pictures

| | |
|---|---|
| **Setup** | **Practice Picture:** I shot the photo in figure 6.43 from a bit of a distance. It was the only way to avoid distracting the mother and wrecking a beautiful moment. |
| | **On Your Own:** Look for shooting positions that allow you to capture candid moments. Keep your camera handy, the batteries charged, and the memory card empty so you are ready to go. Take practice pictures to check exposure and white balance. |
| **Lighting** | **Practice Picture:** I used an accessory slave flash placed on a shelf to the right of the frame. It balanced out the light coming from the on-camera flash. I used a little piece of handkerchief to subdue the PowerShot flash. |
| | **On Your Own:** Try for natural light whenever possible. If capturing a group shot, why not have everyone step outside? Just be careful of bright sun, which can lead to harsh shadows and squinting subjects. If you shoot outdoors, you might have to use a flash to fill some light in the shadows. |
| **Lens** | **Practice Picture:** I shot from across the room to be discreet. |
| | **On Your Own:** Shoot from a distance to capture candid moments. Make use of Auto Focus lock (AFL) if you're not able to lock onto the right part of the scene. Avoid the distortion of wide angles on faces. |
| **Camera Settings** | **Practice Picture:** Manual mode. I set up a Custom White Balance before anyone was in the room. |
| | **On Your Own:** To help you to blend in, turn off any sounds the camera makes. Set your white balance before you start shooting. If possible, choose a preset white balance setting to reduce shutter delay. If you aren't using flash, use Continuous mode to capture different moments. Although Portrait mode can work well, use Kids & Pets. |
| **Exposure** | **Practice Picture:** Evaluative Metering, ISO 200, Exposure compensation −1/3. I checked exposure with some test shots. |
| | **On Your Own:** You may have to shoot with a higher ISO to avoid blur. |
| **Accessories** | An accessory flash can be handy. A tripod is a must if you want to be in the shot. |

# People photography tips

✦ **Backgrounds matter.** While the main focus of the composition is the people, pay attention to backgrounds. Avoid distracting elements that might cause a viewer to focus away from your subject. Watch out for the floor lamp that looks as though it is growing out of someone's head. Look for backgrounds that may tell more about when the photo was taken.

✦ **Protect your photos.** People love to look at the photo you just took. The LCD's instant feedback has truly changed the dynamics of taking a person's picture and passing the camera around is a popular after-effect of digital photography. Unfortunately, the Erase button can easily be pressed while handing the camera from person to person. Protect those once-in-a-lifetime shots before you turn the camera over.

✦ **Use an alternate playback method.** You save battery life by having a short review length. If you want to show someone an image, however, it can be frustrating when the image disappears as soon as your viewer looks at the LCD. Of course you can put the camera in Playback mode, but there is another method that temporarily extends the review time. After you take the shot and before the image review ends, press the Display button to freeze the image review. The image remains on the LCD until you press the Shutter release button or turn off the camera.

✦ **Take pictures of people doing what they normally do.** The concept of making someone sit still and stare into a camera came out of photography's early days, when exposures took a long time. People photography is more than images befitting a passport. Shoot when people are no longer aware of the camera and they are doing what they normally do.

✦ **Step away when taking portraits.** When most cameras turn on, the lens is set at its widest angle. This is not a flattering look for a portrait. The wide angle makes a face wider than it really is and it stretches other facial features. Zoom in, and then step back to compose the shot.

✦ **Use a Custom Self-Timer.** Take advantage of the Custom Self-Timer settings to take extra shots when you are included in group shots. It can be fun to see what happens when people have finished posing. Or plan a second shot where you give everyone an assignment for the next shot.

# Pet Photography

Is there a better way to capture cute than through pet photography? Puppies and kittens don't have to be directed or posed; it seems they already know their only job in life is to be the adorable subjects of photographs.

Pet photography is different than trying to capture animals at a zoo because you can get close and wait for great moments. The trick with pet photography is not to try to make your pets act cute, but to capture them being cute as they naturally are.

6.44 This dog is more concerned about getting his feet wet than what I am doing with the camera. Distractions help.

## Inspiration

Catch pets in those funny moments of sleeping in a strange position or trying to get that ball out from under the bed. Avoid trying to set up a funny or cute situation. It often comes out looking staged and appears as natural as the group photo where everyone says "Cheese."

 **Caution** *Pets can react differently to strange circumstances. Be careful when you photograph. Don't allow your pet to get in a situation where it is uncomfortable or in danger.*

When trying to get more of a portrait-style shot, know that pets can focus on your eyes, and they are distracted when the camera interrupts that line of vision. Try using the Self-Timer and a tripod, or set the camera on a secure support so your pet can continue to look at you while its photograph is being taken.

6.45 After a hard day's work this herding dog heads for the pool.

# Pet photography practice

6.46 Patience helps to find the right time when these dogs allow their personalities to shine through.

## Table 6.14
### Taking Pet Pictures

| Setup | **Practice Picture:** The trick with figure 6.46 was to take the picture without distracting the dogs. I preset the camera before I took the shot and quickly brought the camera up to my eye to shoot. I used the optical viewfinder because the bright snow made the LCD difficult to use at the angle I was shooting. |
|---|---|
| | **On Your Own:** You really have to be ready with the camera powered up and set to go when capturing pets. Some pets get very nervous when you point a camera at them so take the shot quickly, but move smoothly. |
| Lighting | **Practice Picture:** The bright snow and intermittent sun were a challenge but I was able to wait for a little cloud cover. |
| | **On Your Own:** Natural light can really show off your pet's coloration. Flash stops action but can quickly overexpose. Combine flash with natural light outdoors to help with high-contrast scenes. |

| | |
|---|---|
| **Lens** | **Practice Picture:** I stayed a distance away and zoomed in to avoid exciting the dogs. |
| | **On Your Own:** Unlike when you shoot people, a little distortion of your pet's face can be fun. Use a wide angle with up-close shots to accentuate your pet's features. That big dog nose can become even bigger when using a wide angle. |
| **Camera Settings** | **Practice Picture:** Manual mode. I muted the camera sounds and used the Cloudy White Balance. |
| | **On Your Own:** Turn off your camera's sounds. Some pets are very sensitive to the sounds of electronic devices. Kids & Pets setting works well for stopping action. Turn on Red-Eye Reduction to help reduce the reflection from the animal's eyes. Try Continuous shooting mode to capture your pet in action. |
| **Exposure** | **Practice Picture:** Evaluative Metering, ISO 200, Exposure compensation -1. I adjusted Exposure compensation so I could still hold some detail in the snow. |
| | **On Your Own:** Pets may have coats that range from dark black to bright white, even on the same animal. Pay attention to the histogram to avoid overexposing or underexposing. Use Exposure compensation to override your camera's meter. |

# Pet photography tips

✦ **Sit.** Be patient with pets. They have little patience themselves, so don't try to force something that isn't going to happen. If you are flexible in your shooting, you'll have more opportunities to capture the fun.

✦ **Get down.** When you shoot down on a pet, you mimic the way people typically see their pets. Be different — move down to their level and shoot low. The difference in perspective can open new opportunities for photographs.

✦ **Speak.** Don't fall into the rut of calling your pet's name before each photograph. Doing so can lose its effectiveness and fail to work when you really need it. Keep your voice calm in order to avoid distracting your subject.

✦ **Outside?** If your pet goes outside, then you should, too. Natural light can help give you a shutter speed fast enough to stop that rambunctious puppy.

# Product and Auction Photography

It may have started with Pez dispensers, but auction Web sites such as eBay have swept the world. The dollar amount of transactions each year is in the billions. To be successful selling in an online auction, you need a competitive starting price, a good description, and a great photograph.

Because Web images don't need to be high resolution, you can use just about any digital camera. The key is not resolution but a clear, well-lit image with a simple background. It is one thing to have an overall brightness that is pleasing in your photo; it is another to have a photo that highlights all of the product's best details.

The better your images are, the more likely people will consider purchasing your items. A great photo also reduces confusion about your product and its condition.

6.47 Shooting metal can be difficult; having a clean surrounding to reflect light helps a lot.

6.48 Check out different angles when shooting products. Lifting the camera up so that you can see the back rim of the pot gives the potential buyer a better view.

## Inspiration

If you are going to sell a number of things or sell things often, it is best to set up an area where you can easily photograph your items. A good background should not fight with your wares. White or gray works well in many cases and serves double-duty reflecting light to fill in shadows. If you sell jewelry, you may want to consider purchasing a piece of black velour cloth from a fabric shop.

Another very important aspect of product and auction photography is lighting. Product lighting should be even, with little or no shadow. If you don't have any artificial lighting, you can set up an area near a window, using pieces of white cardboard to reflect light into shadowy areas.

## Product and auction photography practice

6.49 Choose the orientation to match the product. A vertical shot helps highlight the graceful handle.

## Table 6.15
## Taking Product and Auction Pictures

| Setup | **Practice Picture:** My sister-in-law's pottery, figure 6.49, looks best against a white background. I used a Lastolite Cubelite kit to shoot it. |
|---|---|
| | **On Your Own:** You need an uncluttered look with even light. Set up a table at a good working height. You may have to take several shots while you play with the light, so you don't want to be on the floor. |
| **Lighting** | **Practice Picture:** The kit comes with a tungsten light and reflector to create a soft lighting source. |
| | **On Your Own:** If you shoot a lot of objects or shoot on a regular basis, consider a small Cubelite kit. If you only plan to shoot a couple items or sporadically, you can use multiple desk lamps as lighting. If the lighting is too harsh, you can shoot through tracing paper to soften it. |
| **Lens** | **Practice Picture:** I zoomed in about half-way in order to keep things in focus. |
| | **On Your Own:** For some items, Macro mode may be the best way of capturing details. Other items require that you shoot a main shot and then shoot a few detail shots, as well. Above all, make sure your objects are in focus. |
| **Camera Settings** | **Practice Picture:**  Manual mode. Because the light was tungsten, I used the Tungsten White Balance. |
| | **On Your Own:** Even if you use a tripod, the Self-Timer can help eliminate camera motion blur. If you do not feel confident using a preset white balance, set a Custom White Balance. |
| **Exposure** | **Practice Picture:** Evaluative Metering, ISO 100, Exposure compensation +1/3. I took a few practice shots and reviewed them on the histogram to make sure the white of the background was very close to the right edge of the histogram. |
| | **On Your Own:** The less noise in your image, the better it compresses for the Web. Use a tripod and set your camera for the lowest ISO available. If the exposure meter is causing under or over exposure, adjust Exposure compensation. |
| **Accessories** | If you use a tripod you have better luck with sharpness. White pieces of cardboard make effective bounce cards that you can use to direct light into details and shadowy areas. |

# Product and auction photography tips

✦ **Keep things clean.** Because you may be shooting details, clean your item so it looks its best. Whenever you have to reposition the item, use a cloth — not your bare hands — so you can avoid adding fingerprints.

✦ **Shoot full resolution.** There is rarely a time when you need to shoot something at low resolution. You must resize the image for the auction site, but it is better to shoot at high resolution in case someone has a detail question. If you have used high resolution you can always go back and crop and magnify a detail area. Remember that you can always decrease the size of your image, but once you shoot at low resolution, it is low resolution forever.

✦ **Check sharpness.** A blurry image can result in missed sales opportunities. After you take your shot, go into Playback mode and zoom in to check your focus. Better yet, take your memory card to your computer, download the image, and look at it on your computer's display.

✦ **Zoom in.** Focus is critical to making your product look attractive and depth of field directly affects focus. When you shoot in the telephoto range of your lens, the area of your scene that is in focus increases in depth. So move your camera back and zoom in to compose your scene.

 Cross-Reference *Chapter 4 explains more about depth of field.*

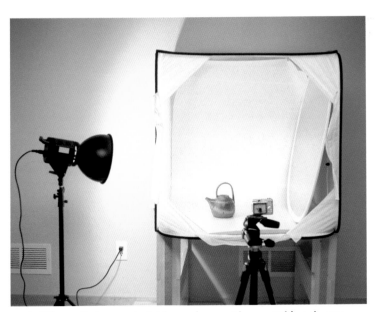

6.50 This studio is easy to fold up when not in use. With only one light, it gives a nice soft light and clean background. www.lastolite.com

# Street Photography

Too often photographers put away their cameras when they get into town. Or they focus on the architecture and miss the hustle and bustle of city life. Street photographs can capture both the action of the daily struggle and the moments of peace amidst the havoc.

In this day and age, however, you have to be more careful because people are more suspicious of photographers. Be polite and ask before you take someone's picture, if you are able. It can be as simple as looking at them, gesturing at your camera, and waiting for a reaction. But when in doubt, be vocal. Make sure you do not take pictures of security areas where law enforcement might pay you a visit.

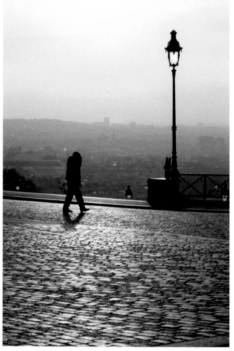

6.51 This Paris street just after sunrise offered great moments. I exposed for the sky to create the silhouette.

## Silhouettes

Shooting a silhouette is one of the few times when you are trying to underexpose part of a scene. In order to have success there has to be a good contrast between the light areas and dark areas of the image. The trick is to use Auto Exposure lock (AEL) to lock on the bright areas of the image. If you are shooting someone against a sky, tilt the camera up so the sky fills the whole frame, then set AEL. The meter will set the camera exposure to make those bright areas less bright. By reducing the bright areas you also reduce the darks areas — to black if possible. You can accentuate the silhouette effect even more by using Exposure compensation to further darken the dark areas of the scene. If you can directly set exposure by using M on your PowerShot, you can create a good silhouette by purposely setting aperture and shutter speed for under exposure.

# Inspiration

Don't let my dire warnings discourage you. When you walk down the street, there are lots of great opportunities for you and your PowerShot. Visit a farmer's market in the morning to capture all the lush produce and the sellers, too! Check the city paper to see if there are any festivals or parades. Hop off the main street and walk through side streets to look for quiet moments to capture.

Head to a city park to see kids at play or retirees enjoying the day. The images can tell a story unique to that city or they can represent your impression of city life.

**Caution** *Be aware of your location. Don't let the LCD be your only focus when shooting on the street. There is a lot going on and being aware of what's happening around you can help keep you safe.*

6.52 The narrow walkway, coupled with a wide angle and goofy friend, added up to a fun shot.

## Street photography practice

**6.53** It took a little patience but the waiter's presence gave this alleyway even more character.

## Table 6.16
## Taking Street Pictures

| | |
|---|---|
| **Setup** | **Practice Picture:** For figure 6.53, I waited for ten minutes for this Italian waiter to finish his cigarette. I didn't want his face to be recognizable.<br><br>**On Your Own:** Don't just look for cool shots now, think about what they will look like in a few minutes. Pay attention to signage that, while usually ignored, might give a humorous counterpoint to what is happening on the street. |
| **Lighting** | **Practice Picture:** Though it was normal daylight, the narrow alleys made things a little difficult. Because I had a longer exposure time, I braced myself against a building in order to avoid blur.<br><br>**On Your Own:** A sure way to call attention to yourself is to use flash. Turn it off and keep it off. Watch for unique lighting situations as the sun moves through tall buildings: one moment the scene may be dark and a few minutes later it might be light. |
| **Lens** | **Practice Picture:** Maximum telephoto kept me far away from the subject.<br><br>**On Your Own:** Typically you'll be at the far end of your zoom range in order to crop in on selected scenes. If there is a lot of action or there are foreground elements that interfere with focus, use Auto Focus lock (AFL) or manual focus. |
| **Camera Settings** | **Practice Picture:** Manual mode. I used a Cloudy White Balance setting to warm up the scene.<br><br>**On Your Own:** Turn off camera sounds. Because the lighting may be erratic, you may want to use Auto White Balance. Continuous shooting mode will help you capture more moments. |
| **Exposure** | **Practice Picture:** Spot Metering, ISO 200. I used Auto Exposure lock (AEL) so the image wouldn't be under exposed. The upper parts of the building were causing the camera's light meter to create an underexposed shot.<br><br>**On Your Own:** Bright lights can often cause the camera's meter to underexpose the shot. To correct this problem, use Auto Exposure lock (AEL) or Exposure compensation. Make sure you pay attention to the histogram. Sometimes there are scenes where bright lights being overexposed are okay. There is no one perfect histogram. |

## Street photography tips

✦ **Be prepared.** With one hand, practice turning on your camera without looking at it. Keep your camera set to Manual or a Shooting mode that doesn't default to using the flash. There are some scenes that may require fast action on your part, so having the camera turned on as you bring it up to your view can help reduce delay.

✦ **Be aware of power-up settings.** As I mentioned previously, you should have flash off to avoid attracting attention and ruining the candidness of the shot. In Auto mode and some scene modes, even if you have turned off the flash it resets to On when you power off the camera. When you turn off your camera, pick Manual or a Scene mode that keeps the flash setting the way you left it.

✦ **Dark can be good.** There are times when what you see just can't be captured by the camera; the human eye is just too good. Instead of fretting about that, think about silhouettes. They can be a great response to high-contrast natural light.

✦ **Blur happens.** The scene is dark; using a tripod would be inappropriate; the people are moving fast. There *is* going to be blur in your shot. That's fine. In fact, it might be even better at communicating the frenzy of a city street.

# Sunset and Sunrise Photography

The sun puts on a show for us every day. Sometimes it is unremarkable; other times it is breathtaking. Those breathtaking days can make you look like a pro when it comes to photography.

## Inspiration

If you use a tripod at sunrise you can get some intense colors by using a slow shutter speed. The sky is more colorful than what you see with your own eyes. This is because the camera's image sensor is being inundated with colored light rather than white light. The pink of an early morning sunrise builds to a more vivid red. If your camera doesn't allow you to directly adjust shutter speed, try using the Fireworks mode.

Silhouettes are the norm for foreground objects and they can create appealing shapes. Sailboat masts or a lone tree make for an interesting contrast to an open colorful sky. Sunset and sunrise photography give you the opportunity to take pictures of the same scene over multiple days, yet still produce unique shots. They are also great opportunities to try out panorama photography.

 **Caution** *Shooting the sun can be dangerous to your eyes and the camera. Never shoot an eclipse or the sun at midday. The lens on the camera acts like a magnifying glass on a bright sunny day. Leaving the camera pointed to the sun for a period of time can damage the sensor.*

**6.54** The sun doesn't have to be in a sunrise or sunset shot. This tree was actually in an urban setting, but careful use of zoom makes it look like it could be out in the wild.

**6.55** This morning boat scene made for a great silhouette.

# Sunset and sunrise photography practice

**6.56** Waiting just five minutes for the light to change transformed this scene from being about the sun to the steeple.

## Table 6.17
### Taking Sunset and Sunrise Pictures

| Setup | **Practice Picture:** For figure 6.56, I walked around a small town in Northern Italy. Farm fields surrounded the area but they had just been planted and didn't have much to look at. As the sun set, I noticed this church tower that by day was not very interesting but made a great silhouette. |
|---|---|

**On Your Own:** Remember that clouds are a good thing. Your image composition accentuates the sky. Avoid the horizon-stuck-in-the-middle shot. If your camera has grid lines, turn them on to remind you to move the horizon down. They can also be helpful in keeping the horizon level.

**Lens**

**Practice Picture:** I zoomed in to get rid of a street light that would have wrecked the shot.

**On Your Own:** A wide-angle view can capture a large colorful sky, but a telephoto helps you minimize distracting foreground or background elements.

**Camera Settings**

**Practice Picture:** Manual mode. Because I used a tripod, I set the Self-Timer to trigger the shutter. I used Daylight for a white balance setting.

**On Your Own:** If you use a tripod, use the Self-Timer to reduce vibration. You can set White Balance for Daylight or use Cloudy to increase the warmth. For extra saturated colors, set My Colors to Vivid.

**Exposure**

**Practice Picture:** Spot Metering, ISO 200. I framed the shot without the sun in it, and then locked exposure with Auto Exposure lock (AEL). I reframed and took the shot.

**On Your Own**: Use AEL to experiment with exposing for the sky and exposing for the sun. If you expose for the sky, the sun will definitely be over exposed. But if you expose for the sun, the colors of the sky may disappear. By using AEL, you can try locking on a part of the scene that will give you a halfway point. Use Exposure compensation to adjust silhouettes. If you use a tripod and the conditions are too dark, try the Fireworks setting for a long exposure. Use Exposure compensation to adjust image brightness.

**Accessories**

A tripod is needed to achieve a sharp image when capturing early sunrises or late sunsets. A flashlight can help you see your camera buttons during those early morning setups for sunrise.

# Sunset and sunrise photography tips

✦ **Know when it happens.** Check the newspaper, a weather calendar, or online to find out when sunset and sunrise occur. If you are in a mountain area, the time of sunrise or sunset won't be the same as when the sun appears from behind the mountains.

✦ **Get there early and stay late.** Magic times can occur before sunrise and after sunset, so get to your location 20 minutes before sunrise and stay late at sunset. Some of the best color happens when the sun has just set or before it rises, so don't think of a sunset shot as one that must have the sun in it.

**6.57** Although clouds help make great sunrises, a few steps to the right and the water reflection is uncovered to make this shot stand out.

✦ **Look around.** While you are shooting a sunrise or sunset, don't forget to look around. The sun might spray its colorful light on other scenes opposite the typical sunrise or sunset scene.

✦ **Know your camera.** Light changes quickly when the sun rises or sets. There is no time to figure out how to adjust exposure compensation or how to lock exposure.

# Travel Photography

There is no better way to document your journey than through photography. Any packing list that doesn't include a camera should be suspect. When you look at the travel brochures before you leave, look at the photography in them for composition ideas for your own photographs.

Prepare for the photographic part of your trip just as you would for any other part. Make sure you have extra memory cards and spare batteries. Depending on the length of your journey and how available power is, bring at least two batteries with you. Make sure your charger is close by and

has the necessary adaptors if traveling in a foreign country. Bring suitable materials for cleaning your camera's lens and LCD.

 *Most PowerShot chargers can handle 100 to 240 volts and 50 and 60 hertz power. This means that you don't need a transformer to convert the power; all you need is an adaptor to change the shape of the plug so it can fit into a foreign outlet.*

## Inspiration

Imagine how you might try to tell a story about your travels when you get home. Think of a book – shoot preface shots like

6.58 This historic room was very dark. I was able to place the camera on a shelf and use the Self-Timer to capture this image.

the luggage waiting at the curb. Capture title pages, such as street signs or iconic structures. Build on the story by photographing rich images of texture and detail. Once you have established the scene, focus on details. Continue shooting each chapter as you move from place to place. Think about that one shot that you might use for your book cover, the image that says in one frame what your trip was all about.

Unlike photographic topics such as fireworks or panoramas, there is not just one technique for travel. In fact, you can use just about all the photographic subject techniques discussed in this chapter when traveling. Travel photography is more of a mindset, a way to think about how to capture your trip.

Involve people in your photographs. It makes the conversation more interesting when you get back and show people your vacation photos. A sunset, while beautiful, might not evoke a response or trigger any questions, but a scene showing one of the members in your group asking someone for directions may lead to some lively discussions.

6.59 A reminder of breakfast in Amsterdam

## Traveling with the PowerShot

What's the packing list for a PowerShot? Extra batteries and memory cards. Lens cleaning fluid and cloth. If you stay at modern hotels with televisions, bring your video cord so you can review some of your shots. This way you can see if your camera is working properly, the lens is clean, and you are getting the shots you want. Viewing your images on a small LCD can make all your images look good and sharp. It is only when you see the image on a bigger screen that you really see how sharp it is. Also bring along a large bag of patience. Travel is more fun if you can go with the flow and let things happen.

# Travel photography practice

**6.60** Castles and churches are typical travel subjects, but don't forget that it is the journey rather than the destination that is unique to your trip.

# Table 6.18
# Taking Travel Pictures

| | |
|---|---|
| **Setup** | **Practice Picture:** I like to include people in some of my travel shots. In the picture shown in figure 6.60, my wife was having a discussion with a friend about where she had just been the previous day. The shot of the two of them talking also includes the name of the area where we were. |
| | **On Your Own:** Don't forget that people make life interesting. Include them in some of your shots if you can, but ask first. Remember to look up and look down. Look for nontraditional shots. Sure, photograph the changing of the guard, but how about the teen on tip-toes trying to get a better view? If an image doesn't look good, delete it and take another. That is one of the great benefits of digital photography. |
| **Lighting** | **Practice Picture:** Mottled sunlight helped add a little interesting lighting to this scene. |
| | **On Your Own:** If you have a full itinerary each day, lighting is what it is. In the middle of the day, concentrate on details and close-ups. Use flash outdoors to fill in shadows when shooting closer subjects. If you have some free time, get to locations early in the morning or later in the day to capture them when the lighting is at its best. When you are in museums or other locations that frown on flash photography, switch to Manual mode so when you turn the flash off it stays off. |
| **Lens** | **Practice Picture:** I didn't want to interrupt the conversation, so I stayed far away and zoomed in. |
| | **On Your Own:** Use your telephoto to zoom past modern edifices in an ancient city. Wide angles can help establish the location, but zoom in to capture details. |
| **Camera Settings** | **Practice Picture:** Manual mode. I muted the camera and used the Daylight White Balance preset. |
| | **On Your Own:** In quiet locations, turn off camera sounds. If you have to shoot in a hurry, stick with Automatic; otherwise take the time to set the White Balance and Scene mode appropriately. If you review your images on a television monitor in a foreign country, you may have to change the video system to PAL. |
| **Exposure** | **Practice Picture:** Evaluative Metering, ISO 100. The sunlight that hit our friend's hand was enough to throw off the exposure. I used Auto Exposure lock (AEL). First, I reframed the shot just to the right, locked exposure, and then reframed. |
| | **On Your Own:** Make sure the histogram is on during image review so you can see if your camera's meter is giving you good exposures. Use Exposure compensation if the camera's meter consistently gives you under or over exposure. Make sure you judge by the histogram because the LCD can be hard to see in daytime. |

# Travel photography tips

**6.61** This was in a courtyard alcove in a town in Italy. It was dark and I didn't have a tripod so I turned on the Self-Timer and placed the camera on the ground to get this picture.

✦ **Know your camera.** If you acquire your camera just days before your trip, go out and photograph with it. If you don't, you'll spend more time trying to figure out your camera and less time enjoying your trip — and the photos won't be very good either. If you are practicing, shoot in similar locations or use similar types of photography. In a big city at night? Go to a nearby town at night to try some night photography or street photography.

✦ **Scope out postcards.** Don't copy what you see in a postcard but use it to give you ideas for good locations and suggestions of how others have interpreted the scene. Go online to research your destination and check out the photos you see there. While you are online, print out sunrise and sunset times. Check to see if there is a full moon (to help with night shots) when you are traveling.

✦ **Always carry your camera.** Don't miss that perfect view by leaving your camera back at the hotel. Most PowerShots are small and easy to carry, so keep your camera with you. Use it to shoot an interesting plate of food before you begin your meal. It can act as an image diary of your trip.

✦ **Get into a nightly routine.** Develop a habit at the end of the day where you recharge your batteries and review your images to see if they are what you expect. Lastly, check your lens, viewfinder, and LCD to make sure they are clean.

✦ **Enjoy the trip.** Unless you are on a photo safari, relax and have a good time. Make sure there are more images in your memory than on your memory cards.

# Winter Photography

Photographing in the cold offers both unique problems and thrilling opportunities for amazing snow and ice compositions. To get the most out of your experience, it is important to be prepared for the cold. Dress appropriately so that you are comfortable; otherwise you may rush your shot and not take the time to compose your framing properly.

Extreme temperatures are the mortal enemy of batteries. Cold weather cuts power output quickly so spare batteries are a must. Keep your spares close to your body, where they will be warm. When the camera indicates that it is time to change batteries, remove the used batteries and put them in a warm pocket. When the batteries warm up again, you may be able to put them back in the camera to shoot a few more images.

 Caution  *When you change batteries, you open the PowerShot to the elements. Try to change batteries or memory cards out of the wind, in a dry area, and with dry hands or gloves.*

## Inspiration

Don't be afraid of the brightness of the snow. Use it to highlight those little bits of color that you may find—the leftover berry

**6.62** As the sun rose and the light lost its magical properties, I started looking for small details in the dormant trees in this winter scene.

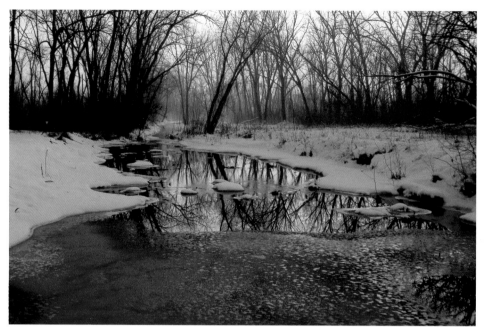

**6.63** Look around when you travel or even when you commute. This gentle scene is right off a busy highway.

on a bush that the birds have missed or the lone tufts of hay that poke through the snow drifts. Challenge yourself to use the winter landscape to communicate ideas like *quiet*, or *cold*, or *peace*.

Experiment with your normal landscape techniques but pay careful attention to your histogram. Snow reflects an incredible amount of light; think of it like shooting someone indoors against a bright window with the sun shining in. Oftentimes there isn't a lot of detail in snow (as a background), so you can let it be overexposed

while your foreground elements are exposed properly.

**Caution** *Camera optics can easily fog up when you move from the cold outside into a warm room. If you plan to go back outside, consider leaving your camera outside (in a protective case) and bring just the battery inside. Otherwise, the condensation that appears on your camera may freeze when you move outside.*

# Winter photography practice

**6.64** By creative use of white balance, this winter shot near sunset brings color to the snow.

### Table 6.19
### Taking Winter Pictures

| Setup | **Practice Picture:** The image in figure 6.64 breaks the rule of thirds. I wanted to create an image of quiet solitude in a winter scene. The footsteps in the snow give a subtle hint of a journey out to the frozen lake. |
|---|---|
| | **On Your Own:** It can be hard to find color in winter, so look for interesting shapes to shoot. Remember leading lines (as explained in Chapter 4). |
| Lighting | **Practice Picture:** The sun was starting to set and I waited for the right mix of color and long shadows. |
| | **On Your Own:** Use flash to fill in harsh shadows. When doing macro work, you might need to "bounce" some light into your scene. Bring along a small white card. If there is good packing snow on the ground, you can even make a bounce card out of a snowball. |

*Continued*

## Table 6.19 *(continued)*

| Lens | **Practice Picture:** I zoomed in slightly just to crop distracting foreground elements.<br><br>**On Your Own:** It can be hard to move about when it is cold or the snow is deep. Use your zoom to help with composition. But winter landscapes are often wide expanses with little detail, so keep your framing wide too. |
|---|---|
| Camera Settings | **Practice Picture:** Manual mode. I experimented with different white balance settings, looking for something that would emphasize the cold. I settled on the Tungsten setting—the right white balance isn't always the correct one! I could have used the Snow Scene mode but then I wouldn't have been able to adjust the white balance.<br><br>**On Your Own:** Cameras generally don't like photographing snow scenes; they tend to underexpose them. Be prepared to operate your PowerShot in Manual mode. |
| Exposure | **Practice Picture:** Evaluative Metering, ISO 100, Exposure compensation –1/3. I set the Exposure compensation down by one third to keep the color in the sky.<br><br>**On Your Own:** The light meter built into the PowerShot does a great job with a variety of situations but snow scenes are an extreme test for any exposure meter. Using Snow Scene mode can help. Play with Exposure compensation when you shoot manually. Turn on flash to add a little fill light. |
| Accessories | Spare batteries are a big help when photographing in the cold. |

## Winter photography tips

✦ **Pay attention to the weather.** Winter weather can change quickly, so make sure you are prepared for cold temperatures and blowing snow. When you operate your camera in bitter cold, use gloves and glove liners to keep your skin covered.

✦ **Don't forget macro.** Look for ice crystals. They can be fascinating subjects. Be careful not to touch the front of the lens to the snow.

✦ **Keep the camera warm.** Use chemical hand warmers (available at sporting goods stores in Fall and Winter) to make one of your pockets a moderately warm place for your PowerShot when it's between shots. This lengthens the battery's charge.

✦ **Watch your histogram.** Keep an eye on the right side of your histogram where the snow could be over exposed. But realize that sometimes overexposing the snow is okay if it has no detail to start with.

# Downloading, Editing, and Outputting

**Y**ou have captured some great images and passed around your camera so family and friends can see them. But now it is time to get those images off the camera, edit them, and, finally, create prints. Fortunately, this process has become easier and easier through the years.

There are many options for each of these steps due to differences in hardware and software. Because this is a field guide I mention just some of them. Also everything you need to download, edit, and output is included with your camera. All you need is a printer and a computer.

## Downloading

Getting your images off your camera is the first step in using your images. Although you could just keep buying memory cards, at some point you'll want to get your images to a computer to edit, e-mail, or print them.

### Downloading from the camera

Each PowerShot camera has a built-in Picture Transfer Protocol (PTP) for downloading images. PTP is an industry-wide standard for downloading images from digital still cameras to computers. The cameras also come with a USB cable to connect the camera to your computer. Most Macs and PCs have a USB connection.

Tip    *The USB cable is fairly standard. If you lose yours, you can purchase a replacement from any store that has a good selection of computer cables. The connector that plugs into the camera is called a mini-B USB 2.0 connector.*

You can download images without installing Canon software if you use Windows XP or Mac OS X 10.2 or higher. If you use other versions of Windows, including Windows 98SE, Windows 2000, or Windows ME, you need to install the supplied Canon software.

**Caution** *There are some restrictions when using PTP. With Windows XP, large movies and sound files may not download. On the Mac it is best to have the latest version of OS X. Otherwise some movies cannot download. Because of these limitations, I recommend installing the Canon software or using a card reader for downloading.*

The following Windows software is supplied with the PowerShot cameras:

✦ **ZoomBrowser EX.** This is the main application for downloading and organizing your images. It gives you some ability to edit your images. It includes the CameraWindow application.

✦ **PhotoStitch.** This software helps you combine multiple photos into a panoramic image.

✦ **TWAIN Driver.** This small application is used to establish communication between the Windows 98 and Windows 2000 operating systems and Canon cameras. It is not needed for Windows ME or Windows XP.

✦ **WIA Driver.** This software is used to establish communication between Windows ME and Canon cameras. It is not used for other flavors of Windows.

✦ **ArcSoft Photostudio.** This application offers more sophisticated image editing.

The following Macintosh software is supplied with the PowerShot cameras:

✦ **ImageBrowser.** This is the main application for downloading and organizing your images. It gives you some ability to edit your images. It includes the CameraWindow application.

✦ **PhotoStitch.** This software helps you combine multiple photos into a panoramic image.

✦ **ArcSoft Photostudio.** This application offers more sophisticated image editing.

Once you install the software, connect the camera to your computer via the USB cable. Put the camera into Playback mode and turn on the power. You have the option of controlling the download process from the camera or the computer.

**Note** *If you use Windows, the first time you connect the camera to the computer you may get a dialog box showing a list of programs and asking you to select the one you want to launch when the camera is connected. Choose Canon CameraWindow. Check the box marked "always use this program for this action" at the bottom of the dialog box to prevent this dialog box appearing each time you connect your camera.*

If you have installed the software properly and the camera is connected correctly, the LCD displays the Direct Transfer menu and your computer displays the CameraWindow application. If you use the camera to control the downloading of your images, you are presented with five menu options:

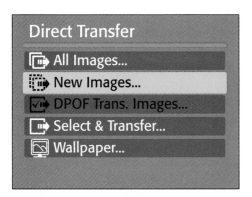

**7.1** When the camera is hooked up via USB, the Direct Transfer menu appears on the camera's LCD.

✦ **All Images.** This option transfers all of your images to the computer. Press the Func./Set button and another screen appears that allows you to start the transfer process. You can bypass the second screen by simply highlighting the menu item and pressing the Print/Share button. The images begin down-loading.

✦ **New Images.** Choose this option to download just those images that weren't downloaded previously. Otherwise it functions similarly to the All Images selection.

✦ **DPOF Trans. Images.** This option transfers those images that you have previously marked for trans-fer. If you have not chosen any images for transfer, this menu item is not accessible.

**Cross-Reference** *See Chapter 2 for more infor-mation on setting the transfer order for images.*

✦ **Select & Transfer.** This option allows you to choose each image for transfer. Once you've selected the option, the last image pho-tographed appears and you scroll

through your images using the left and right areas on the 4-Way Controller as you normally would in the Playback mode. When you find an image to download, you press the Func./Set button to select the image for downloading and the process begins immediately. Press the Menu button to exit this mode. Because the downloading occurs after each selection, you may want to use the DPOF Transfer method to select all of the images you want to download. DPOF Transfer allows you to download the images in a batch so you can do something else while the images are downloading.

✦ **Wallpaper.** Use this function to choose an image as your com-puter's desktop image. Like the previous option, selecting Wallpaper shows you the last image photographed and allows you to scroll through your images. Any image that you choose using the Func./Set button is immedi-ately downloaded to your com-puter and becomes your computer's desktop image.

If you want to control the downloading from your computer, you have two buttons in the Downloads using computer section on the CameraWindow application you can choose from:

✦ **Starts to download images.** This is the same as selecting New Images on the back of the camera. All of the images that have yet to be transferred to your computer download.

✦ **Lets you select and download images.** Select this button to open up another screen. The window fills up with small thumbnail

images of all of the photos on your camera. You can select a single image or Ctrl+click (⌘+click on a Mac) on several to download multiple images. When you have selected all of the images, press Ctrl+D (⌘+D on a Mac) to begin the download. The software offers the options of changing where the files are saved and how they are named.

## Downloading from a card reader

Although downloading with the USB cable is easy to do once it is set up, I never transfer my images this way, for three reasons. First, downloading via the USB method uses the camera's battery. Even though USB can power some computer devices, it does not power the PowerShot. Yes, the battery is rechargeable but only so many times. If you develop a regular habit of downloading images, particularly if you spend a long time choosing images or use very large memory cards, your battery might not last as long as you expect it to last. Although it is difficult to predict how many years or months a battery can last, I think it is better to use that battery life for taking pictures.

The second reason for not using a USB cable is to avoid accidents. Many times you have to find a place to set the camera during downloads. Often this location is not very stable and the camera can tip over or fall on the floor. While PowerShots are well built, they are precision optical devices that should not be dropped.

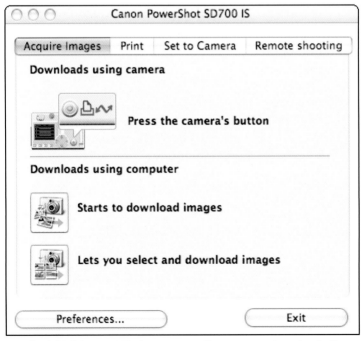

7.2 The initial CameraWindow screen allows you to download all your images, or select a few.

Third, the USB connection can be finicky at times. If you have to swap batteries or want to change modes while the CameraWindow is open, you may lose the connection and have to restart the application, or even have to disconnect and reconnect the camera. Also, as I mentioned in the beginning of this section, there are some limitations downloading large movie and sound files when you download via USB.

For all of these reasons, I highly recommend a memory card reader. They connect to your computer via USB but you can leave them connected all the time. Once the reader is connected, when you insert the memory card into the reader, CameraWindow opens up automatically (if you have the Canon software installed) and you follow the same procedure for downloading images as you use for a USB connection. You can also use your computer's file system to drag your images onto your hard drive.

When you have finished downloading images, make sure to properly eject the card. If you're using Windows, right-click on the memory card in My Computer and choose Eject. If you're using a Mac, go to your Desktop and drag the memory card icon to the Trash.

# In-Camera Editing

Although it is common to think of image editing as something that happens in the computer, there are a number of tasks that you can perform right in the camera before you download your images—deleting, protecting your images, rotating your images, adding audio comments, and adjusting the color.

**Tip** *If you plan to do more advanced image editing, several popular software applications are available that are dedicated to image editing.*

# Deleting

Although rather obvious, one of the more important editing tasks you can do in the camera is to delete images that you do not want. Since the advent of low-cost memory cards, people take more pictures than they did with film. The barriers of 36 exposures on a roll and the associated processing costs really caused people to think before they shot. With digital cameras and big memory cards, you don't have to worry about those limitations. However, the number of images you may have to wade through can be daunting. Get into the habit of deleting images that you never want to see again. Blurry faces? Delete them. Overexposed landscape? Delete it. Remember that you can delete an image during review and during playback.

To delete the image right after you have taken the picture (review):

1. **While the image is still displayed on the LCD, press the Delete button (it is marked with a trash can).**

**Note** *If you have not changed the default review time of 2 seconds, it can be difficult to erase the image during review. Chapter 2 explains how to change the review time.*

2. **The camera displays a choice of Erase or Cancel.** The default choice is Erase. Press the Func./Set button to erase.

To delete the image during playback:

1. **While the camera is in Playback mode, scroll to the picture you wish to delete.**

2. **Press the Delete button (it is marked with a trash can).**

3. **The camera displays a choice of Erase or Cancel.** The default choice is Erase. Press the Func./Set button to erase.

 **Note** *Some PowerShot cameras have a button dedicated to deleting images and others use a multi-purpose button. The key is to look for the trash can icon.*

## Protecting images

Because it is so easy to delete images, if you like passing your camera around to show off your images, consider protecting them first. If you don't do this, someone could accidentally press the Trash Can button while grabbing

7.3 A protected image appears with a key icon at the bottom of the LCD.

the camera. The camera does not default to Cancel; if someone then presses the Func./Set button the image is gone. To protect an image:

1. **Put your camera in Playback mode.**

2. **Press the Menu button and use the 4-Way Controller to navigate to Protect.**

3. **Press the Func./Set button.**

4. **Use the 4-Way Controller to scroll through your images and find one you want to protect.**

5. **Press the Func./Set button.** A key icon displays on the bottom of the screen.

6. **Repeat steps 4 and 5 to protect more images.**

7. **Press the Menu button twice to exit.**

## Batch erase using protection

You can also use protection to delete a large group of images and leave a few instead of formatting the memory card, which wipes out all images. For example, say you have 100 images on a card, only 10 of which are worth keeping, but you are running out of space. It would take a long time to individually delete 90 images and you want to keep those 10, so formatting isn't an option. Instead, protect those 10 and erase all the rest. Follow these steps to use protect to remove a number of images:

1. **Put the camera in Playback mode.**

2. **Press the Menu button and use the 4-Way Controller to navigate to Protect.**

3. **Press the Func./Set button.**

4. **Use the 4-Way Controller to scroll through your images and find one you want to protect.**

5. **Press the Func./Set button.** A key icon displays on the bottom of the screen.

6. **Repeat steps 4 and 5 to protect more images.** Protect all the images you want to save.

**7.** Press the Menu button to exit.

**8.** Use the 4-Way Controller to scroll down to Erase all and press the Func./Set button. The camera displays the message "Erase all images?"

**9.** Select OK and press the Func./Set button. Any images that haven't been protected are deleted.

 **Caution** *Make sure that you have protected ALL the images you want to keep. There is no undo. Also, protect does not have any effect when you format the memory card – all images, protected or not, are lost.*

## Rotating images

As I mention in Chapter 2, the PowerShot has an orientation sensor to determine if you are taking a horizontal or vertical picture. There may be times when the sensor has difficulty making this determination and images do not appear in the correct orientation when displayed on the LCD. In this case you can rotate the image manually:

**1.** Put the camera in Playback mode.

**2.** Press the Menu button and use the 4-Way Controller to navigate to Rotate.

**3.** Press the Func./Set button.

**4.** Use the 4-Way Controller to scroll through your images and display the one you want to rotate.

**5.** Press the Func./Set button. The image is rotated 90 degrees clockwise. If the image is rotated the wrong direction, press the Func./Set button again. The image is rotated 90 degrees counterclockwise.

**6.** When the orientation is correct, press the Menu button twice to exit.

 **Note** *Manually rotating the image or automatically rotating the image via the orientation sensor does not actually rotate the image. It simply changes a value in the image file's metadata, which tells the camera how to display the image. Most (but not all) image-editing software can also recognize this value and display the image properly.*

## Adding audio comments

PowerShot cameras have a built-in microphone that you can use to add audio comments to your images. The audio is available anytime you play back your images on your camera. Consider adding notes to your images if there is a chance you may not remember where you took the photo or if you want to remember an interesting fact about the object that you are photographing. To add an audio comment:

**1.** Put the camera in Playback mode.

**2.** Press the Menu button and use the 4-Way Controller to navigate to Sound Memo.

 **Note** *Some PowerShots have a dedicated sound recording button marked with a microphone icon.*

**3.** Press the Func./Set button.

**4.** Use the 4-Way Controller to scroll through your images and display the one to which you want to add a sound note.

**5.** Press the Func./Set button. The bottom of the display shows the following sound recording icons. The default selection is Record.

- Exit
- Record
- Pause
- Play
- Erase

6. **Press the Func./Set button to begin recording.**

7. **Speak close to the camera.** Consult the manual that came with your PowerShot to determine where the microphone is located on your camera — usually it is on the front of the camera. Once you start recording, speak into the small microphone hole.

8. **Press the Func./Set button to end recording.**

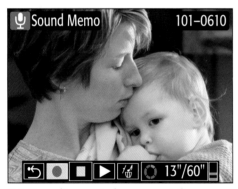

7.4 Recording controls appear at the bottom of the LCD.

After recording your message, you can play it back. To make changes to your audio comments, you can do the following:

✦ **Adjust the volume of the playback.** Use the up and down portions of the 4-Way Controller. You can adjust the playback volume while it is playing or when it is stopped.

✦ **Add more to the memo.** Highlight Record and press the Func./Set button. The new recording is appended to the end of the old one. The total length of recording time for each image is 60 seconds.

✦ **Delete a recording.** Highlight the Erase icon (a small trash can next to the play button) and press the Func./Set button.

You can tell if an image has an audio memo associated with it by looking on the camera's display for the musical note icon next to the file name.

7.5 A musical note signifies there is an audio memo associated with the displayed image.

## Adjusting color

On some PowerShots another in-camera editing feature you make is color adjustment. This is a way to change the look and feel of your images. There are ten My Colors choices.

 *These choices are similar to the My Colors setting used when in Shooting modes. See Chapter 3 for more information.*

 *The difference between My Colors in Playback mode versus Shooting mode is that during Playback mode My Colors creates a copy of the original image with the color effect applied. When you use My Colors during shooting, the image is permanently modified. If you shoot in sepia, the image is always sepia-toned.*

✦ Vivid

✦ Neutral

✦ Sepia

✦ B/W

✦ Positive Film

✦ Lighter Skin Tone

✦ Darker Skin Tone

✦ Vivid Blue

✦ Vivid Green

✦ Vivid Red

 **Cross-Reference** *For a description of each of these My Colors choices, see Chapter 3.*

To use My Colors to adjust your images:

1. **Put your camera in Playback mode.**

2. **Press the Menu button and use the 4-Way Controller to navigate to My Colors.**

3. **Press the Func./Set button.**

4. **Use the 4-Way Controller to scroll through your images and find the one you want to modify.**

5. **Press the Func./Set button.** The bottom of the screen displays the My Colors choices.

6. **Use the 4-Way Controller to scroll through the choices.** The image changes to preview each effect.

7. **When you find the setting you like, press the Func./Set button.**

8. **When the Save new image? message appears, navigate to OK and press the Func./Set button.**

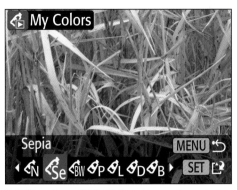

**7.6** Here I used My Colors to create a sepia-toned image.

# Image Editing via Software

Each PowerShot comes with Canon's image-editing application, which is called ZoomBrowser EX for Windows and ImageBrowser for the Mac. With this application you can organize, adjust, e-mail, and print your images. Editing your photos can be as simple as deleting the ones you don't like or as complicated as removing red-eye or adding text. The next few sections discuss the software that comes with the camera and some of the more useful functions for editing your photos.

## Image management

ZoomBrowser EX/ImageBrowser lets you rename, copy, and delete images. You can also attach a rating based on how much you like the image, and add keywords to each image that can be used as future search criteria, such as "Vienne, Birthday." As Table 7.1 shows, all of these actions are easy to perform.

## Table 7.1
## Rename, Copy, and Delete Functions of ZoomBrowser EX and ImageBrowser

| Software Application | Rename | Copy | Delete |
|---|---|---|---|
| ZoomBrowser EX | Click on the image and press F2 or right-click on the image and choose Rename from the menu that appears. Type a new filename in the Rename Image dialog box. | Right-click the thumbnail and choose Copy from the menu that appears or press Ctrl+C. Click in the gray margin and click Paste or press Ctrl+V. The new image's filename is Copy (#) of [Original Filename]. | Ctrl+click the files you want to delete and press Delete or click the Delete icon on the toolbar. |
| ImageBrowser | Click the filename below the image and type in a new filename. | ⌘+click the thumbnail and choose Copy Image from the menu that appears. Choose the destination for the duplicate image. The new image's filename will have "copying" appended to it. | ⌘+click the files you want to delete and click the Send to Trash icon in the Control Panel. |

**Tip** *Consider copying an image if you plan to make any dramatic image adjustments to it. For example, although making an image black and white might work for one purpose, once the color is gone, it is gone.*

**Caution** *There is no Undo when you delete images. If you need to recover your deleted image, you must go to the Recycle Bin/ Trash and move the image to another location.*

## Rate

If you use large image cards, it can be a little over-whelming to sift through all your images. By giving them a star rating, you can filter the image display to show only your best shots. This can also be a big help if

7.7 You can set the rating of an image using the pull-down menu in the information panel.

you download all of your images without deleting bad images from the memory card

while it is still in the camera. You may want to consider first changing all of your images to one star and then going through and rating the images that are good and then rating the ones that are best. The default rating for all images is two stars.

To rate your photos individually, follow these steps:

1. **Go to Preview Mode/Preview.** Click Preview at the top of the win-dow. Make sure the Information Panel is displayed on the right side of the screen. If it is not, choose View ⇨ View Settings ⇨ Information display panel.

2. **Click the thumbnail of the image to rate.**

• **In ZoomBrowser EX.** Right-click the thumbnail, choose Change Star Rating from the menu that appears, and then choose the new rating. Highlight the rating you want and release the mouse button to accept the new rating.

• **In ImageBrowser.** Click and hold on the star rating menu in the Information Panel. Highlight the rating you want and release the mouse button to accept the new rating.

To give multiple photos the same rating all at once:

1. **Set view mode to List.** Click List at the top of the window or choose View ⇨ View Mode ⇨ List.

**7.8** It's easy to set the star rating on multiple images.

2. **Ctrl+click (⌘+click on a Mac) the images you want to rate.** This allows you to select individual images that are not all in sequence.

3. **Choose Edit ➪ Change Star Rating, and then choose the rating you want to apply.**

4. **Click Yes when the software asks if you want to change the star rating on multiple images.**

Tip
*You can also right-click one of the selected images, and then choose Change Star Rating from the menu that appears to change multiple images.*

## Filter

Once you have rated the images in your folder, you can filter them to display only those that have a high-enough star rating.

✦ **ZoomBrowser EX.** Click the Show drop-down list (at the top of each Mode window), and then click on the star rating you want to see.

✦ **ImageBrowser.** Just below the image window you should see options for Filter by Star Rating. Select or deselect the star options for each rating to show only the rating you want to see.

7.9 Filtering to three stars shows your best images in that folder.

## Keywords

If you are good at organizing your images and you have an excellent memory, you won't have much trouble locating any of your images by subject matter. But if your memory isn't that good and your images are fairly disorganized, consider using key-words to help you find images. Add key-words to your images using the Keywords section in the Information panel.

**Tip** *By adding keywords consistently, you can easily search for images.*

# Image adjustment

Even though by now you have learned a great deal about capturing great images with your PowerShot, there are times when your image may need a little help. Although image adjustment can conjure up ideas of complicated image-editing applications like Photoshop, ZoomBrowser EX and ImageBrowser have easy-to-use tools that allow you to make image adjustments.

To make any adjustments to an image, double-click its thumbnail. A new image

**7.10** I added "home" and "dew" as keywords to this image. "Home" was a default keyword but "dew" I added for this image.

window appears. Click the Edit button and a menu appears with the following options:

> **Tip** *Double-clicking the thumbnail brings the image to almost full screen size.*

✦ **Trim/Trim Image.** Use this tool to crop your image, or to eliminate unwanted objects around the edge of the frame.

✦ **Color/Brightness Adjustment.** Adjust the amount of red, green, and blue in the image. You can also adjust the image's overall color saturation and brightness.

✦ **Red-Eye Correction.** If the red-eye flash reduction didn't turn on or didn't work well enough, you can get the red out by using this tool. The Auto/Automatic Mode attempts to find the problem for you. If you prefer to make the correction yourself, click Manual

Mode, and then click on the red-colored pupils.

✦ **Level Adjustment.** Available only in ImageBrowser, you can make changes to your histogram after the shot has been taken. If the image is slightly underexposed, drag the adjustment slider to brighten up the image.

✦ **Auto Adjustment.** If you don't want to fool around with individual levels and color controls, use this automatic tool. It evaluates your image and applies corrections in order to achieve a good white balance and proper exposure.

✦ **Edit with Registered Application.** If you already have an image editor installed on your computer, you can send the image out to the image editor by using this command.

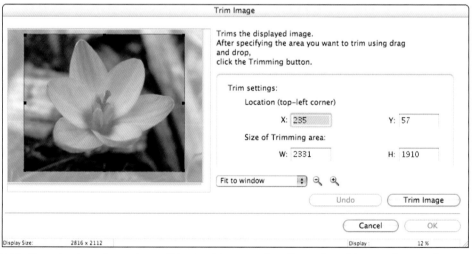

**7.11** Cropping is an important editing tool to removing distracting objects, colors, and especially bright objects near the edge of your image.

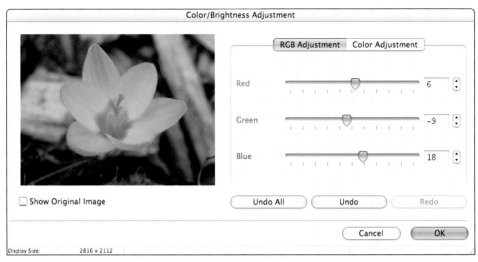

**7.12** Here I wanted to punch up the blue in the flower. Be careful about adding too much color to your image. Oversaturated colors can add noise to your image.

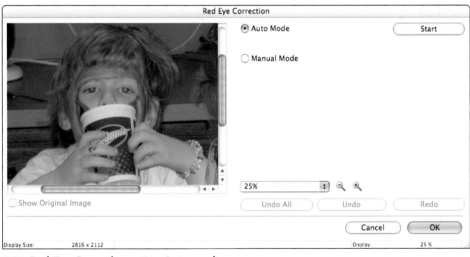

**7.13** Red-Eye Correction, set to Auto mode.

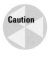

**Caution** *Although these image editing adjustments work well, nothing compares to a properly exposed image. You can ruin your images if you try to compensate for overexposure or underexposure by using Level Adjustments or Tone Curve.*

## Resizing images for e-mail

One of the most common errors that people make when sending an image via e-mail is to send an image that is too large. An e-mail message that is overloaded with images is oftentimes rejected by the receiver's mail

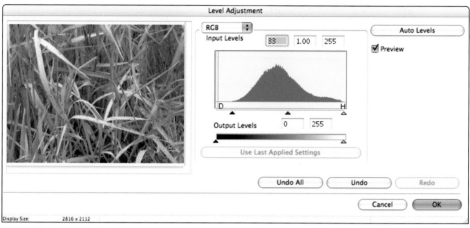

**7.14** This image didn't have enough punch. Correcting the image involved dragging the triangular control on the left of the histogram to the right, to add more contrast to the image.

server. If the message makes it past the mail server, it may fill up the recipient's e-mail box so she or he can't receive any more mail.

You can use ZoomBrowser EX/ImageBrowser to reduce the size of your images so they make it through the Internet. When you send your images via e-mail, make sure that you select the Resize and compress images into JPEG type and Resize, Compress, and Send options in the Create Image for Email dialog box (Internet ⇨ Send Images by Email/Create Image for Email). If you don't check these boxes, the files will be too big.

You must adjust the image size and compression quality. Your final image size should be measured in Kilobytes (KB) not Megabytes (MB).

# Printing

When you really want to see your images, nothing beats a print. PowerShots are capable of producing some great prints. There are two options for printing: directly from the camera or via your computer. I highly recommend printing directly from your camera.

Why? Because you are more likely to print your images. The scenario where the photo printer is in the home office connected to the computer means that if all you want is one little print, you have to fire up your computer, download your images, tweak them, and then print them. When you print from the PowerShot, the camera takes the place of the computer. In less than five minutes you can have a print in your hands.

## Printing from the camera

PowerShot cameras can print to any PictBridge-enabled printer. You can choose to connect your camera and simply print all the images from the memory card, or you can choose specific images to print. You can also make some minor adjustments in-camera before printing.

 **Note**  *PictBridge is an industry standard technology that allows cameras to talk directly to printers. It is not just a Canon protocol, so if you have another brand of printer that supports PictBridge, it will work with your camera. Using a Canon printer allows for some additional effects and paper sizes.*

To print using a PictBridge-enabled printer:

1. **Turn off the printer and the camera.**

2. **Connect the camera to the printer using the Canon USB cable.** This is the same cable as the download cable. Make sure that you connect the cable to the printer's Pictbridge USB connector.

3. **Turn on the printer.** You must turn the printer on prior to the camera.

4. **Turn on the camera and Set it to Playback mode.** If everything is connected properly, the blue direct printing light on the camera turns on. The Pictbridge icon displays in the upper right of the camera's LCD, together with the Set icon.

5. **Press the Print/Share button on the camera to print your images.** This option prints all the images from your memory card.

 **Note** If the camera-to-printer connection isn't working, try turning off the printer and camera again and then re-powering each.

When the camera is connected directly to the printer you can use the camera display to set up the printer's printing parameters. Options to choose from when printing from the camera include:

✦ **Choose specific images and image quantity.** If you only want to print selected images, go the Select Image & Qty. menu. You select the images you want to print as you scroll through all of the images on your memory card. When you select an image, you can also adjust the number of prints needed.

**Note** Each time you mark an image for printing you are setting a DPOF or Digital Print Order Format flag. You can also do this when you are in the field, and not connected to a printer. When you connect the camera to the printer, the DPOF flags are used to select images for printing. They are also recognized at some photo kiosks.

✦ **File number and file date.** From the Print Settings menu, you can choose Print Type, which allows you to turn on or off whether the file number and file date appear in the prints you make.

✦ **Delete DPOF selections after printing.** This removes the DPOF flags that were used to mark the images for printing.

✦ **Choose paper size, paper type, and page layout.** From the Print... menu, you can choose the paper size, the paper type, and even the page layout that you'd like to have printed.

✦ **Image optimization.** The Print Settings menu lists image optimization settings that you can use to modify how your prints look. The settings for image optimization include:

  • **On.** This setting optimizes the image for printing by using the camera's shooting data stored with the image.

  • **Off.** This mode does not apply any processing to the image.

  • **Vivid.** To enhance colors, the Vivid mode saturates colors in the scene before sending the image to the printer. Foliage is greener and skies are bluer.

- **NR.** This setting applies noise reduction algorithms to the image. Use this setting if you have been shooting with high ISO settings.

- **Vivid + NR.** Both noise reduction and color enhancement are applied to the image.

- **Face.** This setting attempts to increase the brightness of people's faces. Use this mode when your shot has strong backlighting. This mode is not available on all PowerShots.

- **Default.** The default mode does not apply any in-camera processing. The image is printed with the default printer settings.

You can also print a directory of all the images on your memory card by printing an index print. Printed on a 4 × 6 inch sheet, an index print shows the images on your card reduced to thumbnail size. It is a good way to catalog your images before you download them.

An index print can be made up of all images or just a select few. To print an index print,

in the Print Settings menu, choose Index from Print Type. Similar to a single print, you can choose to have the file number or file date printed on your index print—you can not have both printed on your index print. Also from the Print Settings menu, you should select the paper size and type of paper for your index print.

# Printing from the computer

If you want more control over the printing process, you can use ZoomBrowser EX/ImageBrowser to print index prints and single images. There are three options to print via the computer. Choose File ⇨ Print and select an option.

✦ **One Photo per page Print.** This is a typical printing setup. You can adjust the cropping for each photo and choose multiple copies of each image.

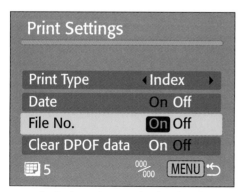

7.15 The index print can display the file number or the date but not both.

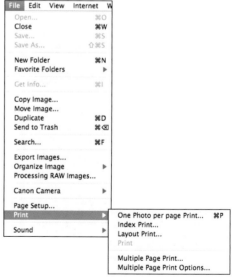

7.16 After selecting your images there are several printing options.

✦ **Index Print.** Just like printing direct from the camera, the index print gives you images represented by thumbnails. However, with the index print from the computer, you can select any or all of the metadata contained in the file, not just the file name or file date.

✦ **Layout Print.** If you always wanted to print out wallet-sized prints, this is the way. This option gives you several preset layouts, including 5 × 7 and 8 × 10.

✦ **Multiple Page Print.** This option is for printing a single image across several sheets of paper.

✦ **Multiple Page Print Options.** This allows you to set the resolution of the final print-out across several sheets of paper.

# Television Slide Shows

If you want to display your images on your television, the PowerShot is capable of producing a slide show that plays back right from your camera. You can set transitions and length of display easily using the camera's menus.

To connect the PowerShot to your TV:

1. **Turn off the camera and the television.**

2. **Connect one end of the audio/video cable that came with your PowerShot to the A/V (Audio/Video) Out connector on the camera.**

3. **Connect the other end of the A/V cable to your TV's Video and Audio In.**

4. **Turn on the TV and set the input to video.**

5. **Set the camera for Playback mode and turn on the camera.** It is that easy!

To create a slide show:

1. **Put the camera in Playback mode and press the Menu button.**

2. **Use the 4-Way Controller to select Slide Show and press the Func./Set button.**

3. **Use the 4-Way Controller to select Set Up and press the Func./Set button.** You can select Play Time from 3 seconds to 30 seconds and whether you want the slide show to repeat.

Tip    *Choose the playback length carefully. Have someone watch the show to give you feedback on how long the images should last on the screen. If you are creating a slide show for playback on a television, make sure you watch it on a television. The experience is much different than watching the back of your camera.*

4. **Press the Menu button to exit the Slide Show menu.**

5. **Use the 4-Way Controller to select the images you want to include in your slide show.**

   • **All Images.** This setting includes everything on the memory card.

   • **Date.** This setting only displays images from a certain date.

   • **Folder.** This setting only presents images from a certain folder.

   • **Movies.** Only movies recorded with the camera are shown.

- **Stills.** All files except movies are included in this mode.

- **Custom 1-3.** This setting allows you to choose the images to include in your slide show. There are three independent memories so that you can have three separate slide shows with different images in each.

If you have selected Date, Folder, or Custom 1-3, press the Func./Set button to select the date, folder, or images you want to include in your slide show. Press the Menu button when you have finished selecting images.

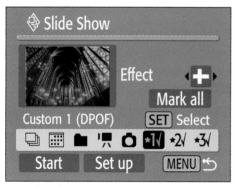

7.17 This slide show is set up to play back a custom-selected series of images.

6. **Use the 4-Way Controller to select Effect.** There are four options for effects. Canon doesn't give them names so I have given them a name that approximates the effect.

   - **Off.** Images cut from one to the next.

   - **Bottom up.** The new image moves up from the bottom of the screen as it dissolves up.

   - **Cross.** A cross shape wipes the image to white. A cursor

appears and moves to another section of the screen where another cross shape wipes on the next image. If the image file has a different date from the previous image, the white screen between the two shows the new date.

- **Multi-pan.** Sections of the image pan across a vertically cropped display. This happens twice before the full image is revealed. The time the image was captured is displayed underneath the cropped versions. If the image file has a different date from the previous image, the date appears before the animation begins.

Tip  *The Cross and Multi-pan effects look fun, but if you have a lot of images, they can be distracting. After all, the images are most important. The Multi-pan, in particular, always crops from the center of the image, so if you have been following the Rule of Thirds, it won't be revealing a very interesting part of your photograph.*

7. **Use the 4-Way Controller to select Start and press the Func./Set button to start your slide show.** While the slide show is playing, pressing the Func./Set button pauses your slide show. Using the left and right portions of the 4-Way Controller steps your slide show back an image or forward an image. Pressing the Menu button stops the slide show.

Tip  *You can begin a quick slide show starting with the current image displayed on the LCD by pressing and holding the Func./Set button, and then pressing the Print/Share button.*

# Using the Video Feature

✦   ✦   ✦   ✦

**In This Chapter**

Setting up to record

Knowing the limitations

When the shooting stops

Successful video

✦   ✦   ✦   ✦

**T**he Canon PowerShot series of cameras excels at capturing great still images, but the cameras can record moving images as well. Although you won't be filming the next *Star Wars*, you can preserve some once-in-a-lifetime moments. Motion can bring to life blowing out those birthday candles or an anniversary kiss in a way that a still picture can't. Or you might capture that next popular YouTube movie!

## Setting Up to Record

As you learned in earlier chapters, setting up your PowerShot to capture a single digital still image takes very little effort. Recording a series of still pictures (that's what video is) consistently requires a bit of horsepower. It is important that you understand how to configure your camera so you can record video properly.

### Resolution

First, you must select your video's resolution. Choose the best resolution for your intended video use, from e-mail to standard television and beyond. There are several resolution settings on the PowerShot to choose from:

> **Note**   As a point of comparison, television programs have a pixel count of 720 × 486.

✦ **160.** This is the smallest resolution, comprising 160 × 120 pixels. Choose this mode when you want to e-mail a movie or when the final destination is a cell phone. Although it may also be used for posting on a Web page, it is on the small side.

✦ **320.** This is a standard size for Internet use. With dimensions of 320 × 240, it is about half the size of regular video. Depending on the video's length, it is not a good candidate for e-mail but it is a size most commonly used for video sharing sites, such as YouTube.

✦ **640.** This is the largest size for video recorded on most PowerShot cameras. At 640 × 480, it is close in size to standard definition video and displays well on a standard television. Although it's out of the question for e-mail and is suitable for only the fastest, well-connected Web sites, if you have multiple uses for your video, start with this size. When you start with a 640 × 480, you can resize it to 160 × 120 for e-mail and/or scale it down to quarter size (320 × 240) to post on your Web site.

✦ **1024.** This resolution is included in the PowerShot G7. 1024 × 768 is a common screen resolution for computer displays. Video shot with this resolution may be played back in full-screen mode on computer screens.

✦ **1280.** Available only on the TX1, this video is high definition. Known as "720" in the digital television environment, the pixel count is 1280 × 720. If you have access to a high-definition digital television, it will likely have a pixel count of either 1280 × 720 or 1920 × 1080. A movie in this resolution looks best when played back on a 720 display.

## Frame rate

Pixel count is only one aspect of moving video. The PowerShot cameras let you set how many pictures per second are recorded. Standard television is displayed at 30 frames per second (fps). The frame rate you choose depends on the subject matter, how much room you have on the card, and your PowerShot's capabilities. Note that not all cameras offer all of these frame rates, so you should check your camera's capabilities. The frame rate options are:

✦ **Fast Frame Rate.** Shooting at 60 frames per second is truly a faster frame rate than a regular video camcorder. It is useful when you want to capture objects that are moving fast. Although not as quick as the super slow motion you've seen on televised sporting events (120 frames per second), it can help analyze a faulty golf swing.

✦ **30 frames per second.** This is the standard television frame rate.

✦ **15 frames per second.** Half the rate of normal video, this mode allows for a longer record time and is useful for recording scenes without much movement. It is common for Web-posted videos to use a frame rate this slow. Because people are accustomed to seeing this rate, it is becoming more and more acceptable for posted videos.

✦ **10 frames per second.** One-third the frequency of normal video, this rate is available in some PowerShot cameras for higher resolution movies.

✦ **Time Lapse.** Much like a security camera system, Time Lapse mode takes images infrequently. The choices for Time Lapse are one image every second or one image every 2 seconds. When Time Lapse is played back, it is sped up so the frame rate of the movie is 15 fps.

**Tip** *Try something different! For example, show up a little early to your daughter's dance recital and record a time-lapse movie of the audience filling up the auditorium before the perform-ance. A tripod is a must!*

## White balance

The camera is not capturing just one image but a series of images, so there is a good possibility the light's color temperature may change if you move with the camera. If this is the case, your best option for recording video may be to use Auto White Balance. If you are sure the light's color temperature will not change, set the white balance just as you would for still images.

**Cross-Reference** *See Chapter 3 for a description of the White Balance setting.*

## Exposure

You have learned that exposure is made of three settings: aperture, shutter speed, and ISO. With the PowerShot's movie modes, the camera adjusts these three settings automatically. The shutter speed is at least as fast as the frame rate. For example, when you shoot at the fast frame rate of 60 frames per second, the shutter speed won't dip below 1/60. ISO and aperture are set at the beginning of the recording and are adjusted continually during the recording.

If you think a particular scene may record too brightly or too darkly, you can compensate before you begin recording by pressing the ISO control. The exposure shift bar appears at the bottom of the LCD display. Use the left and right controls to darken or brighten the image.

## Focus

Getting proper focus while shooting video is just as critical as when shooting stills. Unfortunately objects in your scene move, sometimes continually. In Movie mode PowerShots set focus when the shutter is pressed halfway, just as in still mode. The focus is set for the entire video. You can set the camera to Macro mode or Infinity mode, but keep in mind that if you are in Macro mode, you'll be in Macro mode for the whole time.

**Tip** *You lock focus using the same technique as you do for locking focus when shooting stills. Press the Shutter release button half way to set focus. Press the Macro/Infinity control to lock focus.*

If you have problems with focus, consider shooting several video segments. After you end recording a segment, reset the focus and start shooting again.

## Recording the video

Once you have done the preliminary setup, you are ready to shoot the video. This is a very easy process, very similar to actually taking a photo with your PowerShot.

To record video, follow these steps:

1. **Set the camera to Movie mode.**

2. **Choose a resolution.**

3. **Choose a frame rate.**

4. **Choose a white balance.**
   Remember if you are unsure of the stability of the lighting conditions, use the Auto setting.

5. **Adjust zoom for desired composition.**

6. **Press the Shutter release button half-way to set focus and initial exposure.**

7. **Press the Shutter release button all the way to start recording.**

8. **Press the Shutter release button again to stop recording.**

# Knowing the Limitations

The PowerShot is, first and foremost, a digital still camera. But that is not to say that videos shot with the camera can't tell a story, or move your viewers—they certainly can. But it is important to manage your expectations when shooting video so you can avoid frustration.

## Frame rate versus resolution

Although there are several different options for frame rate and resolution, capturing and recording video is a hardware-intensive process. Because of this, there are limitations

to the combination of frame rate and resolution. Canon has give names to some combinations:

✦ **Compact.** Specifically designed for e-mail, the compact setting marries 160 × 120 pixels with 15 fps. Once set for this mode, you cannot adjust either the frame rate or resolution. Ten seconds of video at this setting is just under 1MB, so it works for e-mail attachments.

✦ **Fast Frame Rate.** While I mention Fast Frame Rate earlier in this chapter as a frame rate, it is also a frame rate/resolution combination. Processing 60 frames per second takes a lot of processing power, so the resolution must be smaller than normal. Fast Frame Rate has a resolution of 320 × 240 pixels. Ten seconds of video at this resolution can easily run over 5MB. This file size is not a good one to e-mail.

✦ **High Resolution.** Spitting out 1024 × 768 pixels at a constant rate chews up camera processing horsepower. The frame rate for this mode is locked-in at 15 frames per second.

✦ **High Definition.** The TX1 PowerShot records its high-definition resolution at 30 frames per second.

✦ **Standard.** This mode gives you the most flexibility. Think of it like Manual mode when you shoot photos. Using Standard, you can change resolution between 320 × 320 and 640 × 480 pixels and also choose between 15 and 30 frames per second.

# Recording length

Even though memory card sizes increase every year, recognize that there are limitations on movie length that are not based on memory card size. As I mentioned previously, Compact mode is specifically designed for e-mailing movies. The recording time for Compact mode maxes out at three minutes.

With Fast Frame Rate, the recording length is one minute. At the end of one minute, the camera automatically stops recording. As a warning, the recording time counter on the LCD turns red ten seconds before the end of the maximum recording length.

The maximum recording length for other modes is generally an hour—memory card space permitting. Although some PowerShots have movie file size limitations of either 1GB or 4GB, the total movie length can still only be one hour.

**Tip**

*Resist the temptation to shoot your videos vertically. While it is easy to rotate a 4 × 6 inch print, putting your television on its side can be difficult. Stick with horizontal composition. If you must shoot vertically, you can use ZoomBrowser EX or ImageBrowser to rotate the image (it will be smaller and have black bars on either side).*

# Storage

One of the most taxing parts of recording video is writing to the memory card. When you capture stills, the camera only has to write one image at a time; when you shoot video, the camera has to process multiple frames. For best success with video, use high-speed, high-capacity cards. When you record large video files, using a memory card scattered with still images can be trouble; in fact, the camera may stop recording.

## SDHC

Digital photographers know memory cards can never have too much room. Originally there was only one type of SD (Secure Digital) card; now there is a new type: SDHC. HC stands for high capacity. In size and shape, the card is identical to the original SD card, but electrically they are not the same. SDHC cards also feature a Class Speed Rating. This rating specifies a minimum sustained write speed. The three classes are simply known as Class 2, Class 4, and Class 6 and represent a minimum sustained write speed of 2MBs, 4MBs, and 6MBs respectively.

However, SDHC cards are *not* backwards compatible with SD cards. It is worth repeating: SDHC is not SD. Yes, physically they are the same size and fit into each other's slots, but electrically they are not the same.

Here are the compatibility rules:

✦ You can use an SD card in any SDHC slot. In other words, if your PowerShot supports SDHC you don't need to throw away all of your old SD cards; they will work just fine.

✦ You cannot use an SDHC card in an SD slot.

For optimum recording speed, reformat your card using the low-level formatting process I outline in Chapter 2.

> **Tip** *Consider carrying an extra memory card that is used just for recording videos. This way you can record your photos on one card and swap it for the video memory card.*

## Sound

While I often joke that audio is just the squeaky part of the picture, it really can be an important element. Be aware of where your camera's microphone is located. It is usually a small hole on the front, facing your subject. When you hold the camera, make sure you do not cover the hole with a finger. The microphone records the sound of your hand moving on the camera, so pick a comfortable grip or use a tripod if you plan to record for a while.

# When the Shooting Stops

Once you have finished shooting your video, you can work with the files several ways, but the most common choices are to edit "in camera," use the Canon-supplied image editing software, or use other applications like Microsoft's MovieMaker or Apple's iMovie.

## In-camera editing

Depending on your model of PowerShot, you can modify each video clip in the camera by using the Playback function. In-camera editing saves a copy of the file, so make sure there is enough room on your memory card before you begin. To edit your video clip, follow these steps:

1. **Switch the camera to Playback mode.**

2. **Scroll through and select the video you want to edit.**

3. **Press the Func./Set button to display the Movie Player controls.**

4. **Select the Play icon and press the Func./Set button to play your movie.**

5. **Select the Scissors icon (Edit) and press the Func./Set button to enter editing mode.** The Movie Player controls are replaced with a timeline representing the entire length of your movie.

    • To trim the beginning of your movie, select the Scissors icon to the left of the film frame.

    • To trim the end of your movie, select the Scissors icon to the right of the film frame.

6. **Use the left and right arrow controls to scroll through your movie and find the frame where you want to begin your movie.** Right goes forward; left goes backwards. Each press of the control moves one frame. Press and hold the control to jump through the video one second at a time. An orange indicator, toward the left, shows your current location on the timeline. The footage to be trimmed is represented in gray on the timeline.

7. **Select the Play icon to preview your edit.**

8. **If you like your edit points, select the Save icon to save a New File with the edits you have selected.**

# Editing on the computer

Whether your camera has in-camera movie editing or not, you can use Canon's ZoomBrowser EX (for the PC) or ImageBrowser (for the Mac) to combine movies to tell a story, export still frames from your movie, or compress a higher-resolution movie so you can e-mail it. First you must download your movies, as I describe in Chapter 7.

> **Note**   *Movie clips appear with a camera icon in the upper-right corner of the thumbnail to differentiate them from still images.*

Once your movies are downloaded, you can give them star ratings like you can for still images, play them in the main window, and add keywords and comments. Use the MovieEdit Task function to arrange, edit, add audio, and then save your movies. Start by assembling several clips into one movie.

> **Tip**   *Trimming (or changing the start and stop points of your movie clip) is one of the most valuable editing functions.*

Next, try adding effects to individual scenes or transitions between them. You can add text on top of your video, zoom into the scene, and add various filters that make your movie black and white or sepia-toned. When adding text, make sure the font, color, and size you have selected is readable on the screen. This is particularly important with smaller movies that you plan to email or post on the Web. Avoid thin fonts.

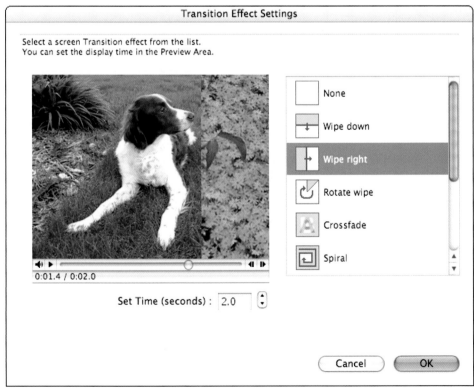

8.1 Add transitions between your movie clips.

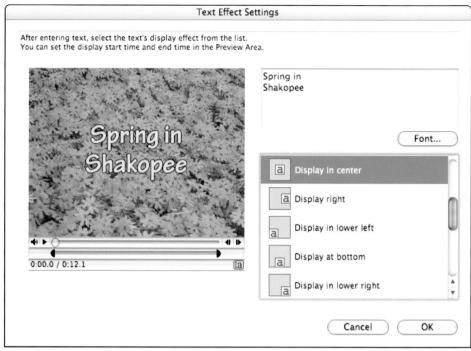

8.2 Add text and text effects.

**Tip**
*Be careful that you don't overdo it with effects. The movie should be about your images not about the effects!*

Once you have added some text, you can begin to work with the audio. You can adjust the volume and add an audio track that spans your entire collection of scenes.

# Video Tips

This chapter has covered a lot of the technical details you need to understand to capture video with a PowerShot. Here are a few tips for shooting video:

✦ **Use a tripod.** I have seen people try to record events while hand-holding a camera and was thankful that I wouldn't have to watch it afterwards. A blurry video image is just as difficult to view as a blurry still image. If you can't use a tripod, support the camera well.

**Cross-Reference**
*Refer to Chapter 4 for methods to support your PowerShot.*

✦ **Tell a story.** Consider your audience. Will they know what is going on? Consider the Movie Making 101 idea of first shooting a wide establishing shot to let the viewer know where they are. Then go in for closer shots to add detail to your story.

✦ **Go easy on camera movement.**
Even if your PowerShot model sup-
ports zoom while recording videos,
be careful with it. Unless you are
making the next *Blair Witch
Project*, sometimes cutting from a
wide shot to a close-up can work
better.

✦ **Edit/trim.** If you took an underex-
posed, out-of-focus photograph,
would you pass it around to your
family and friends to view? Video
should be treated the same way.
With the PowerShots that can trim
videos in-camera, you have no
excuse not to trim out your
mistakes.

✦ **Pay attention to audio.** It is
worth repeating: Remember where
the camera's microphone is and
avoid making a lot of noise when
you hold the camera. You should
also pay attention to where you
are standing when recording video.
If you are outside next to an air
conditioning unit when you record
that outside birthday party, you
might never hear the resounding
chorus of "Happy Birthday."

✦ **Shoot a background for titles.**
Consider shooting some abstract or
close-up shots to use for back-
grounds to title your video. If you
can't find a suitable background,
try setting the camera to Macro,
locking focus on something very
close, and then pulling the camera
back to make the whole scene out
of focus. Put a title effect on it and
you have great way to start the
show.

# Appendixes

# Online Resources

The Internet provides a massive amount of information about digital photography and PowerShot cameras. Remember, though, that just because you see something on the Internet doesn't make it true — be prepared to question and experiment.

## Updating

PowerShot cameras are essentially small image-processing computers. They run on software. When you edit downloaded images, you use image-editing software. Sometimes Canon provides software updates in order to add a feature or correct a problem. It is a good idea to check for updates on a regular basis.

### Firmware updates

The software, called firmware, that runs the PowerShot is written into a special memory area that is built-in to the camera. When Canon provides a patch or section of computer software code to correct a problem or add a feature, it is contained in something called a *firmware update*.

1. The process for updating firmware is listed step by step on Canon's Web site.

**Caution** *Make sure you use a fully-charged battery or AC adaptor when you start this procedure.*

There are two Web sites you can check out to see if there are any firmware updates for your PowerShot. The first site is Canon's support site in the United States:

```
www.usa.canon.com/consumer/controller?act=
SupportIndexAct
```

You must select the product category, type, and model in order to get to your camera's support information. This is also a good place to check for product recalls or important information about your camera.

The other site is in Japan and links directly to all of Canon's camera firmware updates:

```
http://web.canon.jp/imaging/
news-f-e.html
```

Unlike software applications that have updates every few months, PowerShot firmware updates are pretty rare. They are difficult to create without compromising other camera functions. In short, if you go to the Web site and don't see your camera listed, don't be disappointed.

## Software updates

The software for downloading and editing that comes with PowerShots (ZoomBrowser EX on Windows and ImageBrowser on the Mac) is often updated. When you go to Canon's U.S. Web site (listed in the previous section), after you search for your camera model, click on the Drivers/Software link. A window should open, showing you the latest software updates for your image software.

# Learning More

There are several avenues for learning more about digital photography; some are equipment related while others help you learn to take better pictures.

## PowerShot

If you want to get more information on Canon PowerShots, whether it be specifications, frequently asked questions, or product

notices, the Canon Web sites offer a lot of information.

## Canon USA

www.usa.canon.com/consumer

This is the starting point for all things Canon in the United States. Click Cameras and then click Digital Cameras to get a list of current models. Click on the Support tab to search for more information about your PowerShot model. Also click on the Resources & Learning tab on the right to access more information about shooting great images.

## Canon Canada

www.canon.ca/digitalphotography/
english/

There are three tabs that you should click on: Learn, Canon Community, and Canon Technology. They are great resources for photo tips and understanding the technology of digital photography.

## Canon Japan

http://web.canon.jp/imaging/
BeBit-e.html

This site is not as easy to get around as others, but if you want technical information on PowerShots, search here. Also check out the links on the right side of the page near the bottom. There are several useful pages that explain Canon's PowerShot features.

## Photography publications

Photography magazines are a great resource for learning more about digital photography. In addition to informative articles, you are exposed to a lot of different printed images.

## PCPhoto

www.pcphotomag.com

This magazine offers a lot of information for the beginning photographer. There are articles about taking great pictures and also articles about editing them on the computer. While there is a fair amount of discussion about equipment, the focus still is on the image. There is a HelpLine column that accepts reader questions on all aspects of digital photography.

## Outdoor Photographer

www.outdoorphotographer.com

This is *the* publication to learn about taking pictures in the great outdoors. Learn about photo safaris, professional outdoor photographers, and the best techniques to shoot outdoors.

## Popular Photography & Imaging

www.popphoto.com

This magazine's focus is on camera gear. If you want to read about the latest equipment or see product reviews and tests, this is a good resource.

## Shutterbug

www.shutterbug.com

If you want to examine equipment reviews and learn about the latest product releases browse through Shutterbug.

# Photographic equipment reviews

When it comes time to purchase cameras or accessories online, equipment review sites can be a great source of information. While they might not cover all the aspects that might be important to you, they can be a good start for evaluating equipment.

## Imaging Resource

www.imaging-resource.com

Launched in 1998 Imaging Resource allows you to evaluate cameras by price, pixels, and performance. There is a tool that allows you to select several cameras and produce a table comparing camera specs.

## Digital Camera Resource Page

www.dcresource.com

Founded in 1997 the Digital Camera Resource Page provides reviews of consumer versus professional camera gear.

## Photography Review

www.photographyreview.com

Photography Review assembles user camera reviews from both professionals and amateurs.

## Digital Photography Review

www.dpreview.com

Established in 1998, Digital Photography Review offers an extensive database of camera reviews. They also preview new cameras as they are announced.

# Photo Sharing

If you want to share your images easily with people all over the world, e-mail may not be the best answer. There are several different types of sites that differ on how they make money. Some charge a fee for storing and

displaying your images. Other sites have advertising on all of the Web pages that display your photos. Finally, some make money through printing images.

 **Caution** *Photo sharing sites are great tools for sharing photos but resist the temptation to use them as your digital image storage. Always keep a local copy of your images.*

There are lots of Web sites that can help you get started; here are just a few.

## Snapfish

www.snapfish.com

Snapfish is owned by HP and offers online sharing and digital printing. It offers free online storage of your images, but you must keep an account active in order to take advantage of the storage. Currently, keeping an account active requires some sort of purchase each year.

## Shutterfly

www.shutterfly.com

Shutterfly offers a full range of products from free online storage to prints that can be picked up at Target. They reserve the right to cancel accounts that have been inactive for 180 days.

## Phanfare

www.phanfare.com

Phanfare is a membership-based site with either a monthly or yearly fee. It offers unlimited storage of images and limited storage of videos. A variety of photo web pages and photo albums are available to display your images. This site is focused on photo sharing rather than photo printing.

## Flickr

www.flickr.com

Flickr is Yahoo's photo-sharing Web site that is built around a photography community. It is advertiser supported and limits your uploads to 100MB per month. It does not offer printing.

## Kodak Easyshare Gallery

www.kodakgallery.com

Kodak Easyshare Gallery began as one of the first photo-sharing sites (ofoto.com). It offers online sharing, special photo printed products, and print orders that can be picked up at many chain camera stores and chain pharmacies.

# Glossary

**A**E   Automatic Exposure. A setting where the camera automatically adjusts the amount of light that hits the image sensor in order to produce a properly exposed image.

**AE lock**   Automatic Exposure lock. A camera control that allows the photographer to lock the exposure from a meter reading. After the exposure is locked, the photographer can then recompose the image.

**AF lock**   Autofocus lock. A camera control that locks the focus on a subject and allows the photographer to recompose the image without the focus changing.

**AiAF**   Artificial Intelligence Auto Focus. A method of focus based on evaluating objects in the scene.

**ambient light**   The natural or artificial illumination within a scene. Also referred to as available light.

**angle of view**   The amount of area seen by a lens or viewfinder, measured in degrees. Shorter or wide-angle lenses and zoom settings have a greater angle of view. Longer or tele-photo lenses and zoom settings have a narrower angle of view.

**aperture**   The lens opening through which light passes. Aperture size is adjusted by opening or closing the diaphragm. Aperture is expressed in f-stops such as f/8, f/5.6, and so on. The higher the number, the smaller the aperture opening. See also *f-number*.

**Aperture priority**   Av Aperture-Priority AE. A semiautomatic camera mode in which the photographer sets the aperture (f-stop), and the camera automatically sets the shutter speed for correct exposure. Av stands for Aperture value. The opposite of Shutter priority.

**artifact**   An unintentional or unwanted element in an image caused by an imaging device; or a byproduct of software processing such as compression, flaws from compression, color flecks, and digital noise.

**artificial light**   The light from an electric light or flash unit. The opposite of natural light.

**autofocus**   The camera controls the focusing elements of the lens in order to create a sharp image.

**automatic exposure**   The camera meters the light in the scene and automatically sets the shutter speed, ISO, and aperture necessary to make a properly exposed picture.

**automatic flash**   When the camera determines that the existing light is too low to get either a good exposure or a sharp image, it automatically fires the built-in flash unit.

**Av**   Aperture value. See *Aperture priority*.

**backlighting**   Light that is behind and pointing to the back of the subject.

**bit**   The smallest unit of binary data — binary digit.

**bit depth**   The number of bits (the smallest unit of information used by computers) used to represent each pixel in an image that determines the image's color and tonal range.

**bounce light**   Light that is directed toward an object, such as a wall or ceiling, so that it reflects (or bounces) light back onto the subject.

**blocked up**   Describes areas of an image lacking detail due to excess contrast.

**blooming**   Bright edges or halos in digital images around light sources, and bright reflections caused by an oversaturation of image sensor photosites.

**bracket**   To make multiple exposures, some above and some below the average exposure calculated by the light meter for the scene.

**brightness**   The perception of the light reflected or emitted by a source. The lightness of an object or image. See also *luminance*.

**buffer**   Temporary storage for data in a camera or computer.

**bulb**   A shutter speed setting that keeps the shutter open as long as the shutter button is fully depressed.

**CCD**   Charge coupled device. The technology used in the image sensor to transfer electric charges. Commonly a CCD is referred to as the image sensor in a camera.

**chroma noise**   Extraneous, unwanted color artifacts in an image.

**CMYK**   Cyan, Magenta, Yellow, Black. This color system is used to represent colors based on colored ink on a white background. This is the color model used on inkjet printers. See also *RGB*.

**color balance**   The color reproduction fidelity of a digital camera's image sensor. In a digital camera, color balance is achieved by setting the white balance to match the scene's primary light source. You can adjust color balance in image-editing programs by using the Color Temperature and Tint controls. See also *white balance*.

**color cast**   The presence of one color in other colors of an image. A color cast appears as an incorrect overall color shift often caused by an incorrect white balance setting.

**color temperature** A numerical description of the color of light measured using the Kelvin scale. Warm, late-day light has a lower color temperature. Cool, early-day light has a higher temperature. Midday light is often considered to be white light (5,000K). Flash units are often calibrated to 5,000K.

**CompactFlash** A memory card used in previous PowerShot cameras. It operates similarly to a Secure Digital (SD) card but is thicker and larger in size.

**compression** A means of reducing file size. Lossy compression permanently discards information from the original file. Lossless compression does not discard information from the original file and allows you to re-create an exact copy of the original file without any data loss.

**contrast** The range of tones from light to dark in an image or scene.

**contrasty** A term used to describe a scene or image with great differences in brightness between light and dark areas.

**cool** Describes the bluish color associated with higher color temperatures and is also used to describe image-editing techniques that result in an overall bluish tint. See also *Kelvin*.

**daylight-balance** General term used to describe the color of light at approximately 5,500K, such as midday sunlight or an electronic flash.

**depth of field** The zone of acceptable sharpness in a photo that extends in front of and behind the primary plane of focus.

**DIGIC** Digital Integrated Circuit. A proprietary computer chip made by Canon to process images coming from the image sensor and to control various camera operations. Currently, there are three versions: DIGIC, DIGIC II, and DIGIC III

**digital zoom** A method of making a subject appear closer by discarding pixels around the edge of an image and then fitting the remaining pixels into the same space to give the appearance of zoom. Digital zoom is accomplished by software within the camera rather than the optical elements in the lens. See also *optical zoom*.

**dpi** dots per inch. A measure of printing resolution.

**dynamic range** The difference between the lightest and darkest values in an image. A camera that can hold detail in both highlight and shadow areas over a broad range of values is said to have a high dynamic range.

**exif** Exchangeable image file format. A file structure used in digital cameras to allow the standardization of metadata and common exchange of files among different hardware systems.

**exposure** The amount of light reaching the light-sensitive medium — the film or an image sensor. It is the result of the intensity of light multiplied by the length of time the light strikes the medium.

**exposure compensation** A camera control that allows the photographer to overexpose (plus setting) or underexpose (minus setting) images by a specified amount from the metered exposure.

**fast** Refers to film or digital camera settings that have high sensitivity to light. Also refers to lenses that offer a very wide aperture, such as f/1.4, and to a short shutter speed.

**file format** The form (data structure) in which digital images are stored, such as JPEG, MPEG, MOV, and so on.

**filter** A piece of glass or plastic that is usually attached to the front of the lens to alter the color, intensity, or quality of the light. Filters also are used to alter the rendition of tones, reduce haze and glare, and create special effects such as soft focus and star effects.

**flare** Unwanted light reflecting and scattering inside the lens causing a loss of contrast and sharpness and/or artifacts in the image.

**flat** Describes a scene, light, photograph, or negative that displays little difference between dark and light tones. The opposite of contrasty.

**FlexiZone** A camera feature that allows you to move the autofocus point around the image being photographed.

**f-number** The numerical representation of the size of the aperture opening of the lens. It actually refers to a fractional formula related to the size of the opening and the focal length of the lens. Wide apertures are designated with small numbers, such as f/2.8. Narrow apertures are designated with large numbers, such as f/22.

**focal length** The distance from the optical center of the lens to the focal plane when the lens is focused on infinity. The longer the focal length is, the greater the magnification.

**focal point** The point on a focused image where rays of light intersect after reflecting from a single point on a subject.

**focus** The point at which light rays from the lens converge to form a sharp image.

Also the sharpest point in an image achieved by adjusting the distance between the lens and image.

**front light** Light that comes from behind or beside the camera to strike the front of the subject.

**f-stop** See *aperture* and *f-number*.

**gigabyte** The usual measure of the capacity of digital mass storage devices; slightly more than 1 billion bytes (1,073,741,824 bytes).

**grain** See *noise*.

**gray card** A card that reflects a known percentage of the light that falls on it. Typical grayscale cards reflect 18 percent of the light. Gray cards are standard for taking accurate exposure-meter readings and for providing a consistent target for color balancing during the color correction process using an image-editing program.

**grayscale** A scale that shows the progression of tones from black to white using tones of gray. Also refers to rendering a digital image in black, white, and tones of gray.

**highlight** Describes a light or bright area in a scene, or the lightest area in a scene.

**histogram** A graph that shows the distribution of tones in an image.

**hot shoe** A camera mount that accommodates a separate external flash unit. Inside the mount are contacts that transmit information between the camera and the flash unit and that trigger the flash when the shutter button is pressed.

**hue** The aspect of a color that allows it to be characterized with names like red or blue.

**image stabilization** A method of reducing blur in an image caused by camera shake. Motion sensors in the camera detect tiny movements and create error correction signals that are applied to optical elements in the lens. When this error is corrected in the lens, it is considered optical image stabilization.

**infinity** A theoretical point of a scene with the farthest focus.

**ISO** International Organization for Standardization. A rating that describes the sensitivity to light of film or an image sensor. ISO in digital cameras refers to the amplification of the signal at the photosites. Also commonly referred to as *film speed*. ISO is expressed in numbers, such as ISO 125. The ISO rating doubles as the sensitivity to light doubles. ISO 200 is twice as sensitive to light as ISO 100.

**JPEG** Joint Photographic Experts Group. A lossy file format that compresses data by discarding information from the original file.

**kelvin** A scale for measuring temperature based around absolute zero. The scale is used in photography to quantify the color temperature of light. In terms of color balance, a lower number appears warmer (or redder) and a higher number appears cooler (or bluer). See also *color temperature*.

**LCD** Liquid Crystal Display. A digital device used on the back of digital cameras to display an image.

**lightness** A measure of the amount of light reflected or emitted. See also *brightness* and *luminance*.

**linear** A relationship where doubling the intensity of light produces double the response, as in digital images. The human eye does not respond to light in a linear fashion. See also *nonlinear*.

**lossless** Refers to file compression that discards no image data. TIFF is a lossless file format. See also *compression*.

**lossy** Refers to compression algorithms that discard image data, often in the process of compressing image data to a smaller size. The higher the compression rate, the more data that's discarded and the lower the image quality. JPEG is a lossy file format. See also *compression*.

**luminance** The light reflected or produced by an area of the subject in a specific direction and measurable by a reflected light meter. See also *brightness*.

**manual** A camera mode in which you set both the aperture and the shutter speed.

**megabyte** Slightly more than 1 million bytes (1,048,576 bytes).

**megapixel** A measure of one million pixels.

**memory card** In digital photography, removable media that stores digital images, such as the Secure Digital (SD) card used to store PowerShot images.

**metadata** Data about data, or more specifically, information about a file. Data embedded in image files by the camera includes aperture, shutter speed, ISO, focal length, date of capture, and other technical information. Photographers can add additional metadata in image-editing programs, including name, address, copyright, and so on.

**middle gray** A shade of gray that has 18 percent reflectance.

**midtone** An area of medium brightness; a medium gray tone in a photographic print. A midtone is neither a dark shadow nor a bright highlight.

**Mode dial** A large dial on many PowerShots that allows you to select shooting modes.

**noise** Extraneous visible artifacts that degrade digital image quality. In digital images, noise appears as multicolored flecks, also referred to as digital grain. Noise is most visible in digital images captured at high ISO settings. See also *artifact*.

**nonlinear** A relationship where a change in stimulus does not always produce a corresponding change in response. For example, if the light in a room is doubled, the room is not perceived as being twice as bright. See also *linear*.

**open up** To switch to a lower f-stop, which increases the size of the diaphragm opening (aperture) and allows in more light.

**optical zoom** Subject magnification that results from adjusting optical elements in the lens. See also *digital zoom*.

**overexposure** Exposing film or an image sensor to more light than is required to make an acceptable exposure. The resulting picture is too light.

**panning** A technique of moving the camera horizontally to follow a moving subject, which keeps the subject sharp but creates a creative blur of background details.

**panorama** A wide-angle view of a scene made up of several images taken in sequence while changing the view of the camera horizontally or vertically.

**pixel** The smallest unit of information in a digital image. Pixels contain tone and color that can be modified. The human eye merges very small pixels so they appear as continuous tones.

**plane of critical focus** The most sharply focused part of a scene.

**polarizing filter** A filter that reduces glare from reflective surfaces such as glass or water at certain angles.

**ppi** pixels per inch. The number of pixels per linear inch on a monitor or image file. Used to describe overall display quality or resolution.

**RAM** Random Access Memory. The memory in a computer that temporarily stores information for rapid access.

**red-eye** A picture anomaly where a person's eye glows red. It is caused by the light from a flash reflecting off of the back of the eye.

**red-eye correction** A feature found on some digital cameras and image editing programs that reduces or eliminates red-eye artifacts by changing the color of the flash reflection to a less noticeable color.  ·

**red-eye reduction** A feature of digital cameras that uses an illumination device to close down the pupils of people looking at the camera before the picture is taken.

**reflected light meter** A device — usually a built-in camera meter — that measures light emitted by a photographic subject.

**reflector** A surface, such as white cardboard, used to redirect light into shadow areas of a scene or subject.

**resolution** The number of pixels in a linear inch. Resolution is the amount of information present in an image to represent detail in a digital image. See also *ppi*.

**RGB** Red, Green, Blue. A color model based on additive primary colors of red, green, and blue. This model is used to represent colors based on how much light of each color is required to produce a given color. PowerShots and computer displays use this color model. See also *CMYK*.

**saturation** As it pertains to color, a strong, pure hue undiluted by the presence of white, black, or other colors. The higher the color purity is, the more vibrant the color.

**sharp** The point in an image at which fine detail and textures are clear and well defined.

**shutter** A mechanism that regulates the amount of time during which light is let into the camera to make an exposure. Shutter time or shutter speed is expressed in seconds and fractions of seconds such as 1/30 second.

**Shutter priority** Tv Shutter-Priority AE. A semiautomatic camera mode that allows the photographer to set the shutter speed and the camera to automatically set the aperture (f-stop) for correct exposure. The opposite of Aperture priority.

**side lighting** Light that strikes the subject from the side.

**silhouette** A scene where the background is much more brightly lit than the subject; so that the subject, when photographed, is represented as a black shape without detail against a bright background.

**slow** Refers to film and digital camera settings that have low sensitivity to light, requiring relatively more light to achieve accurate exposure. Also refers to lenses that have a relatively small aperture, such as f/3.5 or f/5.6, and to a long shutter speed.

**speed** Refers to the relative sensitivity to light of photographic materials such as film and digital camera sensors. Also refers to the ISO setting, and the ability of a lens to let in more light by opening the lens to a wider aperture.

**spot meter** A device that measures reflected light or brightness from a small portion of a subject.

**stop down** To switch to a higher f-stop, thereby reducing the size of the diaphragm opening and reducing the amount of light reaching the sensor.

**telephoto** A zoom setting (or lens with a long focal length) that narrows the field of view and makes objects larger.

**telephoto effect** The effect a telephoto lens creates that makes objects appear to be closer to the camera and to each other than they really are.

**TIFF** Tagged Image File Format. A universal file format that most operating systems and image-editing applications can read. Commonly used for images, TIFF supports 16.8 million colors and offers lossless compression to preserve all the original file information.

**tonal range** The range from the lightest to the darkest tones in an image.

**top lighting** Light, such as sunlight at midday, that strikes a subject from above.

**TTL**   Through The Lens. A system that reads the light passing through a lens that will expose film or strike an image sensor.

**tungsten lighting**   Common household lighting that uses tungsten filaments. Without filtering or adjusting the correct white-balance settings, pictures taken under tungsten light display a yellow-orange color cast.

**Tv**   Time value. See *Shutter priority*.

**underexposure**   Exposing film or an image sensor to less light than required to make an accurate exposure. The result is a picture that is too dark.

**value**   The relative lightness or darkness of an area. Dark areas have low values, and light areas have high values.

**viewfinder**   A viewing system that allows the photographer to see all or part of the scene that will be included in the final picture. Some viewfinders show the scene as the lens sees it. Others show approximately the area that will be captured in the image. Some digital cameras have optical viewfinders, some have digital viewfinders that are similar to the LCD display, and some cameras have no viewfinders.

**warm**   Reddish colors often associated with lower color temperatures. See also *kelvin*.

**white balance**   The relative intensity of red, green, and blue in a light source. On a digital camera, white balance compensates for light that is different from daylight to create correct color balance.  See also *color balance*.

**wide angle**   A zoom setting (or lens) that produces a field of view that is wider than you would normally see with your eyes.

# Index

*Continued*